IMPRESSIONIST ROSES

BRINGING THE ROMANCE OF THE IMPRESSIONIST STYLE TO YOUR GARDEN

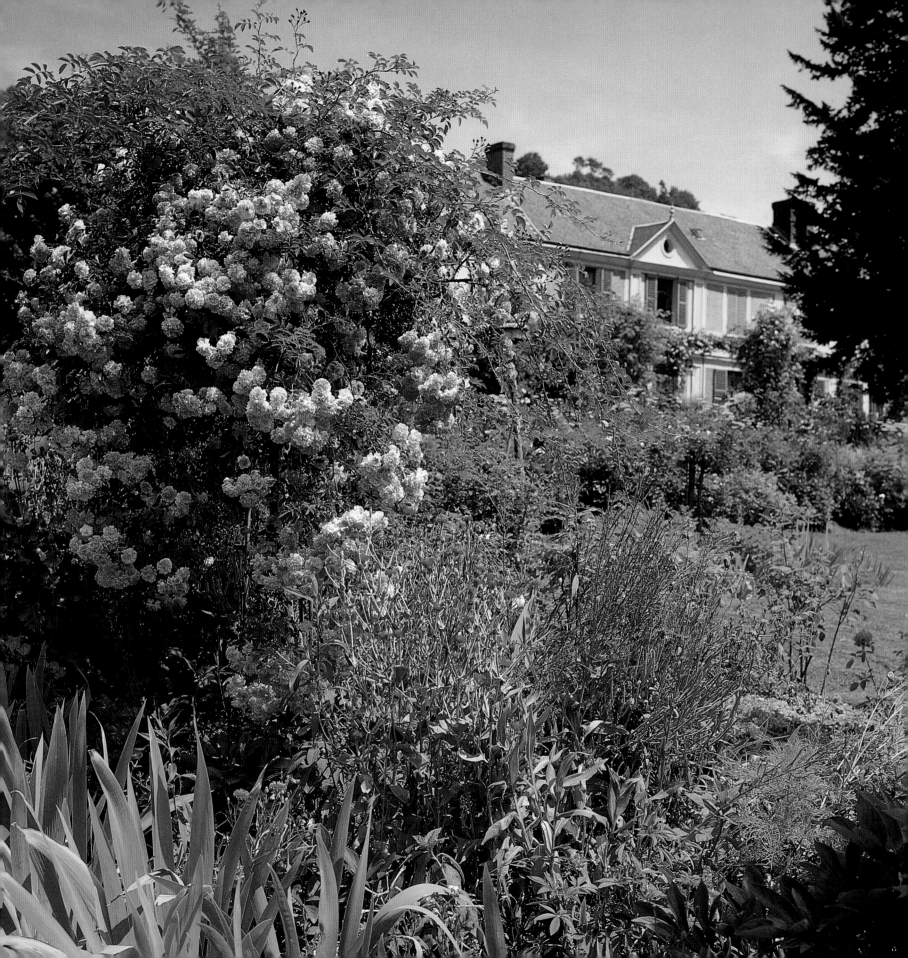

IMPRESSIONIST ROSES

BRINGING THE ROMANCE OF THE IMPRESSIONIST STYLE TO YOUR GARDEN

TEXT AND PHOTOGRAPHY BY DEREK FELL

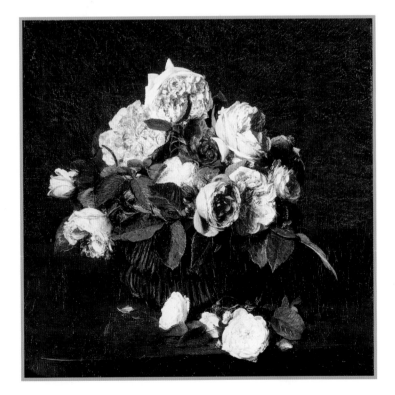

FRIEDMAN/FAIRFAX
PUBLISHERS

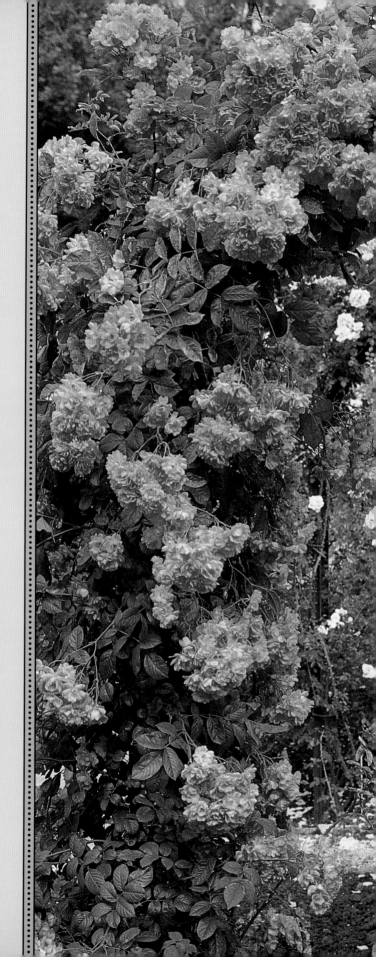

A FRIEDMAN/FAIRFAX BOOK

©1999 by Michael Friedman Publishing Group, Inc.

Library of Congress Cataloging-in-Publication data

Fell, Derek.
 Impressionist roses / by Derek Fell.
 p. cm.
 Includes index
 ISBN 1-56799-801-1
 1. Roses. 2. Rose gardens. 3. Impressionist artists—
 Homes and haunts—France. 4. Rose culture. I.
 Title.
 SB411 .F455 1999
 635. 9′ 33734—dc21 99- 11801

CONSULTING ROSARIAN: Pete Haring
EDITOR: Susan Lauzau
ART DIRECTOR: Jeff Batzli
DESIGNER: Milagros Sensat
PHOTOGRAPHY EDITOR: Amy Talluto
PRODUCTION MANAGER: Richela Fabian

Color separations by Colourscan Overseas Co Pte Ltd
Printed in China by Leefung-Asco Printers Ltd

10 9 8 7 6 5 4 3 2 1

For bulk purchases and special sales,
please contact:
Friedman/Fairfax Publishers
Attention: Sales Department
15 West 26th Street
New York, New York 10010
212/685-6610 FAX 212/685-1307

Visit our website: http://www.metrobooks.com

TITLE PAGE AND OPPOSITE: *'Belle Vichysoise' roses trained as standards punctuate the flower borders in Monet's Garden. Still Life with Roses and Glass of Wine by Henri Fantin-Latour.* THIS PAGE: *Arches of lush flowering roses at the Roseraie de l' Hay.*
CONTENTS PAGE: *'Gertrude Jekyll' roses paired with purple vervain create a cool color harmony.*

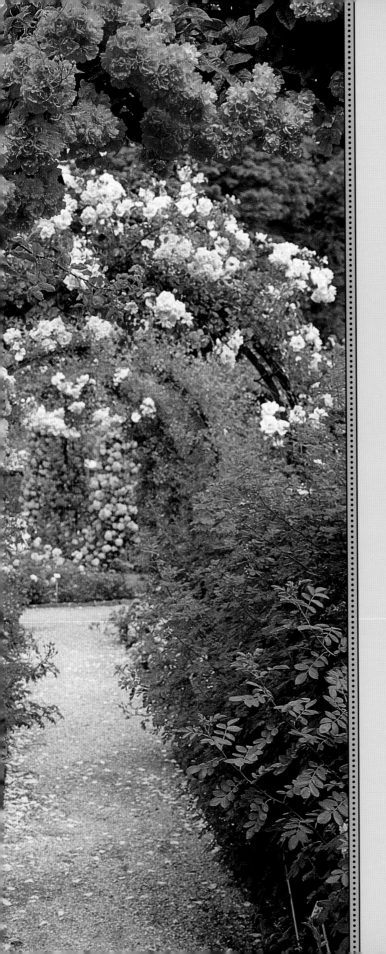

Dedication

For Victoria Rose, my youngest daughter

Acknowledgments

First, I value the support of my wife Carolyn, a professional stylist and floral arranger who worked with Pierre Cardin and Calvin Klein during her career as a designer and color specialist. She not only advised me on the section about flower arranging, but also created the rose arrangement on page 22, inspired by the beautiful painting *Roses* (1912) by the early California Impressionist, Franz Bischoff.

Second, a big thank you to my friend Julia Elliott, a talented contemporary British Impressionist painter, who rendered a painting of the rose garden at my home, Cedaridge Farm. Julia and I had the same art teacher in our teens, and I was fortunate to be reacquainted with her during a recent school reunion.

Also, a word of appreciation to Olive Dunn, a retired florist, whose romantic Impressionist-style rose garden at her home in Invercargill, New Zealand, inspired the rose garden design featured on page 61; and to Gwenda Harris, whose Impressionist-style rose garden in New Zealand is featured in this book.

Then there are many people involved in the gardens of Monet, Renoir, and other Impressionist painters I need to acknowledge, for providing essential background information—especially Jacques Renoir, great-grandson of the painter; Gilbert Vahé, head gardener at the Monet Museum and Garden at Giverny; and Francois des Noës, owner of La Croix Fantin, the home and studio of Fantin-Latour in the Normandy countryside.

Finally, my appreciation to Kathy Nelson, office manager at Cedaridge Farm, for organizing my extensive photo files, and to Wendy Fields, grounds supervisor at Cedaridge Farm, for maintaining the gardens during my research trips.

C O N T E N T S

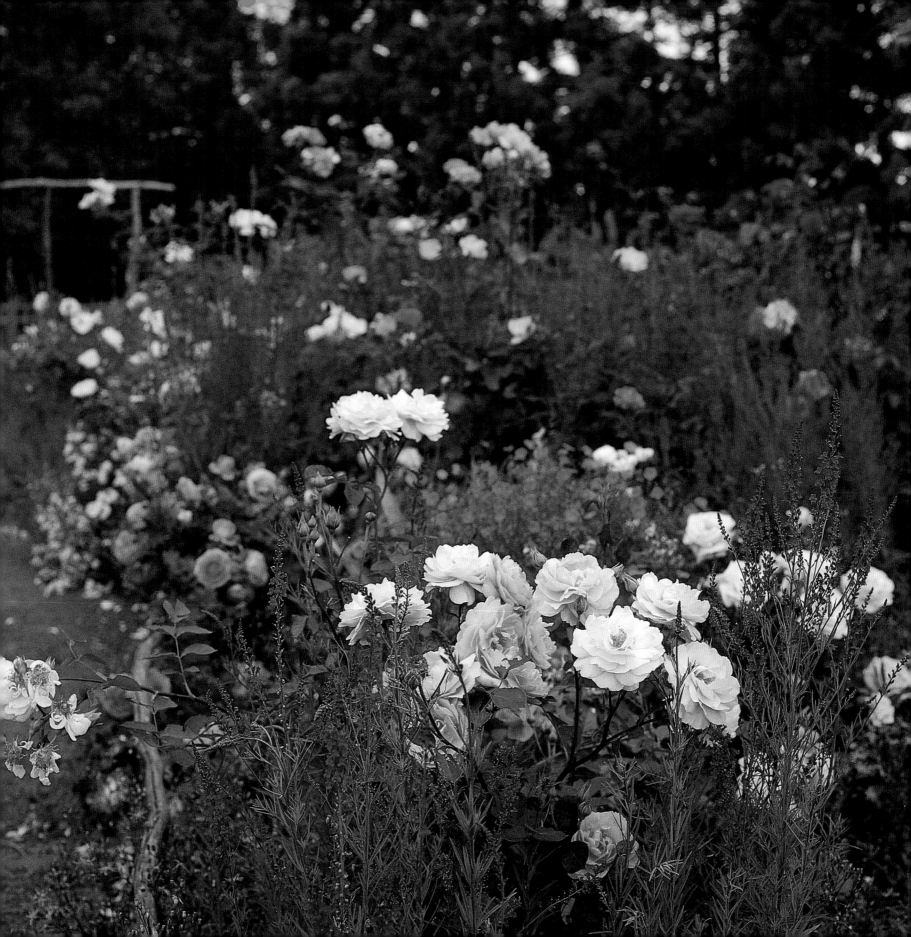

I KNOW OF NOWHERE IN NORTH AMERICA THAT ROSES CANNOT BE GROWN WELL. AS A MATTER OF FACT, I KNOW OF FEW PLACES IN THE WORLD WHERE ROSES DO NOT ENJOY A STRONG FOLLOWING. INDEED, MORE COUNTRIES HAVE ADOPTED THE ROSE AS THEIR NATIONAL FLORAL EMBLEM THAN ANY OTHER FLOWER, INCLUDING THE UNITED STATES (THE ROSE WON OUT TO STRONG COMPETITION FROM THE MARIGOLD).

But the rose was not always so universally popular. Although the rose has been cultivated for more than five thousand years—mostly as a source of fragrant oil—it was not until Empress Josephine, the wife of Napoleon, began collecting roses in her garden at Malmaison, north of Paris, that the rose took on a special significance in the hearts of gardeners. The Empress's real name was not Josephine, but Rose—a name that Napoleon disliked, for reasons unknown—and she steadfastly promoted the rose as a beautiful garden flower, encouraging nurserymen to hybridize a wealth of new varieties. The Napoleonic era ended in 1815 at the Battle of Waterloo; Renoir and Monet were born just twenty-five years later, and they and other early French Impressionist painters were beneficiaries of this hybridizing. Although they admired quite a few of the old roses the empress collected from all corners of the world, they especially liked many of the roses hybridized from her collection—not only as motifs to paint, but as ornamental plants to decorate their own gardens. The rose is now the most cherished of all cultivated flowers.

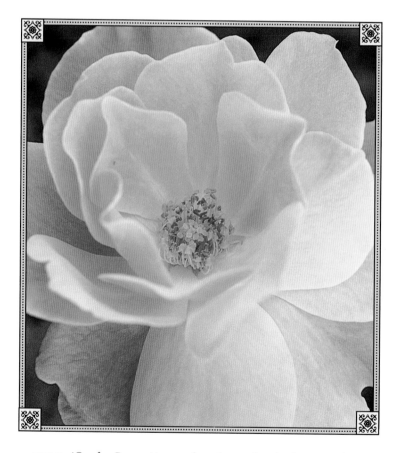

ABOVE: 'Carefree Beauty' is a modern, disease-free shrub rose similar in look to the fabulous 'Centenaire de Lourdes' roses used in Monet's garden.
OPPOSITE: The rambling roses featured in my garden at Cedaridge Farm include the pale pink 'Dorothy Perkins'.

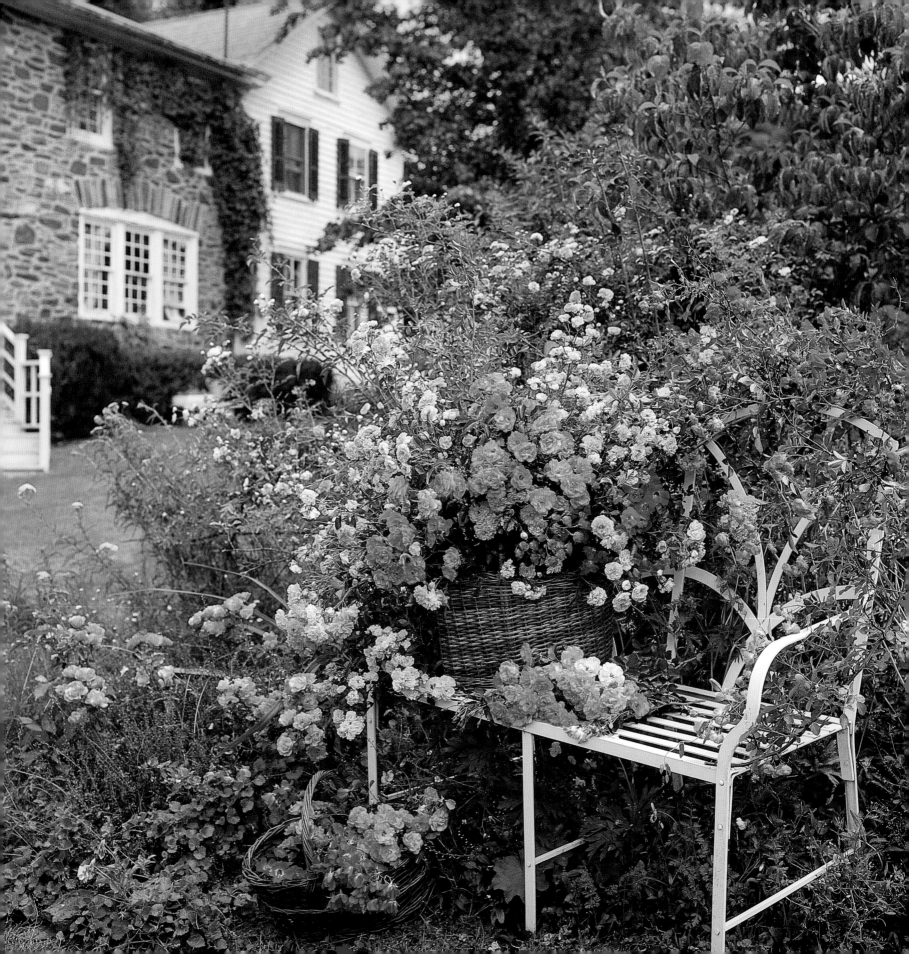

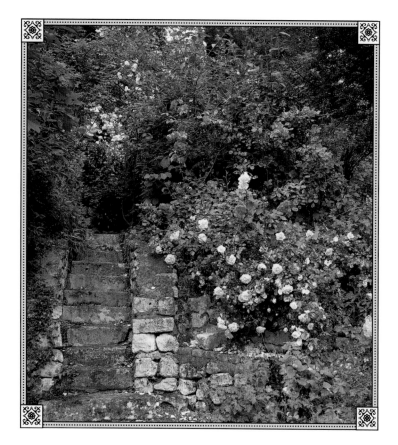

ABOVE: *This charming flower-bordered stairway is part of the old-fashioned rose garden at the Hotel Baudy, where Monet often met with his artist friends.* OPPOSITE: *Impressionistic in style, the rose garden at Cedaridge Farm uses scarlet 'Meidiland' and 'Dorothy Perkins' roses in combination.*

In spite of the rose's popularity, I have found that most rose gardens today lack imagination. The Impressionist painters, of course, did not suffer from lack of imagination. They not only enjoyed painting roses—both indoors as arrangements and outdoors in the garden—but many had rose gardens of their own. And they were as creative with their planting ideas as they were with the revolutionary painting technique the whole world came to admire for its freshness and brightness. When I began planting my own rose garden at Cedaridge Farm, I discovered more inspiration among the Impressionists—both

in their restored gardens and in their surviving paintings—than I did from visiting famous rose gardens!

In the research for this book, I especially enjoyed discovering the country home of Henri Fantin-Latour, the French painter, who more than any other in the Impressionist age, popularized the rose. I found his house and garden in the village of Buré, now in private ownership, and was able to recreate a Fantin-Latour–style arrangement on the beautiful property, featuring roses mixed with wayside wildflowers (see page 36).

I also fastidiously documented the roses used today in Monet's garden and in a magnificent new Impressionist-style garden on the grounds of the Hotel Baudy, Giverny, where all the famous French and early American Impressionists stayed when visiting Monet. Bagatelle Garden, in the Bois de Bologne, Paris, which celebrates more than ninety years of testing roses for award status, was one of Monet's favorite places to evaluate new rose introductions, and I caught the gardens in full glory. The best roses for climbing, rambling, pillar-form, standard (or tree–form), groundcover, hedging, shrub-form, and bedding display are all in the Bagatelle Garden—the new along with former award-winners.

I have traveled several times throughout France, Great Britain, and New Zealand to visit some of the world's finest display gardens for roses. Of all the rose growers and rose gardens I visited, few stand out more prominently than the public rose garden at Roseraie de l'Hay, near Orly Airport, Paris; Hershey Roses Gardens, perched on a hill above the famous chocolate factory, at Hershey, Pennsylvania; and the International Rose Test Garden, on a hillside overlooking the city of Portland,

Oregon. These famous gardens are unique not only for the wealth of modern varieties they grow, but also for their large collections of old-fashioned roses.

I am fortunate that the Conard Pyle Company (also known as Star Roses), one of the world's largest and oldest-established rose growers, is just an hour's drive south of Cedaridge Farm. Located in West Grove, Pennsylvania, Conard Pyle has extensive production fields, as well as test plots where rose plants from all over the world are evaluated. The company is also a distributor in the United States for Meilland, the prominent French rose breeder. Conard Pyle has a long history; in fact, it

even sold roses to Claude Monet. Monet was so taken by 'American Pillar', a rambler he bought from the company, that he propagated it himself from cuttings and distributed it as gifts to his friends, including Georges Clemenceau, former premier of France.

Although the highly cultivated hybrid teas and floribundas command the lion's share of the rose market, recent efforts by Meilland and David Austin have produced some excellent new cultivars featuring the wild or old-fashioned appearance so cherished by the Impressionist painters. Of particular importance are Meilland's Meidiland series of shrub roses—known as

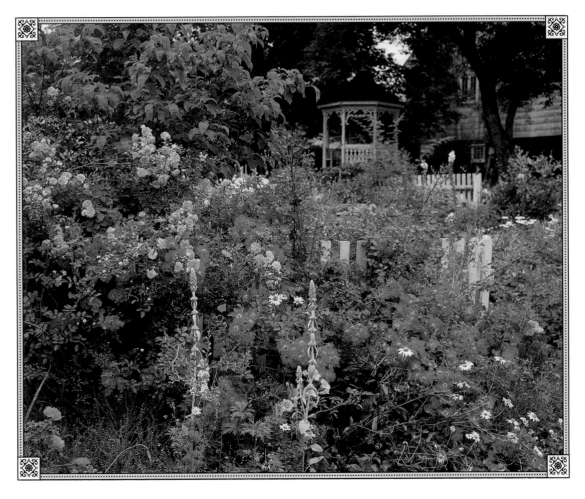

"the wild bunch"—and David Austin's very different English rose series. The English roses offer a swirling petal formation, large size, repeat-flowering, and haunting fragrance. For the future, look to the Conard Pyle Company for the introduction of a sensational new class of shrub roses called The Romanticas, bred by the Meilland family. These are hybrid tea varieties that start out with the classic urn shape so much admired by Renoir, but then change to a more old-fashioned appearance. They also repeat their

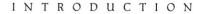
bloom and are more disease resistant than ordinary hybrid teas. Romanticas are Meilland's answer to David Austin's spectacularly successful English roses, but they tend to be more widely adaptable and possess superb disease resistance, which many of the early Austin roses lack. Interestingly, with headquarters at Antibes, on the Mediterranean coast, the Meillands were the source of many roses planted and painted by Renoir, whose house and garden still survives in that region.

Impressionist painters did not grow only old garden roses, usually classed as those in existence before hybrid tea roses appeared. The first hybrid tea, 'La France', came into cultivation in 1869 and caused a sensation for its large flower size, vigor, and repeat bloom. This spectacular rose took the horticultural world by storm, and features prominently in a painting by Gustave Caillebotte of his own rose garden. Flower arrangers, in particular, welcomed the advent of the hybrid tea rose, because many of these blooms possess the high-centered urn shape that is so beautiful in its mature-bud stage.

BELOW: This exuberant painting of a rose garden by Pierre-Auguste Renoir is titled Picking Flowers *(1875).*
OPPOSITE: 'Mary Rose', an English shrub rose, creates an Impressionist-style garden in pink when combined with rosy shades of nicotiana. White-flowering Nicotiana sylvestris *adds a painterly shimmer to the planting.*

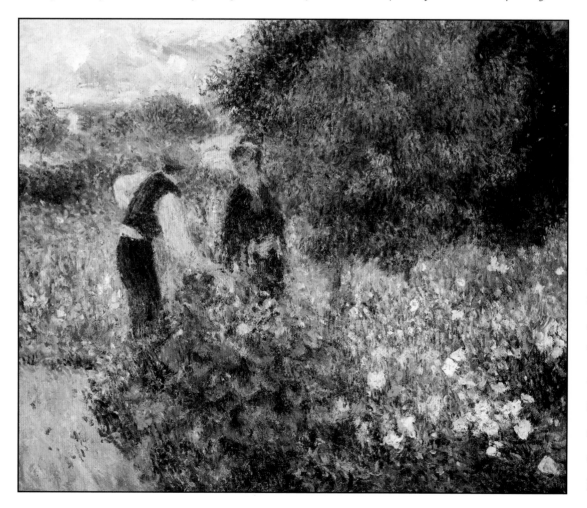

I grow some of the wild species roses known to the Impressionists (such as *Rosa rugosa* and *Rosa gallica*) for their intense fruity fragrances—these flowers are also lovely in indoor arrangements and potpourris. I also like to use a lot of modern shrub roses—especially 'Bonica' (also called 'Meidiland Pink') and 'Meidiland Red'. We find the Meidilands are resistant to mildew and blackspot, which are recurring problems during our humid summers here in Pennsylvania. The Meidilands

produce spectacular flower displays, yet the top growth is seldom eaten by deer (which visit our garden every night), and the vigorous root systems resist depredations by mice, which do great damage to many other modern roses. The Meidilands bloom faithfully every spring in an avalanche of blooms and continue all summer, with another heavy flush of bloom in autumn. For me there is no finer landscape rose.

Since there are thousands of desirable rose varieties in commerce—and dozens that the Impressionist painters admired—it is impossible in a book of this scope to feature them all. So I have spotlighted those roses that stand out in Impressionist paintings or in the restored gardens of the artists. After narrowing the selection down to the fifty best roses, I compared the Impressionists' favorites with roses that carry modern improvements. I have included some of these modern roses as alternatives, as many now combine an old-fashioned appearance with disease resistance or repeat-flowering qualities that may make them more desirable than the roses known to the Impressionists.

Note that some of the roses admired by the Impressionists—such as Yellow Lady Banks rose (*Rosa banksiae lutea*) and

'Mermaid' (hybrid bracteata)—are not suitable for all areas. These two tend to suffer winterkill during severe winters in northern gardens, but thrive in warm climates such as Florida and Southern California. To help you choose the best rose for your garden I note the plant's hardiness range and offer some hardy substitutes where appropriate. Tender rose varieties, however, are the exception, and the majority of roses presented in these pages are survivors, capable of enduring extremely cold winters throughout North America.

Most of all, I want this to be a book of ideas, so rose gardeners of today can recapture the romanticism of yesteryear, for I have yet to see roses grown more gloriously than in Monet's Garden. Perhaps our gardens can echo the sentiments expressed in a letter Monet's wife wrote to her daughter Germaine, in which she said: "I wish you could see the garden right now, it is a paradise; everything is in bloom—the irises, the poppies, the azaleas, the roses. It's just wonderful."

Derek Fell
Cedaridge Farm
Gardenville, Pennsylvania

13

THE ROSE APPEARS AS A MOTIF IN IMPRESSIONIST PAINTINGS MORE THAN ANY OTHER FLOWER. NOT ONLY DID THE GREAT FRENCH IMPRESSIONISTS PAINT IT IN STILL LIFE ARRANGEMENTS INDOORS, THEY ALSO PAINTED THE ROSE OUTDOORS IN MANY DIFFERENT KINDS OF SETTINGS, BOTH IN THEIR OWN GARDENS AND IN THE GARDENS THEY VISITED. WHILE SOME OF THE PAINTINGS SHOW OVERALL VIEWS OF ROSE GARDENS, OTHERS SHOW DETAILS OF ROSES GROWING IN SPECIAL GARDEN SPACES, COVERING AN ARBOR, ARCHING OUT OVER WATER, OR DECORATING A VICTORIAN-STYLE VERANDA. THE STILL LIFE ARRANGEMENTS, TOO, VARY CONSIDERABLY, FROM A SINGLE PERFECT ROSE IN A BUD VASE TO LAVISH BOUQUETS OF ROSES IN COMPANY WITH OTHER LUSCIOUS BLOOMS.

ABOVE: *Dried roses decorate a table in Renoir's studio at his home near Nice, France.* OPPOSITE: *This 'Painter Renoir' shrub rose, flowering at Cedaridge Farm, was grown from a cutting taken from Renoir's restored garden.*

Today, the world of gardening is seeing a tremendous surge of interest in growing roses. While the hybrid tea (an innovation of the Impressionist era) and the floribunda (a much more recent development) command the greatest sales among home gardeners, there has recently been a substantial interest in old garden roses, and many of these older varieties are the very roses immortalized by the Impressionist painters.

Moreover, the Impressionists' creative use of garden roses—whether crowded into exuberant cottage plots or elegantly trained over an arbor—are exactly the sorts of ideas today's adventurous gardeners seek to adapt for their own backyards. The Impressionists

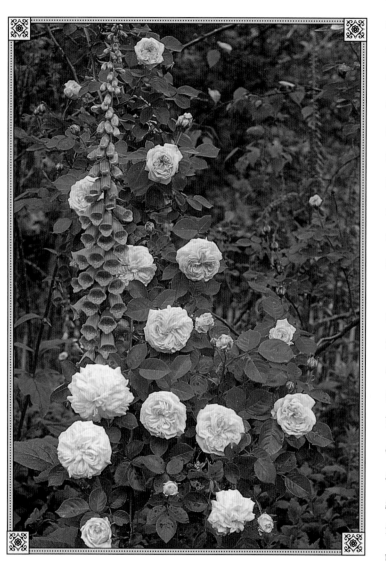

BELOW: *The English shrub rose 'Graham Thomas', among the loveliest of the yellows, is paired with a spiky foxglove in a stunning combination easy for backyard gardeners to copy.* OPPOSITE: *Edouard Manet's* The Bench (1881) *portrays the artist's own rose garden.*

tance of creating stimulating color combinations. For example, Monet planted a stunning hot color garden that showed off a harmony of orange and yellow tones. In addition, the Impressionists sought interesting companion flowers, planting spirelike foxgloves and hollyhocks, for example, to grow up through rose canes so that the blooms of both plants would mingle.

All the Impressionists admired the rose for its color range. Although not as diverse as the tulip or the bearded iris, the rose nevertheless is blessed with many gradations of pink, red, orange, yellow, and purple. There are even green and brown roses! In fact, the only important colors missing are light and dark

also have much to teach us about the colors and forms of roses—attention to their choices can guide us in designing our own rose gardens more beautifully. Many of the Impressionists transferred to their gardens lessons learned from their experiences painting roses—they especially understood the impor-

blues. The purity and brilliance of color found in rose petals and their appealing contrast with the plant's vigorous green leaves also enchanted the Impressionists. Often lustrous and leathery, the serrated, oval leaf can vary in color from light green to dark green to almost black. The new growth on many

roses—such as 'Mermaid'—is often infused with reddish tones, another facet the Impressionists considered attractive for their close-up studies.

The Impressionists particularly favored the rose for still life arrangements. Roses were, of course, abundant during spring and summer, but they were also grown year-round in Holland and the south of France in glasshouses—a recent invention, along with the watering hose and the lawn mower. An active cut-flower industry was concentrated around Nice, and roses were rushed to Paris by train for the city's flower markets. Thus, improved growing methods and advances in transportation enabled artists to paint still lifes even when roses were out of season in their own gardens.

The notable French Impressionist painters—such as Pierre-Auguste Renoir, Claude Monet, Camille Pissaro, and Gustave Caillebotte—came to popularity at the turn of the century. These artists introduced a painting technique that rebelled against traditional concepts of fine art, particularly defying the notion that a painting should be as realistic as possible. Others in the original group were Edgar Degas, Frederic Bazille, and Edouard Manet, as well as an

Englishman, Alfred Sisley; there were also two women, Berthe Morisot and Mary Cassatt (an American from Pittsburgh). Henri Fantin-Latour—a traditional salon painter of the time—was a close friend to them all, and although he is not considered a true Impressionist, many of his floral still lifes involving roses are in an Impressionistic style.

The artists Paul Cézanne, Vincent van Gogh, and Paul Gauguin are considered Post-Impressionists, since their conversion to Impressionism came a little later. Another famous group of artists is known as the early American Impressionists, and included Willard Metcalf, Childe Hassam, and Edward

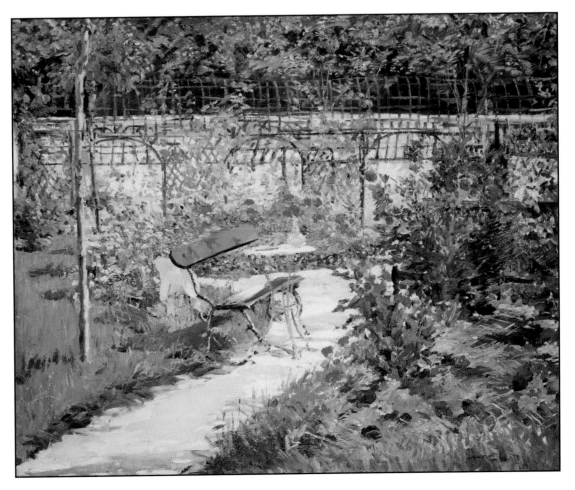

An 'Autumn Damask' rose from Renoir's garden shows the influence of rose colors on the work of this artist's youngest son, Claude, who decorated these plates.

in the impassioned paintings of the British artist, Joseph Turner. A school of French painting calling itself the Barbizon School had started to imbue their images with colors and brushwork that spoke more of how a painter felt about a scene than of how the subject actually looked. An element of exaggeration crept in to suggest nuances of fleeting atmospheric conditions and a strong sense of season. Their favorite subject was the Fontainbleau Forest, west of Paris, where the village of Barbizon is located.

Redfield—all of whom studied in Paris and later settled in New England or Pennsylvania. Art institutions in Boston and Philadelphia taught the Impressionist technique, and this influence soon spread to California, where two schools of Impressionist painting took root—one centered in Laguna Beach, in Southern California, and the other in the town of Carmel, in Northern California.

With the invention of photography in 1839, which captured a scene more realistically than any painting ever could, many artists were no longer satisfied to paint realistically in the tradition of great classical painters such as Jean-Auguste-Dominique Ingres, Francois Boucher, Antoine Watteau, and Jean-Honoré Fragonard. Many French artists found inspiration

The Impressionists took the departure from visual reality even further by painting form and structure in terms of gradations of light rather than sharply defined outlines. They often used flickering brushstrokes to present several colors in juxtaposition, so that the scene was brighter than it would be if rendered with one color alone. The rose proved an excellent subject for practicing this technique, for its petal color had a clarity and vibrance that was challenging to paint and its flower form was beautifully sensuous. Its large flowers, swirling petals, crown of powdery yellow stamens, and range of soft flesh tones inspired many painters to experiment with quickly rendered vignettes. The spontaneous nature of these pieces

may be why many of the rose paintings by Renoir and van Gogh seem unfinished.

For a painter to be recognized it was necessary that he or she be selected for one of two annual art exhibitions. One was at the Royal Academy in London, where a committee judged paintings submitted for display; the other was administered by L'Ecole des Beaux Arts, in Paris. Acceptance in the Paris salon exhibition was essential for a French artist to earn acclaim, and it took time for Impressionism to become accepted by the art establishment; the Impressionists had to overcome a bias against their unusual brushwork, as well as skepticism about their choice of motifs. Before the age of Impressionism the subjects that most impressed juried exhibitions were religious, mythical, or military.

Japan's opening up its borders from self-imposed isolation, however, changed the face of the European art world. The Japanese art that began appearing in London and Paris included not only ceramics, furniture, and fabrics, but also silk screen and woodblock prints that showed completely

'Painter Renoir' dresses the facade of Renoir's home at Les Collettes near Nice. The rose was introduced in 1911 by French rosarian Henri Estable.

new subjects for artistic expression. Indeed, Japanese art was nearly devoid of religious and military motifs, for throughout certain eras of Japan's history a strict code of censorship forbade religious or political artistic statements. Japanese artists, therefore, turned their attention to close-ups of flowers, gardens in all seasons, and the natural landscape, such as seascapes with weather-beaten trees and rugged rock formations. The world of the theater and of the geisha houses were also permitted motifs in Japan, and when the French Impressionists—especially Degas and Renoir—saw how lyrical these images could be, they turned their attention to flowers, the opera, and the ballet.

The rose, camellia, and peony were highly esteemed by Japanese painters, but camellias and peonies were expensive to collect and rather scarce. The rose, however, was available everywhere in Europe, thanks to the Empress Josephine. Her endeavor to collect every known variety and species of rose was seen as scientific by botanists. In fact, it is said that during the Napoleonic Wars British naval captains who detained ships headed for France were

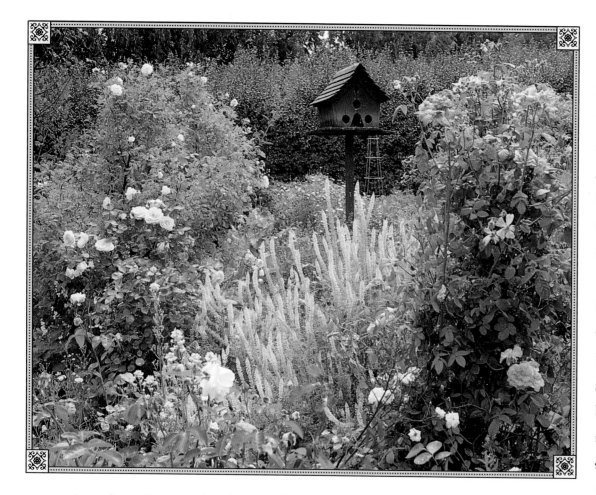

ABOVE: *A care-free small-space garden achieves its old-fashioned appearance through a liberal use of English roses. Glittering blooms of white mignonette (Reseda alba) impart an Impressionist shimmer.* OPPOSITE: *A rose arbor draped with the pink rambler 'Dorothy Perkins' frames the cottage garden at Cedaridge Farm.*

tivation. Previously unknown plants were introduced to Europe by explorers who had traveled through the wilderness areas of China, Persia, and Japan, as well as by many French, British, and Dutch nurserymen, who had begun an intensive project of hybridizing.

The tremendous rise in popularity of the rose coincided with a rise in gardening interest in general. This burgeoning interest in the home landscape was spurred by industrial prosperity, an explosion of housing development throughout Europe, and the rise of a middle class that had increased amounts of disposable income and leisure time.

instructed not to impound any rose varieties intended for the Empress's garden.

Empress Josephine not only encouraged nurserymen throughout Europe to begin aggressive breeding programs for the improvement of the rose, she also engaged the services of a botanical illustrator, Pierre-Joseph Redouté, to record the best of the roses in her garden. This initiative heralded a period in European history now known as the Golden Age of Horticulture for the incredible quantity of new plants brought into cul-

In the following chapters I will examine ways in which the Impressionists used roses—both in their gardens and in their floral arrangements—and will also highlight their favorite varieties and suggest some modern alternatives.

Above all, I wish to present a romantic view of the rose, as seen through the eyes of the Impressionists. Here you'll find scores of ideas for incorporating Impressionist roses into your garden, as well as details on growing healthy roses.

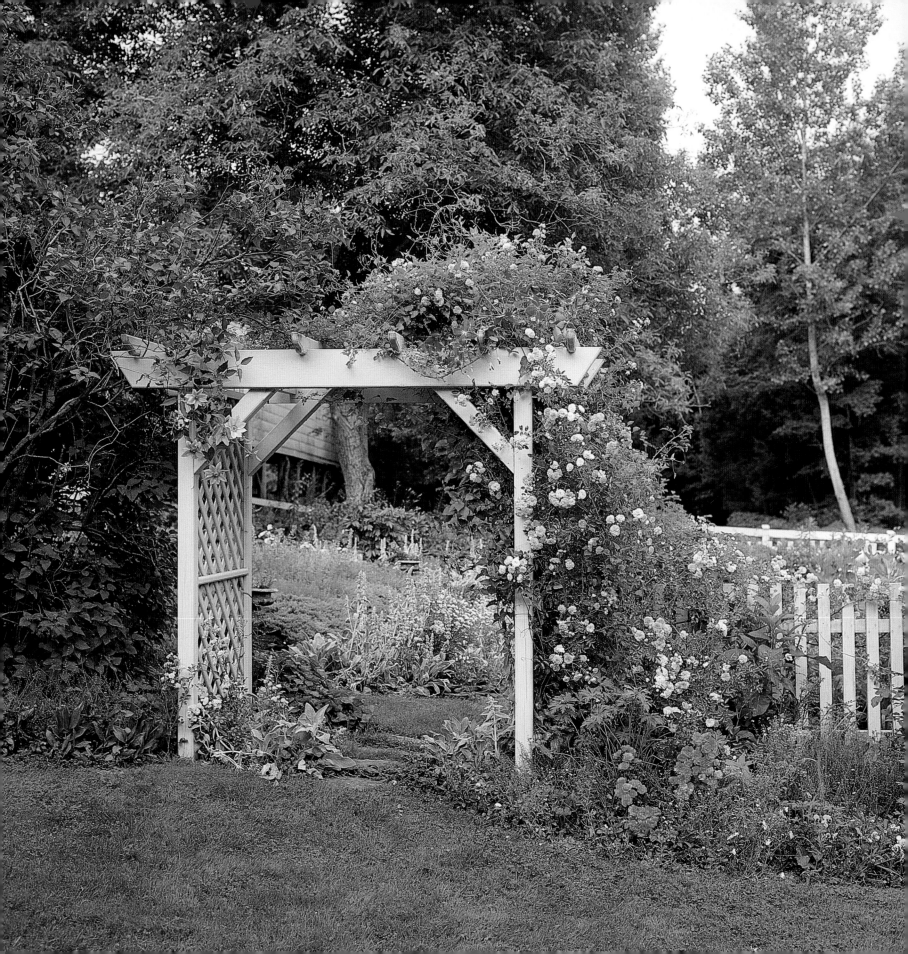

ARRANGING ROSES

No flower is more versatile, more satisfying, or easier to arrange than the rose. The rose comes in a vast range of flower forms—from clusters of small cheerful blossoms to exquisite urn-shaped blooms held erect on strong stems. And because the rose is a woody plant, the stems do not wilt quickly, but retain their rigidity for a completely fresh, natural look. Moreover, rose blossoms are capable of long life, although their longevity depends on the stage at which they are cut.

The rose's extensive range of colors allows for tremendous scope in creating color harmonies and subtle or dramatic color combinations. In addition to many shades of red, yellow, and orange (called "hot" colors for their assertive qualities), there are shades of violet-blue, purple, and mauve (classified as "cool" colors for their tranquil qualities). There are many bicolors and tricolors that expand the color possibilities even further, and there are singles, doubles, and semidoubles that provide a wide range of flower forms that add interest to arrangements.

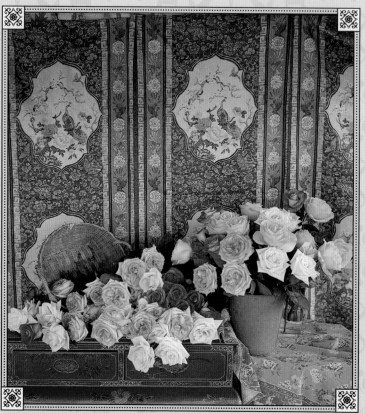

This exquisite arrangement of Romantica hybrid teas was inspired by an Impressionist painting (see painting opposite).

A solitary rose (especially a double-flowered rose cut in its tightly folded bud stage) is a wonderful candidate for a bud vase. At the other extreme, a mass of roses—especially a combination of complementary colors—can make a bold arrangement when simply fanned out in a vase. Because roses are available throughout the year from florists, it is also a joy to combine them with other plants that complement the colors or the style of the design. Branches of red pepper fruits, for example, are a dramatic complement to pink roses during autumn and winter. Lady's mantle (*Alchemilla mollis*)— with its citron-colored flower clusters—will enliven an arrangement of red or crimson roses, while the spires of blue delphiniums look sensational with deep pinks. Roses also combine well with wayside flowers, such as wild asters and ox-eye daisies, and common annuals, such as cornflowers and poppies.

Arranging roses need not be limited to cut stems. Place an entire plant, such as a potted miniature variety, in a lovely basket edged with dry greens or moss for a memorable gift or a charming centerpiece at a family picnic or country

wedding. On a more grandiose scale, consider using groups of potted standard roses to create a dramatic entrance for a community hall or country club event. Use rambler roses with their long, pliable stems coiled over wire frames to create garlands, or twine roses through twig and moss to create an appealing floral arch. Add height and drama to a large room by hanging pendulum balls of roses tied tightly at the neck from the ceiling.

Do not overlook dried roses. In order to obtain a beautiful dried rose, simply hang one by its stem upside down from a rafter or hanger. Once dried, you can leave them hanging in place, add them to dried flower arrangements, or use them to decorate the brim of a summer hat.

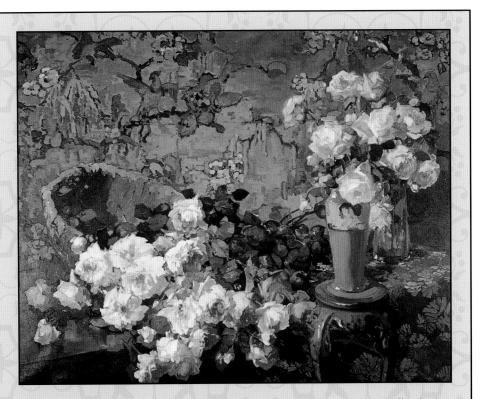

This glorious painting, entitled Roses *(1912), is the work of Franz A. Bischoff, a leader of the early California Impressionist movement.*

CONDITIONING ROSES

Conditioning cut roses properly can extend their vase life considerably. When cutting roses from your garden, carry a bucket of warm water with you. Choose blemish-free roses with strong, straight stems and deep green, lustrous leaves, and immediately plunge up to two-thirds of the stems into the water. This helps to prevent air from entering the stem, which will cause blockage of the water intake. Cut roses require a lot of water, especially those with large blooms or large floral clusters.

Once the roses have been cut and carefully placed in buckets, return to the house and fill a second bucket with warm water. Then add a floral preservative, such as Aquaplus or Crystal (available from florists). If these are unavailable, add sugar (for nutrition) and bleach (to kill any harmful bacteria). For a 5-gallon (18.9L) bucket add one tablespoon of sugar and ¼ cup of bleach.

Using a sharp knife or pruning shears, remove the leaves and any thorns from the lower third of the stem (the thorns can be broken off with a fingernail). Make a severe diagonal cut about 2 inches (5cm) from the original cut and plunge the stem immediately into the new bucket. This long diagonal cut is important to ensure that a good amount of cut surface is exposed to the warm water. Allow the roses to stand in a cool, dark area for at least twenty-four hours before arranging.

THE ROSE GARDENS OF THE IMPRESSIONISTS

ALMOST ALL THE EARLY IMPRESSIONIST PAINTERS LOVED ROSES, A PASSION THAT CARRIED OVER TO THE POST-IMPRESSIONISTS AND REMAINS WITH MODERN IMPRESSIONIST PAINTERS. BUT THE EARLY IMPRESSIONIST PAINTERS HAD A SPECIAL REVERENCE FOR THE ROSE. MONET, FOR EXAMPLE, FOUND CLIMBING ROSES TO BE ESSENTIAL IN HIS DESIRE TO TAKE COLOR HIGH INTO THE SKY, WELL ABOVE THE REACH OF FLOWERING SHRUBS AND PERENNIALS. HE WANTED HIS ENTIRE FIELD OF VISION INFUSED WITH COLOR WHEN HE STEPPED OUT OF HIS HOUSE AND INTO HIS GARDEN. HE VISITED ROSE NURSERIES AND TEST GARDENS, MAKING METICULOUS NOTES ABOUT COLOR AND PLANT HABIT.

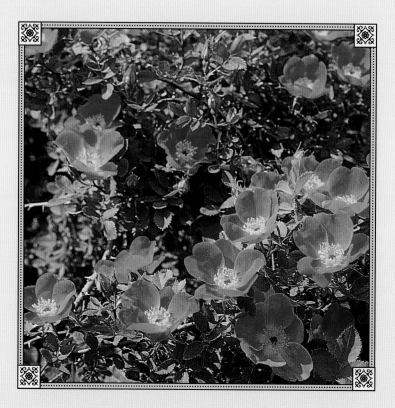

ABOVE: *'Austrian Copper'—with its coppery red and rich yellow—is unmatched in its vivid coloring.* OPPOSITE: *'Floral Carpet' (foreground), 'Meidiland Red', and 'Dorothy Perkins' mix with orange 'Enchantment' lilies and oxeye daisies in an informal planting typical of Renoir's garden designs.*

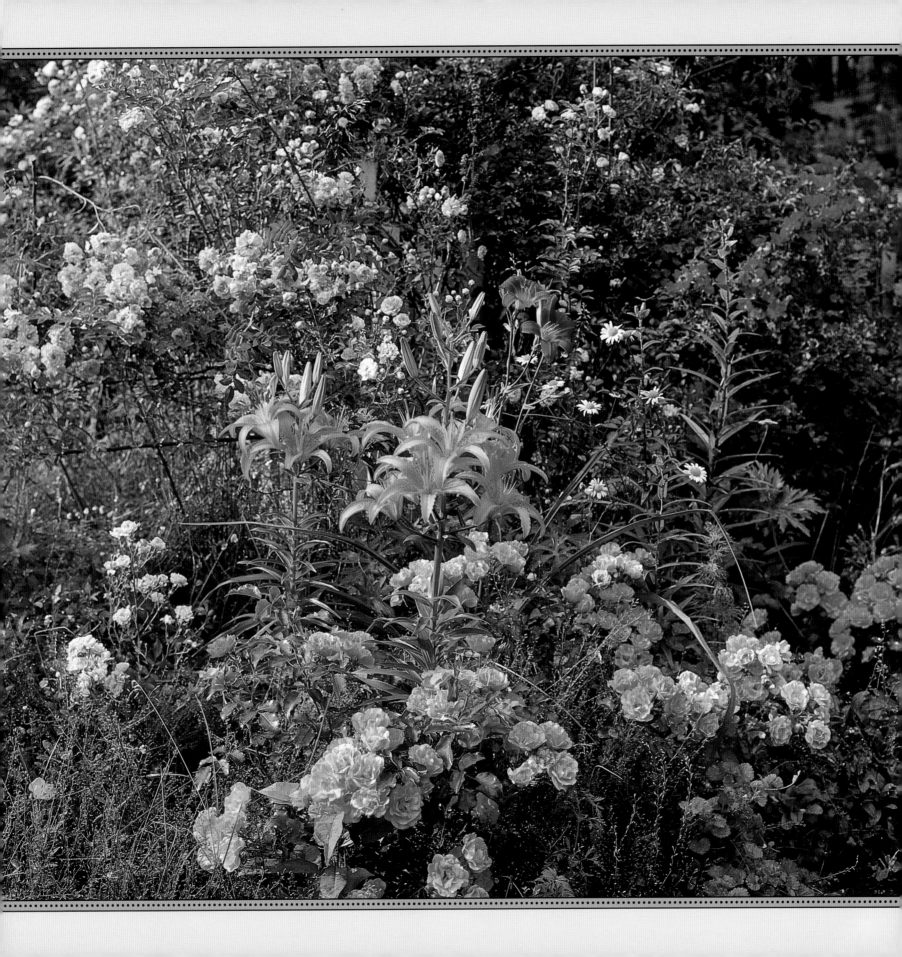

RENOIR, WHO ESPECIALLY LIKED CLIMBING ROSES, USED ROSES FOR EXPERIMENTS WITH COLOR TINTS AND NUANCES OF LIGHT—BY PAINTING ROSES HE PERFECTED THE "ROSY GLOW" THAT CHARACTERIZES MANY OF HIS NUDE STUDIES. HE LOVED THE SWIRLING PETALS AND PENDANT HABIT OF SOME OF THE OLD-FASHIONED BOURBON, NOISETTE, AND PORTLAND ROSES (ALSO CALLED DAMASK PERPETUALS). RENOIR ALSO ADMIRED SOME OF THE NEWER HYBRID TEA ROSES FOR THEIR HIGH-CENTERED URN SHAPE, ESPECIALLY EVIDENT IN THE MATURE BUD STAGE. ABOVE ALL, RENOIR LOVED TO SEE ROSES USED INFORMALLY—EVEN MIXED WITH WILDFLOWERS IN MEADOW PLANTINGS.

Renoir's Roses

Of all the Impressionist painters, none was more skillful at painting the rose than Pierre-Auguste Renoir (1841–1919), and the rose became his favorite flower. Although he painted dozens of still life arrangements featuring roses, he also painted rose gardens, both formal and informal in design. He loved to include roses in his compositions of women and children by showing his models holding, wearing, or admiring roses as incidental decorative elements.

Renoir's paintings of children and women are unique in the distinctive rosy glow that seems to surround them—especially noticeable in the skin tones. His experience in painting roses was clearly important in his painting of figures. In fact, one of his dealers, Ambroise Vollard, following a visit to Renoir's home near Nice, reported: "As I was leaving the studio, I paused before some sketches of roses. Renoir told me he was doing some studies of flesh tints for a nude." Renoir himself said, "When I am painting roses, I can experiment boldly with tones and values without worrying about destroying the whole painting. I could not dare to do that with a figure, because I would be afraid of spoiling everything. The experience I gain from these experiments can be applied to my painting."

Renoir's father was a tailor with a meager income, and in 1844—when Renoir was only three years old—the family moved from Limoges to Paris, into an area of slums that then clustered close to the Louvre Art Museum. Renoir's love for the

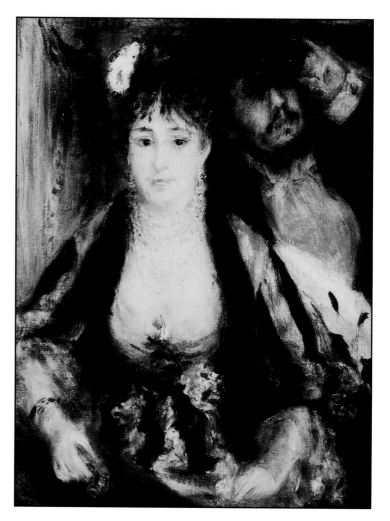

rose began at the age of thirteen, when he left school and took employment in a ceramics factory, where he painted swags of roses on porcelain. Another frequent motif was Marie Antoinette, complete with peaches-and-cream complexion, rosy cheeks, and low neckline. Renoir often visited the Louvre and copied romantic motifs from the great French masters, especially Boucher and Fragonard—both of whom glorified women with rosy skin tones.

Renoir's career as a painter of porcelain ended with the development of a porcelain transfer technique, which eliminated the need for laborious hand painting. He then turned his attention to becoming a serious painter and at the age of twenty enrolled in the Charles Gleyre Studio, where he met Claude Monet, Edouard Manet, and others who were experimenting with new means of artistic expression. Renoir had a good singing voice and was keenly interested in the world of opera. There he would observe society ladies dressed in elegant fashions, often carrying bouquets of roses or wearing roses in their hair and as

OPPOSITE: *Renoir used roses artfully to enhance his portraits of women. In* The Theater Box (1874) *blush-tinted roses help to accentuate the woman's delicate skin tones.* BELOW: *Renoir's painting accoutrements are set out in his restored garden at Les Collettes.*

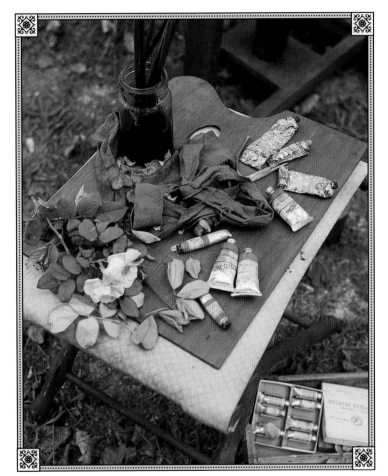

corsages. Renoir noticed that the colors of roses generally flattered a woman's skin tones and clothing.

During his early years Renoir enjoyed the hospitality of several wealthy art patrons. He often accompanied Monet to weekend parties at the estate of Montgiron, owned by Ernest Hoschedé, a Paris department store owner. There, he greatly admired an informal rose garden that bordered a lake on the property. Renoir also visited another art patron, by the name of Georges Berard, at his Wargemont estate on the Normandy coast. At the entrance of the main mansion was a beautiful formal rose garden that included standard, or tree-form, roses that towered above shrub roses and beds of geraniums. Renoir's painting of this rose garden so impressed Monet that he established rose beds identical to the Wargemont beds when he designed his garden at Giverny.

For most of his life Renoir remained a bachelor, but at the age of fifty he married his favorite model, Aline, and she bore him three sons (the youngest of whom—Claude—he fathered at

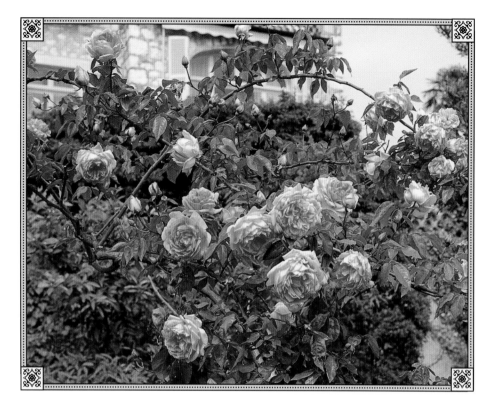

ABOVE: *'Empress Josephine', a hybrid gallica, grows with abandon in Renoir's garden.*
OPPOSITE: *Flowering Garden (1886) is a study Monet painted of the standard roses underplanted with geraniums that grew in his garden at Giverny.*

the age of sixty). After years of struggle, Renoir had become wealthy from his paintings, which were especially popular in the United States. Initially, Renoir rented a house in Montmartre, in an area called the Chateau des Brouillards, overlooking the city of Paris. Montmartre boasted many fine houses with large gardens, and Renoir especially loved the month of June, when roses bloomed everywhere. Some of these were ramblers that could climb as high as the tallest trees, and filled the air with the sweet fragrance of their blossoms.

During the summer, the Renoir entourage—complete with servants and models—moved to a farm in the Burgundy countryside, where roses were cultivated in a spacious garden that bordered a vineyard owned by Aline's parents. But it was in Nice that Renoir finally found his Eden. He had begun renting a house in the picturesque medieval village of Cagnes-sur-Mer, and one day he learned that an old olive orchard he loved to paint was to be uprooted for development. Distraught at the thought of such magnificent old trees being destroyed, he purchased the land and, with his wife's encouragement, built a house on a corner of the property overlooking the olive trees. He named the property Les Collettes—a colloquial name for a region of hills.

At Les Collettes, Aline Renoir laid out a formal rose garden below their bedroom windows. It was planted with many large-flowering hybrid tea varieties, early-flowering Lady Banks roses, late-flowering 'Autumn Damask' roses, and old-fashioned Bourbon roses between rows of citrus trees. Many of the roses came from Cap d'Antibes, where the Meilland family had established a rose breeding nursery. The four rows of citrus trees, seven to each row, were mostly oranges and tangerines. Since oranges ripen in the winter months and stay on the trees well into spring, the roses and oranges were on display in the garden together.

Renoir was such a prolific painter of roses, and was so admired for his romantic portraits of women with roses, he even gave his permission for a new rose to be named for him. Rosarian Henri Estable, who worked in the Nice area, intro-

duced 'Painter Renoir' in 1909. This beautiful, pale pink shrub rose received an Award of Merit from the Nice Horticultural Society and is the predominant rose in the garden of Les Collettes today. We have two specimens in our garden at Cedaridge Farm—a cherished gift from the head gardener at Les Collettes. Although the plant needs some protection from windburn during severe winters, it has good heat resistance and a beautiful growth habit, sending out arching canes studded with pale pink, pompon-shaped flowers. We especially like to show it off against a background of blue agapanthus or any blue flowering perennial. The combination of pale pink and blue is a wonderfully appealing color harmony.

Renoir's house and garden, Les Collettes, has been fully restored and is open to the public. See page 139 for details about arranging to visit the garden.

Monet's Roses

The first we learn of Claude Monet's fondness for roses is actually in a painting done by Renoir—the work shows Monet (1840–1926) painting the rose garden on a property he rented at Argenteuil, near the River Seine, west of Paris. In the garden at Argenteuil, all appear to be shrub roses that arch their canes through and over a picket fence. The mix of colors is informal and haphazard, and includes glorious reds, yellows, pinks, and white.

Monet was born in Paris, but at an early age his father moved the family to Le Havre, a channel port on the Normandy coast, where he established a wholesale food business provisioning ships. At first, Monet earned pocket money as a cartoonist, but after meeting the French seascape painter

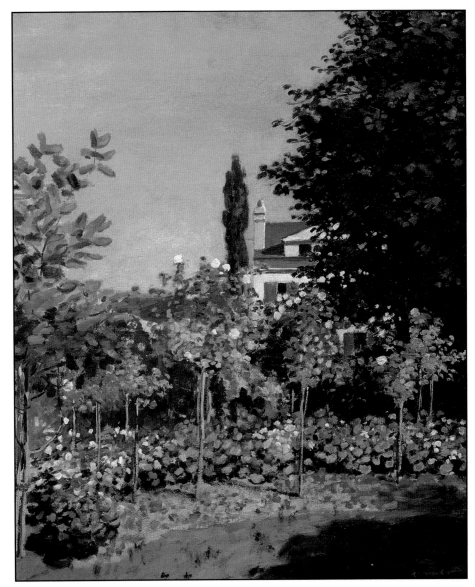

Eugene Boudin, he turned to serious painting and returned to Paris to study at the Gleyre Studio. There he met Renoir and others seeking new ways of artistic expression. At one of their independent exhibitions, Monet showed a painting of the harbor at Le Havre, depicting the sun burning through morning mist. Entitled *Impression, Sunrise* (1872), it was singled out for savage criticism by the press and gave birth to the term Impressionism.

Monet struggled to earn recognition for his work, and his complicated domestic life put enormous pressure on his time and financial resources. His fortunes changed at about the same time as those of his friend Renoir, when both found their work in demand by North American collectors. Shortly after his first wife died following the birth of their second son, Monet added four step-daughters and two step-sons to his family by inviting Alice Hoschedé, the estranged wife of his art patron, Ernest Hoschedé, to live with (and later marry) him. They needed a large house, and Monet eventually found it in the village of Giverny. It came with an orchard of plum trees and a garden of boxwood parterres, which Monet ripped out. He then modeled the land to his aesthetic ideal, producing a design that was formal in layout but relaxed in the exuberance of its plantings.

Monet planted his garden to paint, and declared it to be his greatest work of art. In my book *Secrets of Monet's Garden*, I've identified more than a hundred special planting techniques that made the garden a unique artistic expression, including special color harmonies and the sensation of glitter, created by sprinkling airy white flowers liberally throughout the flower beds. Roses were to figure prominently in this garden.

Monet much admired the garden of Gustave Caillebotte, a friend and fellow Impressionist painter, whose work is often characterized by pronounced lines of perspective. Monet liked the idea of a garden with long lines of perspective, as it gave his paintings infinite depth when viewed along the beds, known as *plante bands*. Conversely, when viewed from the side, the parallel beds would present a sea of color—like rolling surf—espe-

Monet's pink house features a deck and canopy of roses that runs almost the entire length of the facade. In June, when all the roses are in full bloom, the sight is magnificent.

cially when the season was well advanced and the lines of the layout were blurred by vegetation. Another important requirement for Monet was color that extended high into the sky, for he planned his garden with the express purpose of painting it, and he wanted his entire field of vision billowing with flowers. Roses accomplished this effect better than any other plant, as versatile climbers and ramblers could be trained up to thirty feet (9m) to cover high arches and scramble into the branches of tall trees.

The first major structural element Monet added to his flower garden was a Grande Allée—a wide, straight path that extended from the main entrance of the house to the bottom of the garden and was punctuated with six wide metal arches. Climbing roses in inspiring tones of yellow, orange, red, and pink were planted at opposite ends of the spans and allowed to meet in the middle, forming a floral tunnel. Along the sides of the spans were flowering perennials, while the path itself was decorated with creeping nasturtiums that carpeted the floral tunnel.

MONET'S ROSES

MONET'S GARDEN FEATURES BOTH OLD AND MODERN ROSES. THE FOLLOWING ROSES ARE THE MAIN VARIETIES USED IN HIS GARDEN TODAY. AN ASTERISK DENOTES A VARIETY INTRODUCED INTO CULTIVATION SINCE MONET'S DEATH.

NAME	DESCRIPTION	USE
'American Pillar'	Single red with white eye	Climber, standard
'Albertine'	Double, pale pink	Climber, pillar
*'Angelique'	Double, pink	Climber, pillar
'Belle de Crecy'	Double, red, fragrant	Shrub
'Bleu Magenta'	Double, purple, fragrant	Standard
*'Centenaire de Lourdes'	Double, deep pink	Standard
'Dorothy Perkins'	Double, pink, clustered	Standard
'Dr. Van Fleet'	Double, pale pink	Shrub, pillar
'Gloire de Dijon'	Double, orange	Climber
*'Iceberg'	Semidouble, white	Climber, standard
*'Lavender Dream'	Single, purple, clustered	Standard, shrub
'Maréchal Niel'	Double, yellow	Climber
'Margot Koster'	Single, white	Climber
'Paul's Scarlet'	Semidouble, scarlet	Climber
'Phyllis Bide'	Double, peach	Standard, pillar
'Purity'	Semidouble, white	Climber
'Reine des Violettes'	Double, violet-blue	Shrub
'Veilschenblau'	Lavender-blue, clustered	Pillar, standard
'Wedding Day'	Salmon-pink	Standard

Monet also added rectangular metal frames for training roses to other parts of his garden. One of his favorite roses for covering these frames was 'Paul's Scarlet Climber', a brilliant red climber developed by a British rose breeder, William Paul & Son. Monet liked to plant this spectacular red rose with vines such as morning glory and clematis, so that the flowering vines and the roses charmingly mingled their colors.

Another choice for growing along the door-shaped frames was 'Mermaid', a single-flowered hybrid bracteata also developed by William Paul & Son. The saucer-sized blooms feature white petals with a golden eye and a crown of powdery stamens at the center. The bounty of 'Mermaid' blooms produced a dazzling lace curtain effect, which added a twinkling quality to the garden. Monet grew this stunning flower along the canopy of a porch that ran almost the entire length of his house, and he considered it his favorite of all roses.

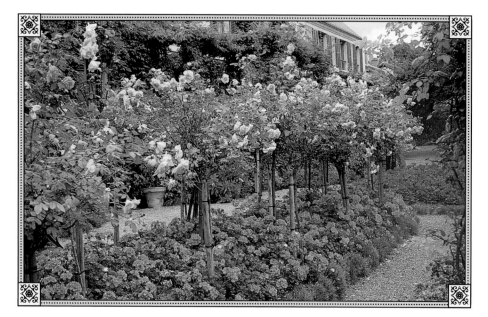

ABOVE: 'Centenaire de Lourdes' roses grown as standards are generously underplanted with pink geraniums. 'Carefree Beauty' and 'Simplicity' make good hardy alternatives for North American gardeners. OPPOSITE: 'American Pillar' climbing roses adorn the boat dock in Monet's garden.

Monet also liked to use 'Mermaid' in his water garden because it arched its canes out over the water and dipped its branches into the pond, where the beautiful white and yellow flowers produced exquisite reflections in the water's surface. Planted among the trees bordering the pond—mainly poplars and bald cypress—'Mermaid' hooked its thorny canes onto outstretched tree branches and extended its long, sinuous canes up to twenty feet (6m) into a tree. Today, the water garden at Giverny features 'Nevada', a large, saucer-sized, white shrub rose with gracefully arching canes.

Two other roses helped Monet create his distinctive garden, which he claimed was his greatest work of art. He obtained 'American Pillar', a rambler with masses of white-centered carmine flowers from Conard and Jones (now Conard Pyle) in Pennsylvania. Although it blooms only once each summer—for three weeks in June—it can reach to thirty feet (9m) in height, draping itself in so many blooms that they almost hide the foliage. Monet planted 'American Pillar' to climb over some especially high arches that framed his boat dock.

'Belle Vichysoise' was another of Monet's favorites used extensively in his water garden. This Noisette was commercially propagated by a French rosarian, Paul Leveche, who found it growing at Vichy. This rose's small, pink, pompon-like flowers are held in generous clusters on extremely vigorous, tall canes. Like the beloved 'American Pillar', 'Belle Vichysoise' grew up the high arches of Monet's boat dock.

Monet loved roses for their heady fragrance, and he regularly brought them indoors to decorate and perfume all the rooms of his house. For this purpose he grew hybrid teas for cutting in a special rectangular rose garden.

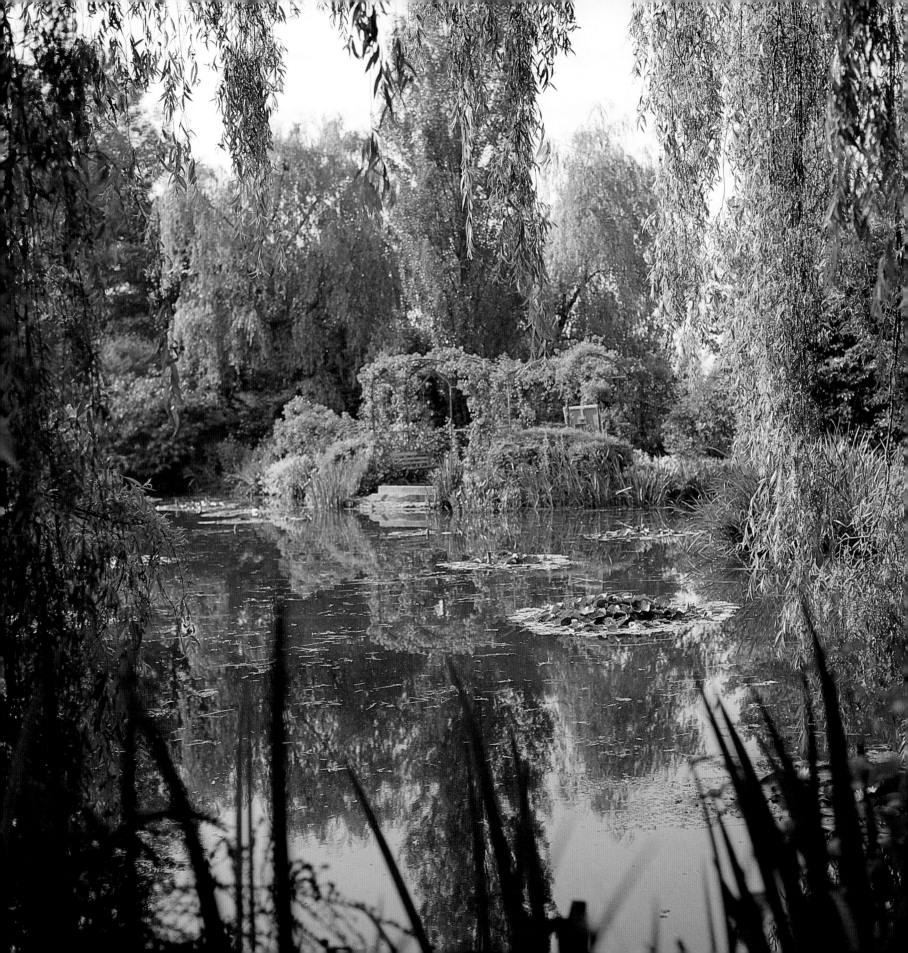

Inspired by Renoir's painting of tree-form roses at Wargemont and by the tree-form roses in Caillebotte's garden, Monet introduced hundreds of these roses into his own garden. Below the deck of his porch, two beds of red geraniums were interplanted with pink tree-form roses. The red-pink-and-green combination of geraniums and roses contrasting with the dark green geranium leaves is a motif Monet greatly admired. From archival photographs, the pink roses appear to be a hybrid tea known as 'La France', but today the gardeners prefer to use 'Centenaire de Lourdes', a disease-resistant, repeat-flowering modern floribunda.

Although Monet had as many as nine gardeners working for him, he was greatly involved in the day-to-day running of the garden. He liked to visit the Bagatelle Rose Gardens, in the Bois de Boulogne in Paris, where trials were conducted and awards of merit given for the best new rose varieties. He probably first spotted 'American Pillar' and 'Paul's Scarlet Climber' in the Bagatelle Rose Gardens. Once he acquired a specimen plant and approved of its performance in his garden, Monet usually propagated his own plants from cuttings. He had a greenhouse that allowed him to do this, and he liked nothing more than presenting special friends with home-propagated plants that had only recently entered the marketplace.

Monet's house and garden at Giverny have been restored and are open to the public. See page 139 for further details.

BELOW: *'Rose des Peintres', literally "the painter's rose," grows in the garden at Roseraie de l'Hay.* OPPOSITE: *In a corner of Cezanne's garden at Aix-en-Provence, the yellow climber 'Maréchal Niel' entwines itself with the blossoms of a white mock orange.*

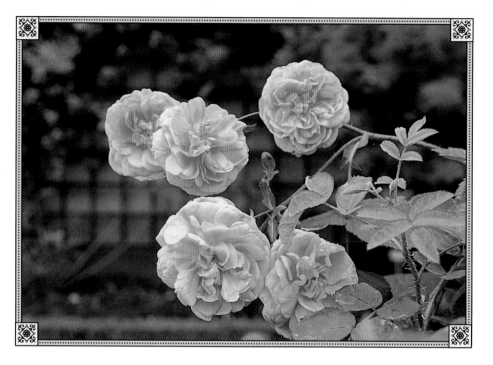

Caillebotte's Rose Garden

The term Impressionism originated with Claude Monet's painting entitled *Impression, Sunrise* (1872), which portrayed Le Havre harbor, but Gustave Caillebotte (1848–94) was perhaps more responsible for establishing Impressionism as a legitimate art form than any other single person. Wealthy from inherited money, he bought paintings from Monet, Renoir, Cézanne, Pissaro, and other Impressionist painters when they were strapped for money. He also sponsored their exhibitions and promoted their talents to the art establishment of Paris. A skillful painter in his own right, Caillebotte first began painting as a teenager at his family estate at Yerres, south of Paris.

The estate had a large walled vegetable garden where Caillebotte liked to paint, and which was featured in one of his earliest paintings, *The Kitchen Garden* (1877). It also had a rosarium—a collection of roses—that is seen in *A Garden, Yerres* (1877). *A Garden* is especially interesting, as it shows climbing roses trained over arches similar to those Monet later used for his Grande Allée at Giverny.

The Caillebotte rose garden contained a great number of old garden roses, including the Cabbage Rose (also known as the Painter's Rose and the Rose of Provence). Produced from crosses in Holland among alba and damask roses, the Cabbage Rose had a unique flower form. Its large pink flower head was composed of a hundred petals, producing a rose of good substance and classing it among the centifolias.

After his parents died and the Yerres estate was sold, Caillebotte purchased a smaller property at Petit-Gennevilliers, on the banks of the River Seine north of Paris. Its long, narrow garden was laid out in narrow beds known as *plante bands*, to create long lines of perspective. These were punctuated with roses trained to create tall tree forms, also called standards, and edged with low espaliered fruit trees known as cordons, *cordon* meaning rope. The *plante bands*, standards, and espaliered trees outlining flower beds were all ideas that Monet later incorporated into his own garden.

The twenty-eight-acre (11.3ha) Caillebotte estate at Yerres—with its Italianate house—still survives as a public park, although much of its original grandeur has been lost through lack of upkeep. Caillebotte's garden at Petit-Gennevilliers, has disappeared, the victim of industrial development.

Cézanne's Garden

"He looks like a cutthroat, with large red eyeballs standing out from his head in a most ferocious manner, a rather fierce-looking pointed beard, and a way of talking that makes the dishes rattle." This vivid description of the Impressionist painter Paul Cézanne (1839–1906) was penned by Juliet Manet, niece of the painter Edouard Manet, after her first meeting with Cézanne. But she found that, far from being a cutthroat, Cézanne had the gentlest nature possible. "In spite of a total disregard for the dictionary of manners, he shows a

politeness which no other man here would have shown. He is one of the most liberal artists I have ever seen," Juliet concluded.

Cézanne's life is full of contradictions like this. The garden that survives him is no exception. There are those who say that the garden today is a mirror image of Cézanne's art, and faithful to his design. There are others in the art world, however, who scoff at this notion as a romantic illusion, and claim that what survives today is nothing more than an overgrown jumble of plants. But I do not subscribe to that school of thought, for the garden has a gardener who has very definite ideas about Cézanne's design and strives to maintain its informal appearance, shady paths, leaf tunnels, clearings, terraces, and stone steps.

Essentially, the acre site is a shade garden, created by a dense grove of tall trees (mainly chestnuts, olives, and redbuds) and flowering shrubs (most notably mock orange and climbing roses). Indeed, the garden of Cézanne is similar in appearance and design philosophy to the restored garden of the Hotel Baudy in Giverny, where a labyrinth of paths climb a shaded slope planted with tall trees and shrub roses.

During a walk along the paths of Cézanne's Garden, at Aix-en-Provence in the south of France, there are numerous tapestry effects employing mostly contrasts of green—fleecy, arching leaf blades of Japanese hakone grass and dark, leathery leaves of English ivy scramble up trunks into the leaf canopy, for example. But the junglelike abundance of foliage is subtly lit with

splashes of vibrant color—most often from pink or yellow climbing roses that twine up into the lower branches of trees then cascade down into a clearing or path. Later in the season, these luscious blossoms drop their petals to carpet the ground like bits of confetti.

Fantin-Latour's Roses

Henri Fantin-Latour (1836–1904) was born in Grenoble, France, and moved to Paris to study at the *Ecole des Beaux Arts*. He quickly made friends with Monet, Renoir, and others who represented the pinnacle of Impressionist painting. His most memorable painting, *Studio in the Batignolles Quarter* (1870), is a group portrait of the most forward-thinking artists of the

ABOVE: *Flowers decorate the table of Fantin-Latour's country retreat in the village of Buré in Normandy.* OPPOSITE: *Fantin-Latour was well-known for his lush still lifes, such as this one, entitled* Roses in a Basket on a Table.

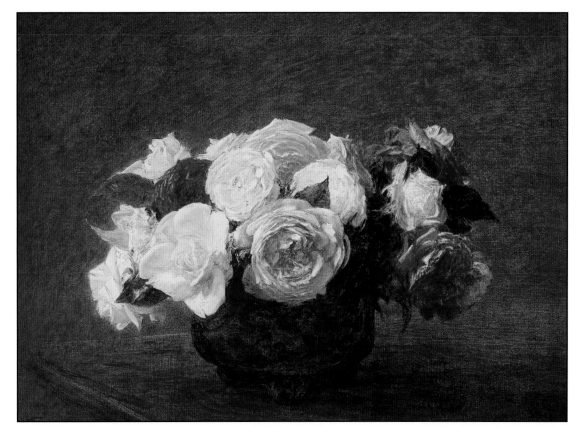

day, including Monet, Manet, Renoir, and Bazille.

Fantin-Latour's greatest strength, however, was his paintings of floral arrangements, particularly roses. In fact, between 1864 and 1896 Fantin-Latour painted flowers almost exclusively. During a trip to London he made friends with a wealthy art patron and his wife, Mr. and Mrs. Edwin Edwards. The Edwards had a beautiful house and garden in the country, at Sunbury-on-Thames, near London, where Fantin-Latour stayed for long periods and painted. His flower paintings began to appear at the Royal Academy summer exhibitions in London, and the Edwards sold his paintings readily—"almost fresh from the easel." Fantin-Latour was exhibiting in London at a time when the British were having a love affair with lush, informal gardens. Led by garden magazine publisher William Robinson and garden writer Gertrude Jekyll, the renaissance of cottage garden style began as a rebellion against French formality. Although Fantin-Latour maintained a studio in Paris and a house and rose garden in the Normandy countryside, at Buré, his paintings were sold almost exclusively in England, and as a consequence he was virtually unknown in France.

In 1876, Fantin-Latour married Mlle. Victoria Dubourg, an accomplished painter of floral still lifes in her own right. Always shy and quiet, Fantin-Latour became reclusive after his marriage, content to stay at home with Victoria, who modeled for him. Every summer they left Paris and spent time together painting at Buré, in a house owned by Fantin-Latour's father. After Edwin Edwards died, his widow would travel to Paris and carry off Fantin-Latour's entire summer output of flower paintings, for shipment to England.

Of his relationship with Mr. Edwards, Fantin-Latour wrote: "Edwards sells what I paint. I am able to live quietly...doing what I please, thanks to Edwards." On another occasion, impressed by a special summer season when the roses seemed more exquisite

37

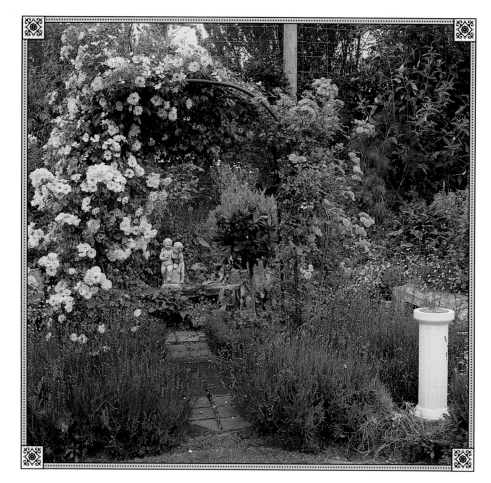

ABOVE: *A small-space rose garden features the climbing roses 'Phyllis Bide' and 'Jeanne Lajoie', both popular in Monet's garden today.* OPPOSITE: *The rambler 'Mrs. F.W. Flight' frames a luxuriant garden space.*

shadow that is the hallmark of Impressionism (see painting on previous page).

Some of Fantin-Latour's favorite roses were white-flowered ramblers, pink, yellow, and red Noisettes, and pink tea roses. He was identified so closely with the rose that an unknown rose breeder (probably a British nurseryman) named a fragrant, light pink, centifolia rose after him. 'Fantin-Latour' is today among the most popular of the old garden roses.

Art historian Pierre Courthion, writing in his book *Flowers by Fantin-Latour*, paid Fantin-Latour perhaps the highest compliment when he wrote: "The mixed flowers, the buttercups, the petunias, the sweet peas, the pansies in their basket, the chrysanthemums, they all appear on his canvases like a thousand-voice accompaniment to the repetitive melody of the rose. The rose, which on his canvas takes on the color and the shape of a never-fading flower, of a flower which has ceased to be the one-day flower, but which is the eternal flower."

than he had ever seen them, he wrote: "I am painting flowers because one must take advantage of the moment...and this year I find the flowers more beautiful than ever."

Fantin-Latour never completely embraced the Impressionist style of painting; he strove more toward photographic realism to impress the salon judges affiliated with the Academie des Beaux Arts. However, his numerous floral still life paintings (and particularly those showing roses) have a lightness of touch, a spontaneity of expression, and a sensitivity to sunlight and

Fantin-Latour died suddenly at the age of sixty-eight on a summer's day at Buré. Feeling ill during lunch on his terrace, he walked out into the garden, and collapsed among his beloved rosebushes. He left a legacy of seven hundred magnificent floral paintings—most of them paintings of roses, rendered alone or in combination with other common garden flowers or wayside blooms.

Fantin-Latour's house and garden survive to this day, in private ownership, and his studio has hardly been touched since the day he died, his palette still encrusted with dried paints and his belongings scattered about. Unfortunately, the studio was burglarized, and an original framed black-and-white photograph of Fantin-Latour standing in his rose garden was stolen. It showed a garden with a pergola covered in climbing roses—similar to Monet's Grande Allée—and winding paths that threaded through beds of roses and cottage flowers in what the French call a "rectory garden" style.

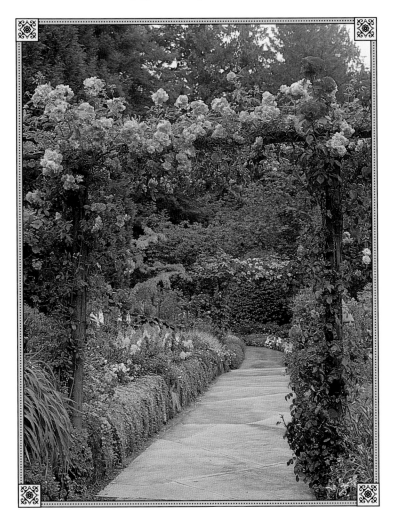

Pissaro's Rose Garden

Camille Pissaro (1830–1903) was born on the island of St. Thomas, in what is now the U.S. Virgin Islands. When Pissaro lived there the island was administered by Denmark, and he remained a Danish citizen all his life. He started painting in the port town of Charlotte Amalie, where he sketched the Danish fort overlooking the dock area as well as some of the local beaches bathed in the light of romantic sunsets and overhung with coconut palms. To broaden his painting skills, Pissaro moved to Paris, where he quickly converted to Impressionism. He was the oldest of the Impressionists. In fact, Paul Cézanne not only looked on Pissaro as his mentor, but signed some of his work "student of Pissaro."

During his lifetime, Pissaro never enjoyed the fame that Monet and Renoir eventually found, and he was invariably strapped for money until he reached old age. He moved his family a number of times to suburban towns north of Paris, finally discovering his idyll in the village of Eragny, south of Dieppe in the Normandy countryside. There he established a magnificent rose garden, complete with high metal arches similar to those of Monet's Grand Allée. Great spires of hollyhocks grew up through the flowering canes of the roses—in one painting, entitled *The Vegetable Garden at Eragny* (1897), these towering hollyhocks are shown to be as tall as the house. At the base of the hollyhocks and roses, Pissaro planted bushy dahlias. He also had a passion for growing vegetables, and his rose garden surrounded a *potager*, or kitchen garden, where he grew lettuce and cabbage, onions and carrots, and all the other delectable root

and leaf crops valued in French cooking. Clearly, Pissaro was innovative in the way he designed a limited garden space to accommodate both fresh vegetables and flowers for cutting.

Unfortunately, Pissaro's garden at Eragny no longer survives.

Van Gogh's Rose Gardens

Vincent van Gogh (1853–1890) struggled for recognition as a painter all his life. At the time of his death—by suicide at age thirty-six—he had sold only one canvas. His painting career spanned a period of just ten years, but his output was prodigious. Moreover, he left reams of letters explaining precisely what he liked about a particular garden or about a floral arrangement he painted. Roses were a favorite motif—he especially adored pink and white blooms.

Van Gogh first began painting roses as experiments in color harmonies. Soon after moving to Paris from Holland, he came under the spell of Impressionism, which called for a much brighter painting technique than he had used previously. Painting flowers—including roses—helped van Gogh learn to brighten his palette and adapt to the Impressionist style of Renoir and Monet, the two painters he most admired.

After two years in Paris, van Gogh moved south, to the town of Arles in Provence, where he expected to find motifs similar to those he admired in Japanese silk-screen prints. He was not disappointed, for the farmers in the area wore peaked straw hats like those of Japanese peasants, and cultivated crops in flat fields similar to Japanese rice paddies. They even built fences of a reed that resembled the bamboo windbreaks used by the Japanese, and the apricot and plum orchards presented angular, flower-studded branches like those painted by Japanese artists.

Van Gogh's correspondence during this time to his brother, Theo—an art dealer in Paris—is full of admiration for the rose,

ABOVE: 'Old Blush' cascades over a wall in the asylum garden at Saint-Rémy in Provence. It may even be the same shrub that van Gogh described as "a bush of pale roses in the cold shadow." OPPOSITE: Still Life with Roses (1890) was painted by van Gogh while he was staying at the asylum.

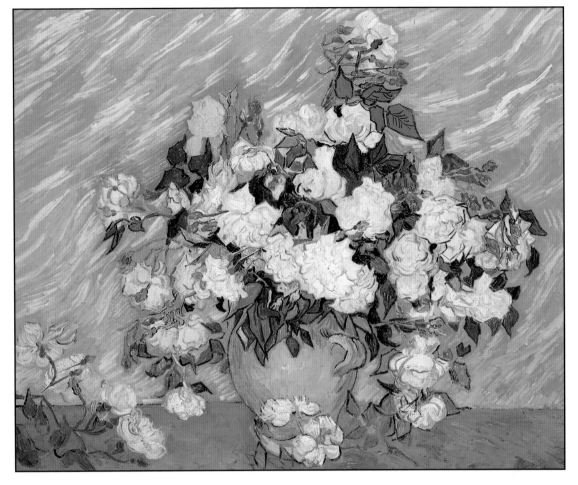

and for a painting of a rose garden by Renoir. Writing from Arles, in 1888, van Gogh reminisced: "You will remember that we saw a magnificent garden of roses by Renoir. I was expecting to find subjects like that here, and indeed, it was that way while the orchards were in bloom. Now the appearance of things has changed and become harsher....You will probably have to go to Nice to find Renoir's garden again." Incredibly, van Gogh's prophecy became a reality for Renoir, whose own rose garden near Nice took form nineteen years later when he bought Les Collettes.

During his stay in Arles, van Gogh began having mental problems and sought treatment at an asylum in the small town of Saint-Rémy. The asylum had a walled garden, and in an early letter to his brother van Gogh described how much he liked the garden for its intimacy and especially for its thickets of trees and shrubs, describing vividly "a bush of pale roses in the cold shadow."

The walled asylum garden survives to this day, complete with its bushes of pink roses—mostly 'Old Blush' and 'Complicata'—in the shadow of beautiful trees. Because the asylum is still maintained as an institution for the treatment of mental illness, the garden is not open to the public. However, there is a well-defined walk around the walls into the surrounding countryside, with markers showing many of van Gogh's motifs, including hedgerows packed with wild roses that van Gogh painted.

At the end of a year's stay in the asylum at Saint-Rémy, van Gogh discharged himself and moved to Auvers-sur-Oise, a village north of Paris where both Pissaro and Cézanne had painted wonderful landscapes. Van Gogh moved there to be close to Dr. Paul Gachet, a doctor of psychiatry, who had a

rose garden that van Gogh painted. In the village there were other rose gardens, notably the garden of an elderly artist van Gogh admired, Charles-François Daubigny. Both these informal gardens were painted by van Gogh, and survive to this day. Though neither of the gardens is open to the public, both are visible from the sidewalk.

The Hotel Baudy's Rose Garden

When Claude Monet settled in the village of Giverny, his presence there drew admirers from all over the world, including early American Impressionists and other French Impressionists such as Renoir and Cézanne. The only place to stay in town was the Hotel Baudy. Recently restored, the hotel now displays photographs showing many of its famous patrons. It is a splendid place to explore or enjoy refreshment in the restaurant, but the best reason to visit the Hotel Baudy is for its restored gardens. Planted in the carefree, informal style admired by the Impressionists, the Hotel Baudy's rose garden has a truly extraordinary design. You will find that many of the roses are grown in woodland settings, and are viewed from a twisting, winding gravel path that climbs a steep, shady hillside to several wide stone terraces. Quite a few of the roses are old varieties and climbers that arch

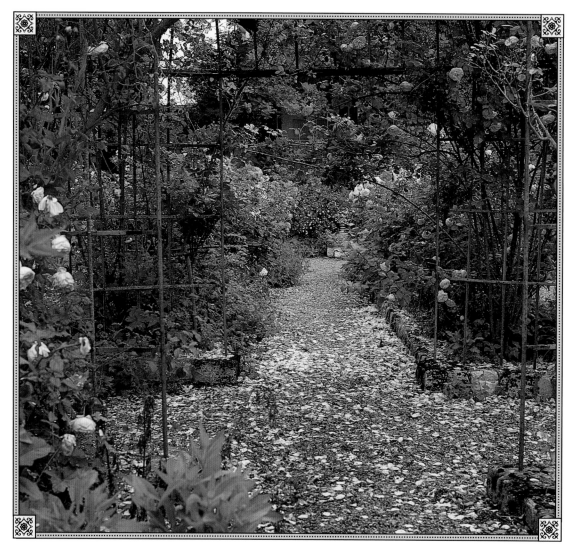

ABOVE: *Beautiful rose gardens grace the grounds of the Hotel Baudy, where friends of Monet—including Renoir, Cézanne, and Manet—stayed during their visits to Giverny.* OPPOSITE: *The garden at Roseraie de l'Hay includes this 'Mrs. F.W. Flight' rose, which is also grown in Monet's garden.*

their canes over the gravel paths—as the roses fade they drop their petals onto the path, creating a beautiful carpeting effect. The gardens of the Hotel Baudy reach their flowering peak in early June. Prominent roses in the garden include 'Veilchenblau', 'Lavender Dream', 'Belle de Crécy', 'Pink Grootendorst', 'Red Grootendorst', and several David Austin roses, most notably 'Graham Thomas'.

Bagatelle Gardens

For more than ninety years Bagatelle Gardens, in the Bois de Bologne, Paris, has conducted trials and presented awards for the best roses. Monet was an enthusiastic visitor, and he probably first spotted 'American Pillar' among the early trials. Today in France 'American Pillar' may well be the most widely grown climber, prominent not only in Monet's garden and at the Bagatelle Gardens, but also at the sumptuous public rose garden at Roseraie de l'Hay.

Roseraie De l'Hay Public Rose Garden

No visit to France during the rose season would be complete without a visit to the public rose garden at Roseraie de l'Hay, a Paris suburb just south of the city. It features an extensive collection of roses trained over arches, up pillars, as standards, and along a vast section of treillage. In addition to modern roses, such as hybrid teas and floribundas, the elaborate rose garden features a large selection of old garden roses.

The overall design is highly formal, with severely clipped boxwood hedges outlining long, narrow, rectangular beds in a sunny space. Although this is in complete contrast to the much smaller, informal, shaded Impressionist-style rose garden at the Hotel Baudy, it is a valuable place to evaluate a huge selection of roses—especially the performance of ramblers and climbers, as well as old-fashioned shrub roses, all of which were important elements of Impressionist gardens.

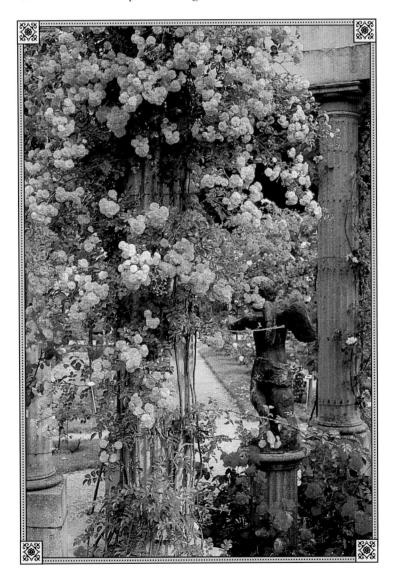

Chapter 3
DESIGNING WITH ROSES

ROSES ARE PART OF AN ELITE GROUP OF FLOWERING PLANTS WHOSE VERY PRESENCE CAN MAKE A GARDEN'S REPUTATION. THEY CAN BE USED ALONE TO CREATE IMAGINATIVE ORNAMENTAL ROSE GARDENS, OR THEY CAN BE INCORPORATED INTO GARDENS THAT RELY ON A DIVERSITY OF PLANTS FOR DECORATIVE EFFECT. WHEN ROSES ALONE ARE USED TO ESTABLISH A DOMINANT THEME—SUCH AS AT THE FAMOUS BAGATELLE ROSE GARDENS, PARIS; HERSHEY ROSE GARDENS, PENNSYLVANIA; AND PORTLAND INTERNATIONAL ROSE GARDENS, OREGON—THE EFFECT CAN BE SO SPECTACULAR AS TO DRAW HUGE CROWDS FROM LATE SPRING ALL THROUGH SUMMER AND INTO AUTUMN. THIS IS ESPECIALLY TRUE WHEN THE GARDEN FEATURES BOTH FORMAL AND INFORMAL PLANTINGS AND THE FULL RANGE OF ROSE TYPES, FROM MINIATURES TO LOFTY CLIMBERS.

ABOVE: 'Excelsa' climbing roses and hydrangeas make fine companions.
OPPOSITE: 'Scarlet Rambler' towers above delicate miniature roses.

WHEN ROSES ARE USED TO AUGMENT OTHER PLANTS, SUCH AS PERENNIALS, SUMMER-BLOOMING BULBS, AND FLOWERING SHRUBS AND TREES, THE COMBINATIONS ARE INFINITE, ESPECIALLY WHEN WE PAIR A PARTICULAR ROSE WITH A COMPLEMENTARY PLANT. BLUE AND WHITE CLEMATIS, FOR INSTANCE, CAN BE ENTWINED AMONG THE CANES OF A PINK CLIMBER, OR A WHITE CHEROKEE ROSE (ROSA LAEVIGATA) CAN BE TRAINED TO MIX ITS LARGE, EARLY, PRISTINE WHITE BLOSSOMS WITH PURPLE-BLUE WISTERIA. BEFORE WE CONSIDER SPECIFIC DESIGN IDEAS, IT IS NECESSARY TO UNDERSTAND THE DIFFERENT FORMS THAT A ROSE CAN TAKE AND HOW ROSES FIT INTO A CLASSIFICATION SYSTEM DESIGNED TO GROUP PLANTS INTELLIGENTLY.

What Is a Rose?

The family of roses is known botanically as Rosaceae. It includes not only garden roses but also claims the strawberry, the blackberry, and the hawthorn tree among its members. Roses have been cultivated for at least five thousand years, and were first grown in China. They survive, and indeed thrive, on all continents except Antarctica. Although there are thousands upon thousands of varieties and cultivars (cultivated varieties), nearly all are derived from about a hundred and fifty species, the majority of which hail from China or other parts of Asia.

There is a rose for every purpose, including miniatures suitable for growing in containers and rampant climbers that can grow to thirty feet (9m) high. To make sense of the many flower forms and plant habits there has arisen a classification system for roses that is extremely helpful in choosing appropriate plants for the garden. Be aware, however, that the European system of classification is somewhat different from the American system, as Europeans do not recognize grandifloras as a group and Americans tend to clump smaller divisions (such as Noisette, Bourbon, and Portland roses) under the umbrella of old garden roses. Even the classification of "climber" can be confusing, as climbers can be mutations of miniatures, floribundas, hybrid teas, and other rose groups. The American Rose Society groups roses developed before 1867 as old garden roses and those hybridized later as modern roses.

Following is a brief summary of the most important rose classifications.

❧ HYBRID TEA ❧

Hybrid tea roses are generally bushy in habit and tend to produce one large flower per stem. Most hybrid teas are repeat-flowering. As a group, the hybrid teas are the best-selling class because they are highly valued for garden display and for cutting and because they remain compact. Since hybridizing often produces weak roots, most hybrid teas are grafted onto a hardy rootstock. The first hybrid tea rose was 'La France', developed by French nurseryman Guillot Fils in 1867. This rose's large flower size, vigorous habit, and repeat bloom made it an instant success, and it was a popular flower form among the early Impressionists.

OPPOSITE: *The climber 'Mercedes Gallart' grows with blue bearded irises in the garden at Saint-Rémy, the asylum where van Gogh spent time.* RIGHT: *'Meidiland Red' shrub roses look natural in an informal perennial garden.* BELOW: *Modern hybrid tea roses growing in Monet's garden include the red 'Christian Dior' and the pink 'Queen Elizabeth'.*

❧ FLORIBUNDA ❧

Floribundas are crosses between hybrid teas and polyanthas. The plants are bushy in habit, like hybrid teas, but they tend to produce clusters of flowers on each stem, a trait inherited from their polyantha parent. Therefore, although they are smaller-flowered, floribundas produce a greater density of bloom than hybrid teas. Most floribundas are repeat-flowering, and they are excellent for garden display, especially where a mass of bloom is desirable. Like hybrid teas, floribundas are grafted onto a special

rootstock to improve their hardiness. Some are single-flowered (like 'Betty Prior') and have the wild rose look much favored by the early Impressionists. Although this class of bedding rose was not recognized until 1940, the variety 'Centenaire de Lourdes' is popular in Monet's garden today.

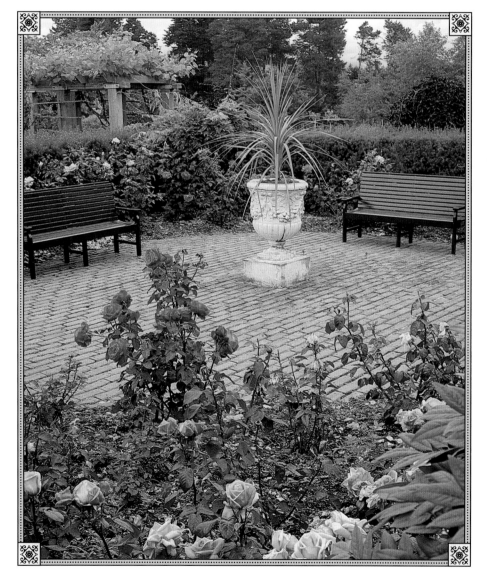

ABOVE: *A formal rose garden is accented with the slatted benches admired by the Impressionists.*
OPPOSITE: *A rustic bench constructed of tree braches is screened by a billowing 'Scarlet Rambler' rose.*

GRANDIFLORA

Grandiflora is a class of modern rose recognized only in the United States. These are roses that show characteristics of both floribundas and hybrid teas. In other countries they are classified as floribundas. In most cases, grandifloras display a cluster of large flowers on each stem, and they are generally tall in stature. Most grandifloras have the bonus of repeat-flowering. The class was created specially for the release of the cultivar 'Queen Elizabeth'. Grandifloras are grown on separate rootstocks to improve their hardiness, and they tend to make excellent cut flowers because of their long, graceful stems.

POLYANTHAS AND RAMBLERS

Greatly admired by the Impressionists for their prodigious quantity of small flowers and their billowing shrub or vigorous climbing habit, polyanthas and ramblers are similar in appearance. Polyantha roses are identified by small button or pompon blooms held in generous clusters and are used mostly as shrubs or groundcovers. Ramblers generally have long canes suitable for climbing. One modern polyantha that is used today in Monet's garden—especially as a tree-form rose—is 'The Fairy', which has the ability to bloom non-stop all summer and well into the autumn months.

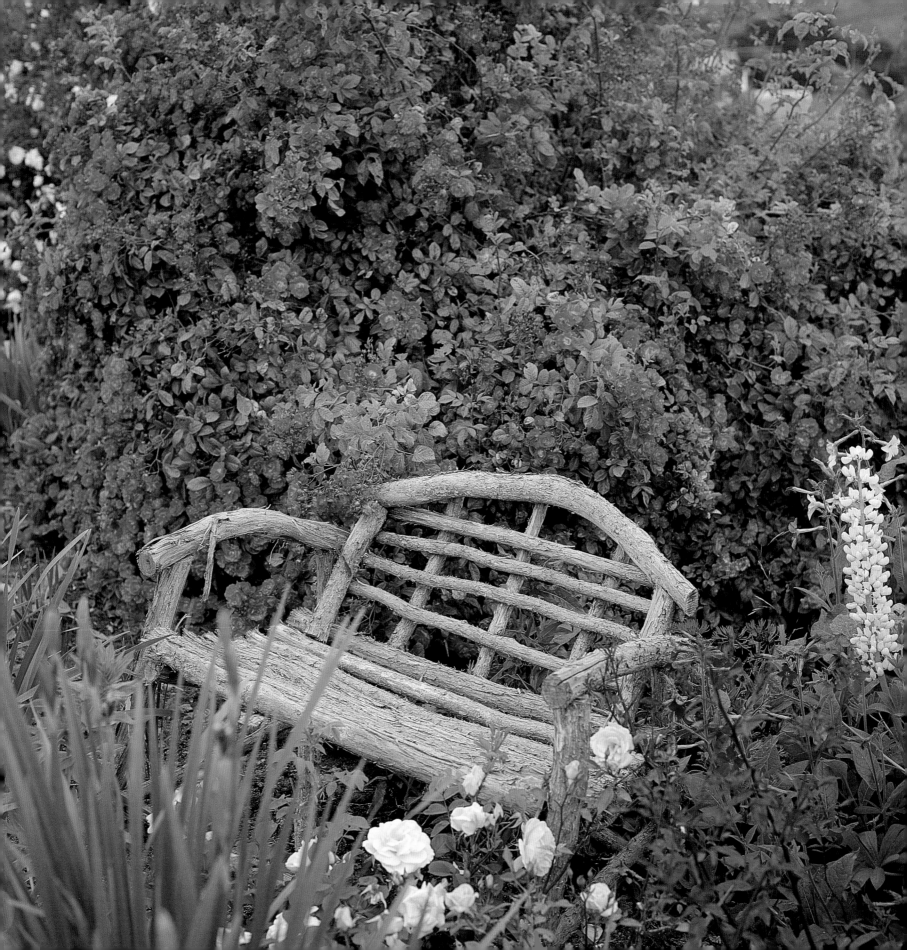

ABOVE: *In Monet's garden 'Westerland' rose blooms on a trellis with 'Paul's Scarlet Climber'.*
BELOW: The Crimson Rambler (1908) *was painted by Philip Leslie Hale, an early American Impressionist.*

✦ CLIMBERS ✦

These are roses with long canes that can be trained to climb. The Impressionist painters loved them because they can take color to a great height, and they can entwine their canes with other flowering vines such as wisteria and clematis. Many climbers are mutations (known as "sports") of hybrid teas, grandifloras, or floribundas; for example, there is a 'Climbing Peace' rose and a 'Climbing Queen Elizabeth'. Some possess large flowers that resemble those of a hybrid tea, but others have smaller flowers that look like floribundas. Many modern climbers are grafted onto sturdier rootstock. There are also old-fashioned varieties, such as the highly fragrant Bourbon rose 'Zéphirine Drouhin', which was favored by the Impressionists in their own gardens.

✦ MINIATURES ✦

These earned some popularity between 1830 and 1850 as novelty plants. They then fell out of favor and only recently—as a result of some innovative hybridizing—have

come into widespread use. Generally, miniatures are roses with small flowers on low, cushion-shaped plants, although climbing miniatures do exist. They are well suited for edging flower beds and for hiding the bare stems of taller roses such as hybrid teas and floribundas, and are perfect for growing in containers. Grown on their own rootstock, most are everblooming.

▨ SHRUB ROSES ▨

Exceedingly bushy in habit, shrub roses produce a dense knit of branches. Some, such as the hybrid musk rose 'Robin Hood', are suitable for hedging, while others make graceful additions to the shrub or perennial border. Shrub roses are the result of hybridizing among modern or old garden roses.

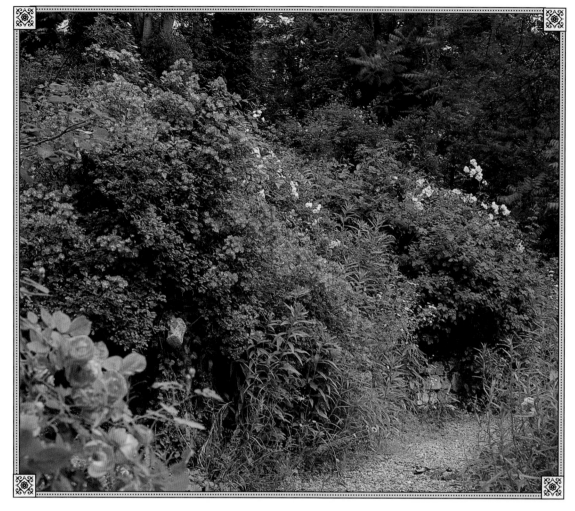

Billowing roses ornament the shaded terrace garden at the Hotel Baudy—in the foreground are the lush blooms of 'Lavender Dream'.

▨ OLD GARDEN ROSES ▨

Also known as antique roses, this grouping covers a whole host of roses in classes established before 1867, the date of introduction for the first hybrid tea. Some have been around for thousands of years, but most originate from the 1800s under Empress Josephine's influence. Many are characterized by swirling petals and a fruity fragrance, and it is these roses that we most often see portrayed in Impressionist still life arrangements. The majority of the old garden roses are spring-flowering and have a shrubby habit—note that the European old garden roses, such as albas, centifolias, damasks, Gallicas, and moss roses, tend to be once-bloomers, while Chinas and tea roses repeat their bloom.

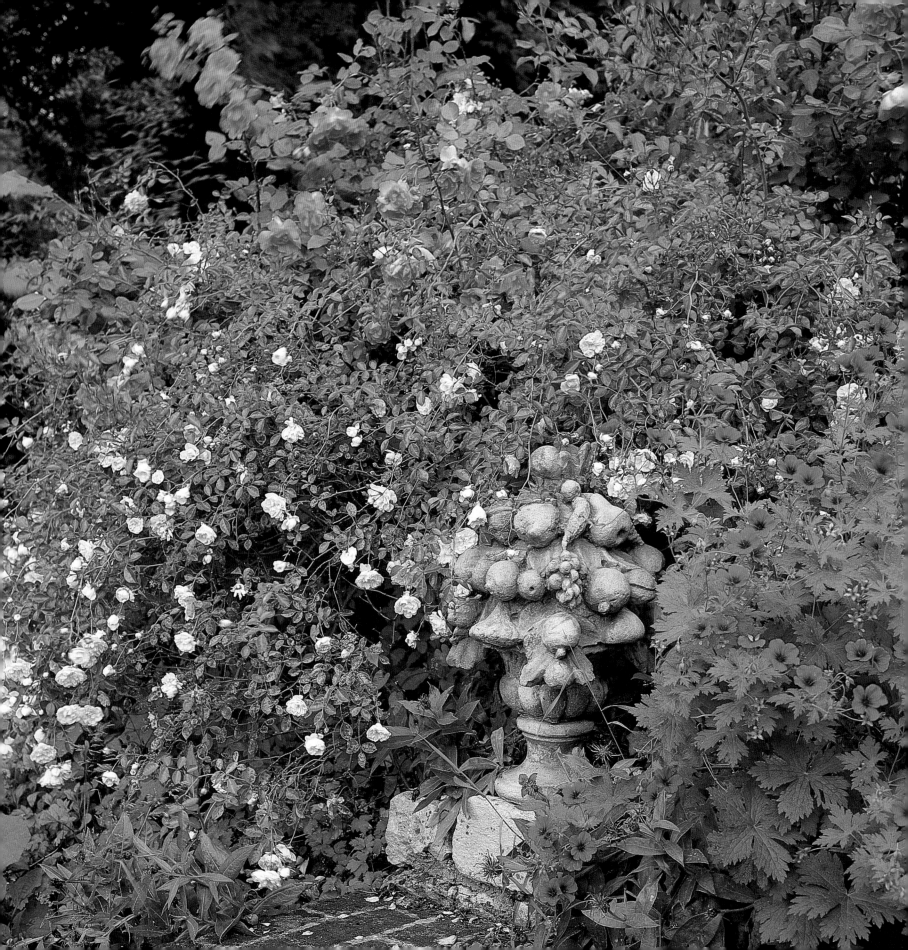

They can belong to several special groups. For example, gallicas are derivatives and hybrids of *Rosa gallica*, and display mostly flat, double blooms. Showy and fragrant, they fostered a tradition of modern rose breeding by being a favorite parent in man-made crosses. Exceedingly hardy (even to Zone 4), they tolerate poor soil. They generally remain below four feet (1.2m) in height.

Damasks, Portlands, and Bourbons are similar to Gallicas, and in fact include *R. gallica* in their parentage. Even experts find them hard to tell apart. Similarly, the old garden rose groups called albas, centifolias, and moss roses have only slight differences. Centifolias—also known as cabbage roses, for their rounded, heavy blooms—were developed three hundred years ago by the Dutch. Moss roses, which were greatly admired by the Victorians, are sports of the centifolias, and possess velvety growth below the sepals.

Among old garden roses, species rugosa roses are distinct. Along the rugged, wind-blown beaches and rocky coasts of New England and the Pacific Northwest, they flourish in wild colonies. Frequently used for windbreaks, rugosa roses offer nonstop bloom and a profusion of decorative orange-red hips, the two often in combination.

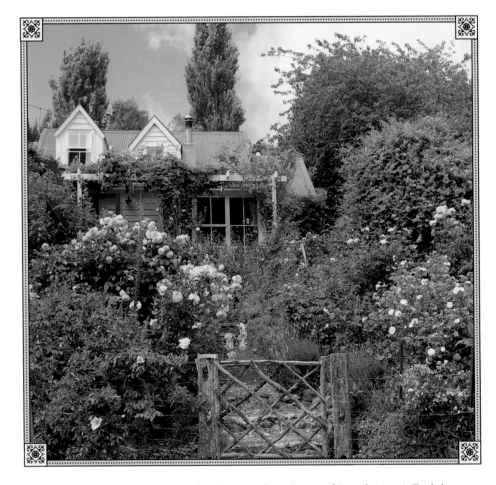

ABOVE: *This beautiful cottage garden features a fine selection of David Austin's English roses.*
OPPOSITE: *White blooms of 'Stanwell Perpetual', introduced in 1838, form a luscious backdrop for a stone ornament in the Hotel Baudy's rose garden.*

✿ ENGLISH ROSES ✿

This is not a true classification, but rather the name given to a family of roses developed in England by rosarian David Austin, and they are sometimes known as David Austin roses. The American Rose Society classifies them as modern shrub roses, though they may also carry other identifiers. 'Constance Spry', for example, is a Gallica hybrid because of its Gallica parentage, but is still classed as a modern shrub rose. Altogether, the Austin rose strain is a vast collection that combines the recurrent bloom of modern hybrid teas with the old-fashioned appearance and fruity fragrance of Bourbons,

Noisettes, and Portlands. They are largely intended for growing in a maritime climate (cool summers and mild winters), but many are suitable for the continental climate of North America, though their height may extend beyond the norm and the recurrent bloom is poor during hot summers. 'Constance Spry' (light pink), 'Gertrude Jekyll' (deep pink), 'Graham Thomas' (yellow), 'Abraham Darby' (apricot), and 'Othello' (plum-red)

are especially popular among North American gardeners. Surely the Impressionists would have loved them!

David Austin has had this market to himself for a long time, and only recently have other rose breeders started to challenge him, recognizing that many of his varieties can be improved upon for disease resistance and heat tolerance. The most significant challenge to Austin's English rose series is the Romantica series, developed by the French rose breeder, Meilland. Some of the new varieties are featured in Chapter Four.

❊ SPECIES ROSES ❊

These are wild roses. The American Rose Society considers them to be a category of old garden roses. The Impressionists favored the slightly tender *Rosa laevigata* and *Rosa banksiae* popular in southern gardens, though their origin is China.

Rose Flowers and Growth Habit

Classifications bring order to the great family of roses, but there is also a language that has arisen to describe their flower form and habit. Although the Impressionists as a group preferred large, double-flowered roses, van Gogh seemed to prefer single-flowered varieties.

The Cherokee rose (Rosa laevigata) cascades over a pond at Middleton Place in South Carolina. Monet's water garden features a similar effect with a hardier white single-flowered rose called 'Nevada'.

✸ FLOWER FORM ✸

Single flowers are usually composed of five petals in a single layer around a crown of powdery yellow stamens (*Rosa sericea* has four, however). Semidouble flowers usually have two rows of petals, while double flowers are composed of multiple layers of petals that in some instances are so dense that they form a globe shape. In some of the old garden roses—especially Bourbons, Noisettes, and Portlands—the doubling is so tight it forms a button center. In others the flower is "quartered," meaning that the petals are gathered at four points around the center. Button centers and quartering were both greatly admired by Renoir, and modern flower arrangers adore their romantic appearance.

The shape of a rose flower is often dependent on its maturity. Many roses—especially hybrid teas and floribundas—will start out with a classic urn shape, hiding their yellow stamens, but then open into a cup shape, displaying their stamens to advantage.

✸ REPEAT BLOOM ✸

Many old garden roses bloom only once each growing season, usually in late spring—these include the albas, centifolias, damasks, gallicas, and mosses. This did not matter much to the Impressionists, as they needed a flower to last only long enough to paint. China and tea roses, however, do repeat their bloom, and the modern trend among rose breeders has been to produce hybrids that bloom steadily until heavy autumn frost. But not all

Both these roses were known to the Impressionists: below is the fragrant, fully double 'Louise Phillipe'; to the right is the single-flowered 'Dupontii', a Rosa moschata *hybrid.*

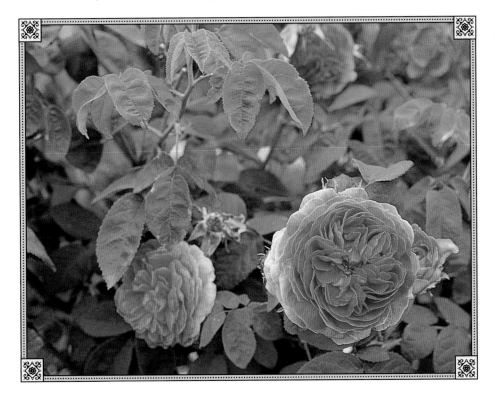

roses described as repeat bloomers actually perform that way when summers are hot. At Cedaridge Farm, for example, we can rely on repeat bloomers in spring and autumn, but not for the rest of the season when days are hot and humid. One exception has been the Meidiland series of landscape roses. With regular watering and feeding, we can expect continuous color all season. A particularly important influence on repeat-flowering is the soil. If the

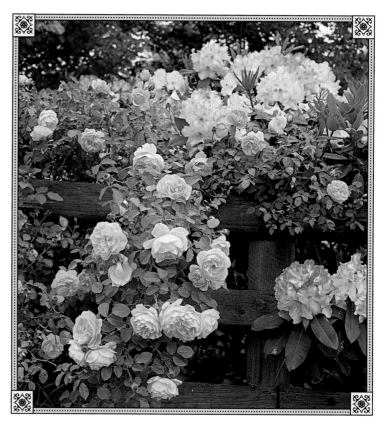

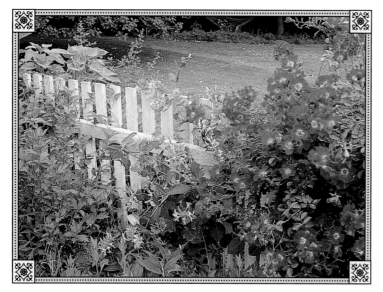

ABOVE: *The English rose 'Graham Thomas' is a perfect companion to the pink late-flowering rhododendron 'Walloper'.* LEFT: *'Meidiland Red', a stunning red shrub rose, grows along a fence at Cedaridge Farm.*

soil is enriched with plenty of humus and covered with a mulch of landscape chips or wood chips, the soil can be kept sufficiently cool to encourage generous repeat-flowering. Deadheading (removing spent flower heads) is also vital, since a rosebush that is allowed to set seeds soon exhausts its flowering display.

✺ COLOR ✺

The color range of roses is strongest in reds and pinks, with oranges and yellows still relatively scarce. Although there is an abundance of white roses, they are not particularly popular with modern gardeners ('Iceberg' is a notable exception). Among the

Impressionists, white was a very important color, for it could be draped high along a frame or an arch to produce a gracious lace curtain effect and a glittering appearance.

While there are some interesting color oddities—including greens and browns—there is still no true blue or black. Color in a rose can vary according to many factors, including maturity, climate, and soil chemistry. The richest coloring of a rose is generally seen in its mature bud stage when the petals first begin to unfurl, before they open out flat. A high overcast day also enhances the colors of roses, while glaring sun makes the blooms appear bleached.

Roses may also be bicolored or tricolored, and these can be highly variable in their appearance. The most stable bicolored and tricolored roses tend to have *Rosa mutabilis* in their parentage. This extraordinary shrub rose from China has red, pink, and yellow blooms on the same plant, and it has passed on its genes to some modern tricolor roses such as 'Joseph's Coat' and 'Glowing Embers'. The flower colors change as the bloom ages, usually turning from yellow to pink to red.

GROWTH HABIT

The habit of growth was vital to the Impressionists, who fancied plants that could climb riotously or billow like a cloud. Each rose has a genetic key controlling its general height and spread, but this can be affected by environmental factors such as soil fertility, insect pests, and diseases. *Rosa wichuraiana* (memorial rose) is noted for its low, spreading habit suitable for groundcover effect, while *Rosa banksiae* can grow to thirty feet (9m). With slender canes, its floral display resembles a waterfall. The most common form for a modern rose is rounded and bushy, with a network of canes that mesh together in such a tight knit that they can form impenetrable hedges. Indeed, *Rosa multiflora* can establish such a dense mass of growth that the plants are used in some states as highway dividers, as they have the capacity to stop a runaway truck.

DISEASE RESISTANCE

Modern roses tend to have much greater disease resistance than those available to the Impressionists, which is why it is sometimes better to use a modern substitute than the rose variety used by the artists. In Monet's garden today, substitutions with disease-resistant roses are frequently made, which explains the popular use of 'The Fairy' and 'Carefree Beauty'—roses unknown to Monet, but highly disease resistant, and repeat-flowering into the bargain.

The most debilitating rose diseases are blackspot and mildew. A hard-hit rose can drop its leaves and remain bare for most of the year, and in areas where these diseases are common it pays to seek out disease-resistant varieties. Similarly, Japanese beetles are the worst insect pest for roses, ravaging first the flowers and then the leaves and skeletonizing rosebushes almost overnight (for more on pest control see page 123).

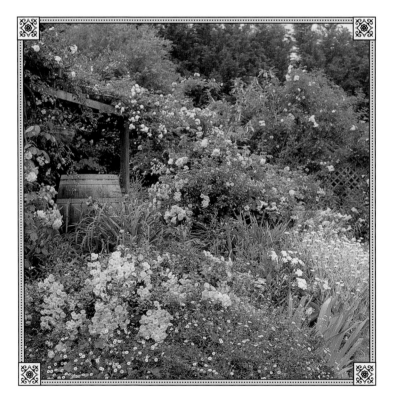

'The Fairy' and climbing 'Angelique' create a monochromatic harmony in a romantic cottage garden. Both these roses are used extensively in Monet's garden today.

Impressionist Design Ideas

Before you decide on a particular type of rose garden, consider what you want out of your garden. First, you'll have to choose between a formal and an informal design, or you may opt for a design that incorporates elements of both these approaches. You'll also need to think about the purpose of your garden. If you want a cutting garden, for example, a formal layout will allow easy access to each variety of rose. If the garden must blend with a particular house style (such as Spanish, colonial, or southern plantation–style), a central structure may help link the garden with the house. For example, a Spanish-style garden could include adobe walls featuring a collection of climbing roses, or perhaps a wellhead with roses scrambling over it. The garden of a southern plantation house might incorporate a romantic gazebo as a focal point, while the space surrounding a colonial-style house might feature old garden roses, trellises garlanded with climbers and polyanthus roses, and foundation beds edged in brick paths.

❊ THE ULTIMATE ROSE GARDEN ❊

Monet had the ultimate rose garden. Indeed, no garden before or since has featured roses so imaginatively, so romantically, and so luxuriantly as Monet's. Even today in Giverny, you will see roses used in every conceivable way—as edging, at eye level, for skyline color, trained over arbors, spanning arches, draped from overhead frames, trained up pillars and trellises, and garlanding porches. In addition, you'll see roses at Giverny in planters, grown as standards, in floral arrangements indoors, mixed with perennials, cascading over the edges of the pond, threaded into the branches of trees to create a flowering avalanche, and even used as a groundcover!

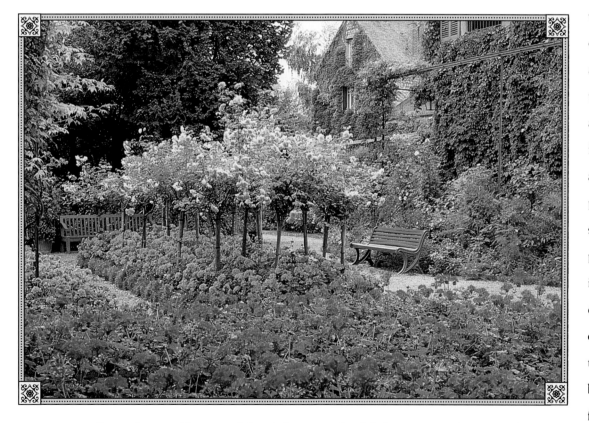

ABOVE: *Repeat-flowering 'Centenaire de Lourdes' is partnered with lush geraniums in Monet's garden.*
OPPOSITE: *The same area is viewed from Monet's porch.*

58

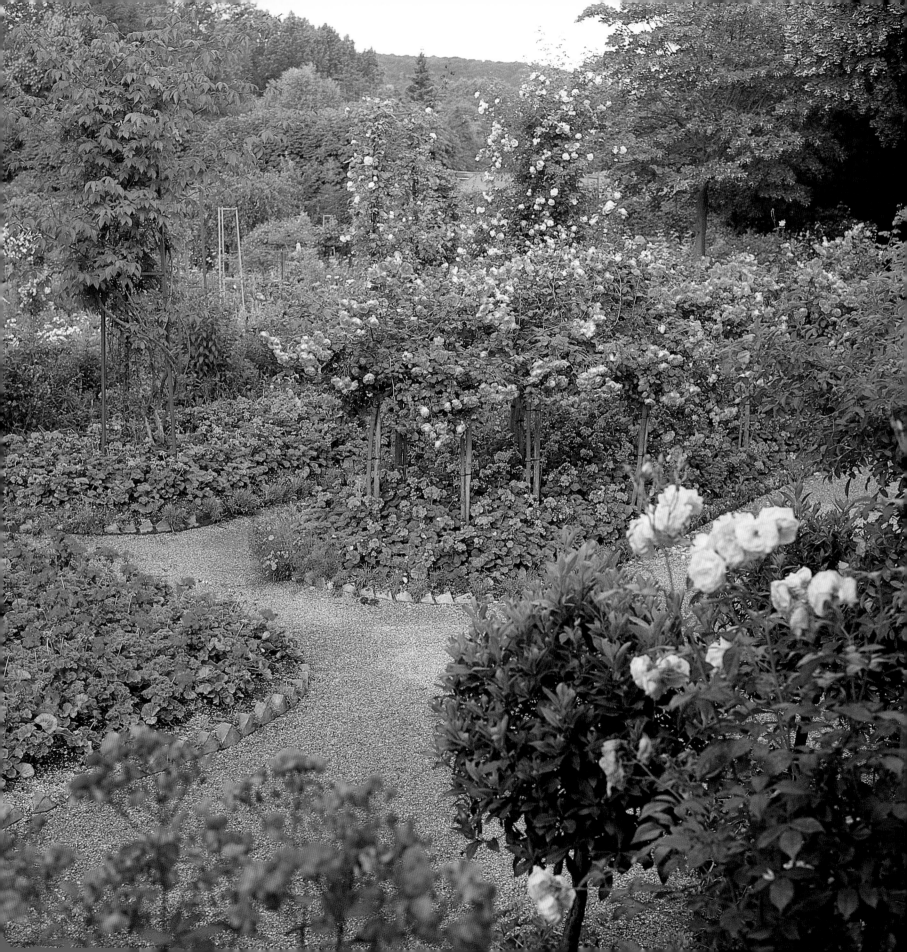

IMPRESSIONIST ROSE GARDEN
20 × 30 FEET (6 × 9M)

This small-space design features a formal layout within a slightly rectangular plot. The space, enclosed by trelliswork, can be entered through either of two arches. Note that trellises match the green trelliswork in Monet's Clos Normand and allow climbing roses to carry color high above eye level. A gravel path surrounds a central square where a rose standard growing in a substantial Versaille planter acts as a focal point. Surrounding this planter are miniature roses and low-growing perennials such as lady's mantle and hardy geraniums. More standard rose are planted in the bed at right, backed by a rose hedge. Other beds are devoted mainly to shrub roses, with an emphasis on the fragrant old garden roses.

The rose varieties suggested below were known to the Impressionist painters or are used in restored Impressionist gardens today.

1. 'AMERICAN PILLAR
2. 'ICEBERG'
3. 'APOTHECARY'S ROSE'
4. 'MERMAID'
5. 'PAUL'S SCARLET CLIMBER'
6. 'PHYLLIS BIDE'
7. 'ZÉPHIRINE DROUHIN'
8. 'STANWELL PERPETUAL'
9. 'VEILCHENBLAU'
10. 'GLOIRE DE DIJON'
11. 'CARDINAL DE RICHELIEU'
12. 'REINE DES VIOLETTES'
13. 'BELLE DE CRÉCY'

14. 'CHARLES DE MILLS'
15. 'GRAHAM THOMAS'
16A. 'STARINA'
16B. 'ORANGE HONEY'
17. 'THE FAIRY', TRAINED AS A STANDARD
18. LOW-GROWING PERENNIALS SUCH AS LADY'S MANTLE, SEDUMS, AND HARDY GERANIUMS
19. TALL, SPIKY PERENNIALS SUCH AS DELPHINIUMS, HOLLYHOCKS, AND FOXGLOVES
20. CLEMATIS

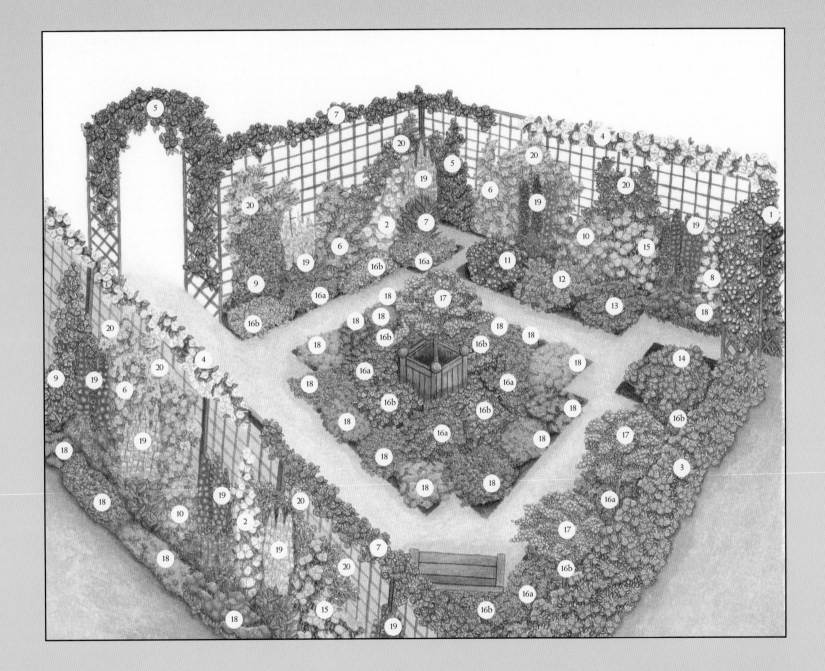

❧ ROSE THEME GARDENS ❧

Commemorative gardens and public gardens often include a design planted exclusively with roses, and some of the world's finest rose gardens include more than three thousand varieties. These rose theme gardens may concentrate on a particular type of rose—old garden roses, for example. However, the opportunity to contrast roses of today and yesterday is hard to resist, so most rose gardens feature modern roses as the main display and confine old garden roses to a special area.

The best rose collections establish three tiers of color—low bushy elements (such as miniature roses) for ground-level interest; shrub roses, hybrid teas, and floribundas for mid-level accents; and climbers to extend the floral display high overhead—as Monet did so successfully in both his flower garden and water garden at Giverny.

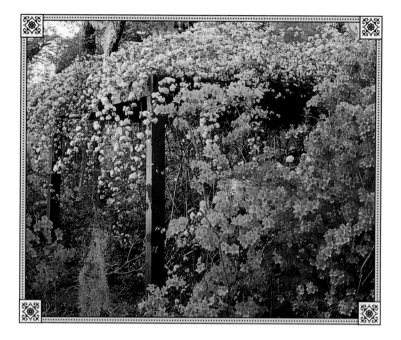

ABOVE: *Yellow Lady Banks rose—a favorite in Renoir's garden—makes a good companion for azaleas.* BELOW: *'Paul's Scarlet Climber' frames a cool-color harmony of perennials in Monet's garden.*

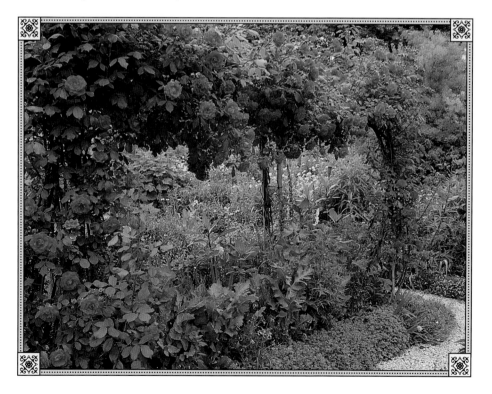

❧ ROSE ARBORS ❧

One of the most romantic rose designs is a flowering canopy over a path or bridge. Encourage strong vigorous growth by ensuring that the soil at the base of the structure is in tip-top condition—deeply dug, fertile, and well drained. This will encourage climbers to grow up and over the arbor, knitting their canes with climbers planted on the opposite side of the structure.

You may choose climbing roses in a range of complementary colors, but you will achieve the most romantic effect if you confine the arbor to roses of one variety. Try yellow or

❈ ROSE ARCHES ❈

Caillebotte, Monet, Fantin-Latour, and Pissaro all trained roses to climb extravagantly over high arches. A single arch covered with roses is beautiful, but when the arch repeats itself along a path to form a tunnel or creates a semicircle around a bird bath, bench, or sundial, the effect is simply magical. Monet used arches along a path to create his famous Grande Allée, and he repeated arches in a circle around a boat dock in his water garden.

There is a temptation to use several colors of roses to cover multiple arches— Monet used six different col-

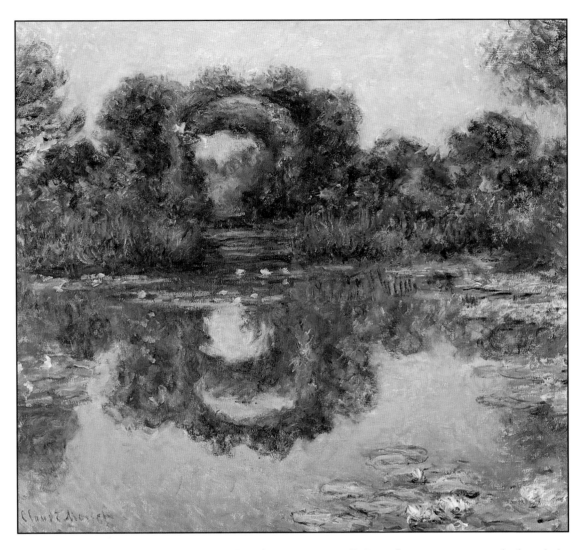

Monet's 1913 painting The Flowering Arches *shows 'American Pillar' roses forming a canopy over his boat dock.*

white Lady Banks rose (for southern gardens) or a pink 'Climbing Cecile Brunner' (for northern climates), and use flowering perennials or flowering trees as supporting players.

For painters, the appeal of an arch is that during the final stages of bloom, roses will drop their petals and produce a colorful carpet along paths. The Impressionists loved to discover a path strewn with silky petals so they could paint the path in unusual shades—such as pink, red, or yellow.

ors for his Grande Allée. But, as with arbors, a truly enchanting effect can be achieved by using a single color such as red or pink. In small-space gardens, the impact of a single color is greater than that of several colors, which may be somewhat distracting. Note that Monet used only red climbing roses to cover his boat dock. Monet favored 'American Pillar', but where mildew might be a problem 'Dortmund' is a good modern substitute.

63

ABOVE: *Monet's Grande Allée features climbing roses that create a decorative floral tunnel.* BELOW: *'Paul's Scarlet Climber' grows in front of Monet's second studio, now an administration building.*

quality. But the star attraction of this garden is a pink rambler, 'Dorothy Perkins', which clambers over an entrance arch and blends its powder-puff blooms with a purple Jackman's clematis.

The idea of entwining a clematis with a climbing rose was made popular by Claude Monet, who particularly liked contrasts of colors such as blue and yellow, pink and blue, and orange and violet. Roses and

❧ ROSES FOR COTTAGE GARDENS ❧

When the Impressionists painted roses out of doors, the artists invariably chose informal cottage garden settings. The most beautiful gardens, similar in style to the lush cottage gardens of England, were found in the Normandy countryside. The French had a special name for them—*clos normand*, the word *clos* denoting a sanctuary or enclosure.

At Cedaridge Farm we have a cottage garden where we grow mostly perennial plants within a white picket fence. The fence is ideal for supporting an assortment of shrub and climbing roses, especially old garden varieties such as 'Betty Prior' and the heavily fragrant 'Reine de Victoria'. Within the garden, dotted among the perennials, we've planted 'The Fairy' for its lovely, light pink, buttonlike flowers and everblooming

BEST ROSES FOR FRUITING DISPLAY

The fruit of a rose is called a "hip," and it ripens in autumn. Usually red in color, it has a fleshy, edible skin that encloses a cluster of small seeds which are hairy and distasteful to humans. In some species—*Rosa multiflora*, for example—the hips are too small to make a significant display but provide an important winter food for songbirds such as cardinals. In other roses—including many of the modern hybrids—the plants are sterile and may not produce any berries. The fruits of some of the species roses—such as *R. rugosa*—can be relatively large, formed in generous clusters, and highly ornamental. Indeed, it's possible to peel the larger fruits like a small orange and use the skins to make a vitamin-rich jelly. Following is a list of the roses that produce the best decorative berry displays:

Rosa rugosa shows its decorative clusters of fruits, called hips.

Rosa alba—large, red, oval hips ½ inch (1cm) across, 1 inch (2.5cm) high

Rosa glauca—large, oval, bright red fruits up to ½ inch (1cm) across

Rosa moyesii—large, oval, red fruits up to 2 inches (5cm) long

Rosa pomifera—large, round, red fruits up to 1 inch (2.5cm) in diameter

Rosa rugosa—large, flattened, round, orange-red fruits up to 1 inch (2.5cm) in diameter

clematis go well together because the rose provides strong support, while the clematis has light stems that don't suffocate the roses.

ROSES FOR SHADY PLACES

Roses much prefer to be planted in sunny spots, so they are seldom associated with shade. Indeed, the shadier the site the scantier the bloom, in most cases. Yet a few roses will tolerate some lightly shaded situations. Shade-tolerant climbers can work well in woodland settings, especially where the leaf canopy is sufficiently high to allow good air circulation. Of particular importance are two southern favorites—Lady Banks rose (*Rosa banksiae*) and the Cherokee rose (*R. laevigata*). Both look sensational planted beside a tall pine, where they can hook their canes onto radiating branches and carry their blossoms high into the leaf canopy.

Another superb shady location is under tall trees beside a pond, lake, or stream; in this situation, the rose can arch over the bank to dip the ends of its canes into the water. The finest Impressionist-style shady rose gardens exist today in the grounds of the asylum at Saint-Rémy (where van Gogh spent a year) and at the Hotel Baudy in Giverny.

Roses noted for shade tolerance include *Rosa spinosissima* and its hybrids, such as

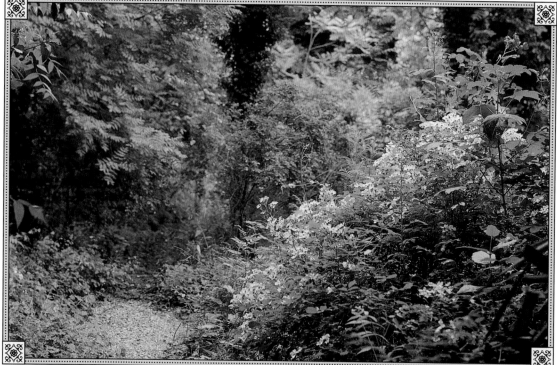

ABOVE: The rose garden at the Hotel Baudy feautures shade-tolerant Rosa multiflora. OPPOSITE: *A non-narcotic form of opium poppy complements the climbing rose 'Veilchenblau' and a medley of old rambler roses in Monet's Clos Normand.*

roses by flowering with them include English lavender (*Lavandula angustifolia*), early-flowering daylilies (*Hemerocallis* spp.) such as 'Stella d'Oro', ox-eye daisies (*Heliopsis heli-anthoides*), foxgloves (*Digitalis* spp.), and delphiniums (*Del-phinium* spp.). Foxgloves, holly-hocks, and delphiniums are particularly good because many shrub roses have arch-ing canes that allow the spires of these tall plants to pene-trate through them and bloom in close proximity to the rose blossoms.

'Harison's Yellow'; and *R. multiflora, R. eglanteria,* and *R. gallica* and its hybrids, such as 'Constance Spry'.

❈ MIXING ROSES WITH ANNUALS AND PERENNIALS ❈

Some of Renoir's outdoor paintings show roses mixed with annuals and perennials in an informal setting. The beauty of combining perennials and roses is that their peak flowering period often coincides. The "big four" perennials—Oriental poppies, bearded irises, herbaceous peonies, and Asiatic lilies—burst into spectacular bloom in early summer, when many roses are also at their best. Some other perennials that complement

Miniatures and shrub roses are considered the most desirable for mixing with perennials. Miniature roses are effective as edging for perennial borders, and shrub roses make lovely taller, mounded accents. For a truly inspiring effect, furnish your perennial borders with a curtain of roses by training climbers along fencing or establishing a hedge using ever-blooming varieties such as the Meidiland strains.

Perhaps the best flowering annuals to grow with roses are Shirley poppies (*Papaver rhoeas*), Flanders field poppies (*Papaver commutatum*), and opium poppies (*Papaver somniferum*). Monet's garden features these three in great abundance between pillars of roses.

❀ COLOR THEME GARDENS ❀

Two of the most popular color theme gardens are all-white and all-red, and rose varieties abound in both colors. White gardens are especially popular for weddings and other special events, and shining white flowers are also used extensively in evening gardens. Without doubt, the favorite rose for all-white gardens is 'Iceberg', a floribunda that produces an incredible quantity of blooms. Some other excellent white cultivars to consider are the miniature 'Gourmet Popcorn' (ideal for growing in a container), 'White Lightning' (grandiflora), 'French Lace' (floribunda), 'White Rose of York' (alba), 'Nevada' (Moyesii hybrid), and 'Wedding Day' (rambler).

Red gardens are generally most effective when the flowers are all a particular shade of red—usually deep crimson—and the foliage is a dark green. The foliage interest may derive from perennials with appealing leaf shapes (such as daylilies, hogweed, and hostas) as well as roses. Deep crimson roses to consider include 'Christian Dior' (hybrid tea), 'Red Fountain' (large-flowered climber), 'Dortmund' (Kordesii), 'Lincoln' (hybrid tea), 'Crimson Glory' (hybrid tea), and 'Beauty Secret' (miniature).

While white and red are beloved monochromatic schemes, many other color harmonies exist. An enchanting color theme Monet used for roses is orange and yellow, and his painting *Monet's Garden at Giverny* demonstrates how beautifully these colors work together. Even the model's clothing (probably one of Monet's stepdaughters) coordinates with the roses; she is wearing what appears to be a yellow straw hat, an orange sweater, and a pale lemon dress. Orange and yellow nasturtiums creep

BEST ROSES FOR FRAGRANCE

Roses are associated with fragrance, but the fact is that many modern hybrids lack scent and some species—such as *Rosa foetida*—actually emit a rather unpleasant aroma. The most uplifting rose fragrance seems to be one that comes close to the rose perfume known as Attar of Roses, which possesses a heavy, fruity fragrance. Here are ten of the best roses for fragrance:

'Apothecary Rose'—pink

Rosa rugosa—pink, red, and white

'Abraham Darby'—apricot with touch of yellow

'Fragrant Cloud'—deep pink hybrid tea

'Gertrude Jekyll'—double pink

'La Reine Victoria'—pale pink, double flowers

'Reine des Violettes'—deep purple, double flowers

'Mister Lincoln'—deep red hybrid tea

'Zéphirine Drouhin'—carmine-red, double flowers.

'Fantin-Latour'—pale pink, double flowers

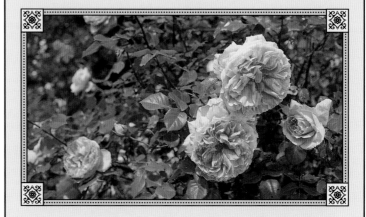

The English rose 'Abraham Darby' is a modern shrub rose with old-fashioned perfume.

across a beige path to complete a wonderful warm-color harmony, something we have not seen in any rose garden we have ever visited. This is certainly an idea worth emulating, and can be re-created using a combination of old garden roses such as 'Lady Hillingdon' (a large yellow tea rose dating from 1910), the charming 'Perle d'Or' (a bushy, small-flowered, apricot polyantha introduced in 1884 by the French nurseryman, Rambaux), and 'Maréchal Niel' (a large-flowered yellow Noisette from 1864). Some newer hybrids will also prove beautiful in such a color-themed garden—try 'Westerland' (orange floribunda), 'Amber Queen' (apricot floribunda), 'Ambiance' (yellow-orange hybrid tea), 'Alchymist' (shrub), and the species *Rosa foetida bicolor*, also called 'Austrian Copper'. An orange and yellow rose garden should certainly include David Austin's 'Graham Thomas' for its strong yellow color and old-world charm, as well as the miniature rose 'Orange Honey', wonderful for a low edging.

✦ CONTAINERS ✦

Monet adored flowers in containers. Though his favorite potted plant was the fuchsia, the gardeners at Giverny today use primarily 'The Fairy' polyantha rose, usually grown as a standard. Roses are ideal for growing in containers, especially the miniatures. The best container to use is a whiskey half barrel, which features good insulation (the wood doesn't overheat the soil, which is a problem with metal and plastic containers),

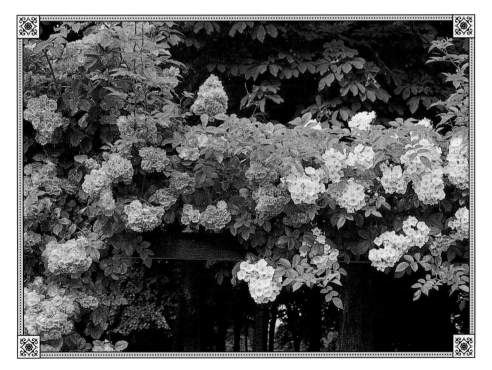

ABOVE: *The climbing roses 'Mrs. F.W. Flight' and 'Thalia' are used to good effect in Monet's restored garden.* RIGHT: *Miniature roses, such as this tiny 'Starina', are ideal for growing in containers.*

ABOVE: *'Orange Honey', a miniature, mixes well with annuals and perennials in a rock garden.* OPPOSITE: *'Centenaire de Lourdes' trained as a standard is framed by foliage in Monet's Grande Allée.*

and is also sufficiently roomy to allow the plants to establish a strong root system. Also consider growing miniature roses in window boxes and hanging baskets.

Use a sandy or peat-based potting soil to promote good drainage and water the pots regularly because container plantings tend to dry out much faster than plants in the garden. A long-handled watering wand is invaluable for tending containers, as it allows you to poke the nozzle through thorny canes to put moisture at the root zone without risk of getting scratched. During the summer months, feeding is essential—either foliar feeding through the leaves or applying a liquid drench directly to the soil for root feeding. Different fertilizer brands have

different rates of application (some every other week, some every two months), so follow the label directions.

Container groupings can be made beautifully appealing by using a variety of rose forms. Pale pink 'The Fairy', for example, cascades around the edges of a container like a waterfall; 'Popcorn', with its tiny white blooms, is often available as a tree-form to provide height. Climbing roses too, can work in containers: trellis-work pyramids placed in planters provide a decorative support for climbing miniatures such as dainty pink 'Jeanne Lajoie'.

ROCK GARDENS

Monet didn't much care for rock gardens, but both Renoir and van Gogh sought out rocky landscapes to paint in Provence. These craggy romantic spaces can be re-created in your garden with a little effort. Miniature roses are at their best in rock gardens, beginning to bloom when many choice alpine plants—such as columbines (*Aquilegia* spp.), catmint (*Nepeta* spp.), and hardy geraniums (*Geranium* spp.)—reach their flowering peak.

Indeed, a rock garden is a perfect spot for a collection of miniature roses. 'Cinderella' and 'Green Ice' will even grow from cracks in dry walls. For the most interesting plantings, group several plants of one variety in drifts so they create an avalanche of blooms, even spilling over boulders and rock ledges. Also consider old garden and shrub roses for rock gardens, especially hybrids of *Rosa rugosa*, which produce lavish quantities of rose hips, and old polyantha roses, which can creep across the ground and provide large expanses of color.

At Giverny, the Hotel Baudy has a rocky slope with roses spilling over retaining walls of rough fieldstone. The combination of stone's hard, gray surface with the roses' velvetlike, brilliantly colored blooms is truly stunning. At the hotel, it is mauve 'Belle de Crécy' and 'Lavender Dream' that arch their canes over the stonework and drop their petals onto a path of beige pea-gravel.

❈ STANDARD ROSES ❈

Standard, or tree, roses are mostly polyanthas, shrub roses, or miniature varieties that have been budded onto long, straight, trunklike sections of rose canes. It is tricky to achieve a suc-

cessful graft, but ready-to-flower mature plants are widely available at garden centers.

Although standards can be planted in the ground, they are ideal for growing in containers, and look lovely placed like sentinels at the entrance to a garden or house. They are also perfect for creating tall highlights in gardens where roses are the main feature. Consider standards also as charming decorations for decks, patios, and courtyards.

To ensure a long life for your standard, you should stake the cane securely. Roses grown this way tend to be top-heavy, and can teeter about in the wind if not held securely in place. If there is space around the rim of the container for other

plants, consider perennial lavender or a fast-growing annual, such as nasturtiums.

Standard roses are used extensively in Monet's garden, and the best of these include 'Phyllis Bide' (peach), 'American Pillar' (red with white center), 'Centenaire de Lourdes' (deep pink), 'Dorothy Perkins' (pink cluster-flowered), 'Lavender Dream' (lavender-pink cluster-flowered) and 'Veilchenblau' (lavender-blue cluster-flowered).

�֍ WALL OF ROSES ✖

It is always thrilling to see climbing roses trained to reach splendid heights. One of my most cherished memories of a visit to Block Island, off the coast of Rhode Island, includes a pink climbing rose almost completely covering an old barn in a cliff-top meadow. Few plantings, however, are more impressive than great towering walls of roses created by massing several climbers along a tall chainlink fence. The planting scheme is all the more magnificent when it features repeat-flowering roses, enabling the wall of color to last through the summer and into autumn.

Some of the best climbers for a wall of roses include 'America' (large-flowered pink), 'Golden Showers' (large-flowered yellow), 'Joseph's Coat' (yellow and red bicolor), 'Constance Spry' (light pink), 'Coral Dawn' (large-flowered coral-pink), 'Viking Queen' (large medium pink), and 'Westerland' (large orange).

In Monet's garden today, a long, high wall of roses at the bottom of the Clos Normand is created by mixing the blooms of 'Purity' (white) and 'American Pillar' (red with white eye).

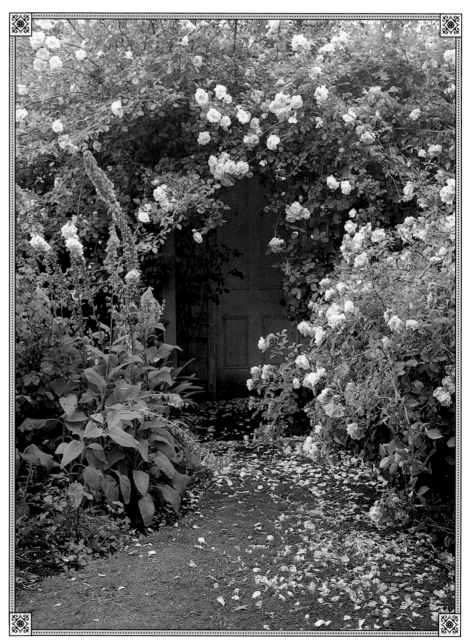

72

❈ ROSE TUNNEL ❈

The most famous rose tunnel in the world is the one down the middle of Monet's flower garden at Giverny. A broad gravel path is completely spanned by six strong metal arches, each span featuring a different color. Below the canopy of roses—on opposite sides—Monet planted a mix of annuals and perennials, and below these at ground level he planted vining nasturtiums that creep across the path, completing the tunnel effect. This spectacular display is achieved with the roses 'Maréchal Neil' (yellow), 'Paul's Scarlet Climber' (red), 'Albertine' (orange-pink), and 'Parade' (deep pink).

When a rose is trained to a great height—especially when it arches over a vacant space—the chances of the canes being subject to winterkill from dehydrating winds is greatly increased. It is vital, therefore, that before the onset of cold weather the canes are thinned to the strongest and tied securely to their supports. Wrapping the canes with a spiral of burlap or horticultural fabric protects them from the worst of winter weather, reducing the risk of winterkill and providing for a heavy repeat-flowering display the following season.

❈ ENTWINING ROSES ❈

The concept of mingling colors by encouraging different plants to twine together was first advocated by Michel-Eugene Chevreul, director of dye quality control with the Gobelins tapestry workshops in France. It was Chevreul who first understood that all colors are created by mixing the three primary colors, red, blue, and yellow—a discovery that led him to develop the color wheel. Chevreul pointed out that flower

OPPOSITE: *The climbing roses 'Albertine' and 'Angelique' (foreground) frame the entrance to a toolshed.* ABOVE: *Sprays of 'Excelsa' mingle with Japanese honeysuckle.*

colors can be mixed optically by "entwining"—as with two different threads in a fabric—so that they appear as one color from a distance. Monet translated this concept for his garden by planting vines that would bloom among his climbing roses—notably blue-flowered clematis mixed with orange roses, yellow honeysuckle entwined with red ramblers, and blue morning glories mingled with yellow climbing roses.

Chapter 4
FAVORITE IMPRESSIONIST ROSES

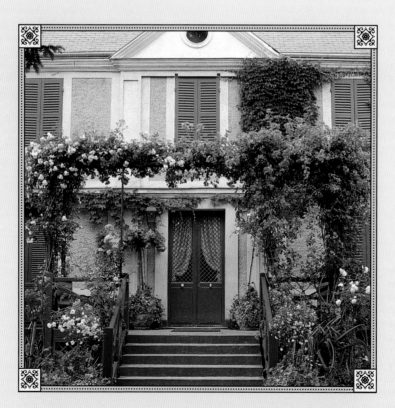

At the time the Impressionists began painting roses, rose breeding was still in its infancy. Many gardeners relied on species roses—and naturally occurring hybrids of species—for decorative display. Some roses the Impressionists used and painted—such as 'Rose des Peintres' (The Painter's Rose)—had been in cultivation since before the sixteenth century, while others—'La France', the first hybrid tea rose, for example—were not introduced until the dawn of Impressionism.

ABOVE: *Snowy white 'Thalia' and 'American Pillar' span the width of Monet's house.* OPPOSITE: *The Roseraie de l'Hay, near Paris, displays a large collection of climbing roses, many of which are also grown in Monet's garden.*

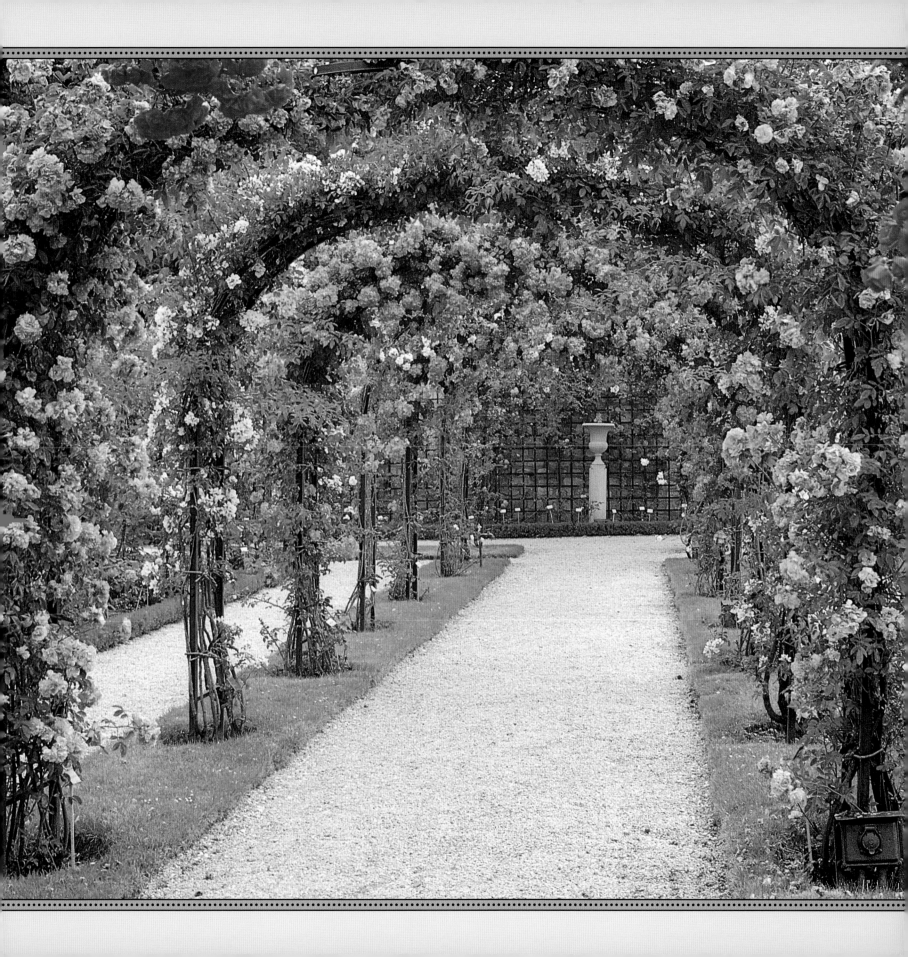

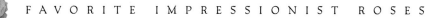

The following is a list of roses that were popular at the time of the Impressionists. Some are species roses but most are hybrids developed by French or British nurserymen, spurred on by the demand set by Empress Josephine. Those with an asterisk are selected for special featuring in the encyclopedia section.

Cultivated for More than Three Thousand Years

Rosa gallica	Gallica	Date unkown

Cultivated Since the Sixteenth Century

Rosa eglanteria	Species	Prior to 1511
Rosa foetida bicolor ('Austrian Copper')	Species	Prior to 1590
Rosa spinosissima	Species	Prior to 1600

Cultivated Since the Seventeenth Century

'Centifolia Muscosa' ('Common Moss')	Centifolia	Circa 1696
Rosa gallica versicolor ('Rosa Mundi')	Species	Date unknown
Rosa sempervirens	Species	Prior to 1629
Rosa sulphurea	Species	Date unknown
'York & Lancaster'	Damask	Prior to 1629

Cultivated Since the Eighteenth Century

*'Complicata'	Gallica	Date unknown
'Great Maiden's Blush'	Alba	Prior to 1738
'Old Blush'	China	Prior to 1759
Rosa laevigata	Species	1759
Rosa rugosa	Species	Prior to 1799

Introduced Before 1830

*'Belle de Crécy'	Gallica	Prior to 1829

'Camaieux'	Gallica	1830
'Champneys' Pink Cluster'	Noisette	1811
'Crested Moss' ('Chapeau de Napoleon')	Moss	1827
*'Duchess of Portland'	Portland	Circa 1800
'Dupontii'	Misc. old garden rose	1817
'Gloire des Rosomanes'	China	1825
'Königin von Dänemark'	Alba	1826
'Marie Louise'	Damask	Before 1813
Rosa banksiae banksiae (White Lady Banks)	Species	1807
Rosa banksiae lutea (Yellow Lady Banks)	Species	1824
Rosa carolina	Species	1826
Rosa glauca	Species	Prior to 1830
Rosa roxburgii	Species	Prior to 1814
Rosa virginiana	Species	Prior to 1807
'Rose du Roi'	Portland	1815
'Tuscany'	Gallica	Prior to 1820

Introduced Between 1830 and 1850

'Anaïs Ségalas'	Gallica	1837
*'Baronne Prévost'	Hybrid perpetual	1842
*'Cardinal de Richelieu'	Gallica	1840
'Celestial'	Alba	Prior to 1848
*'Charles de Mills'	Gallica	Date unknown
*'Harison's Yellow'	Hybrid foetida	Circa 1830
'Ispahan'	Damask	Prior to 1832
'Louis Philippe'	China	1834
'Madame Hardy'	Damask	1832
'Madame Plantier'	Alba	1835

'Petite de Hollande'	Centifolia	Prior to 1838
'Queen of Bourbons'	Bourbon	1834
'Rose des Peintres'	Centifolia	Prior to 1838
'Stanwell Perpetual'	Hybrid spinosissima	1838
'Viridiflora' (Green Rose)	China	Prior to 1845

Introduced Between 1850 and 1860

'Comte de Chambord'	Portland	1860
*'Fantin-Latour'	Centifolia	Date unkown
*'Gloire de Dijon'	Climbing tea	1853
'Madame de Tartas'	Tea	1859
'Sombrieul'	Climbing tea	1850

Introduced Between 1860 and 1870

'Alba Semi-Plena'	Alba	Prior to 1867
'Jacques Cartier' ('Marchesa Boccella')	Hybrid perpetual	1860
*'La France'	Hybrid tea	1867
*'Maréchal Niel'	Noisette	1864
'Paul Neyron'	Hybrid perpetual	1869
*'Reine des Violettes'	Hybrid perpetual	1860
'Rêve d'Or'	Noisette	1869
*'Zéphirine Drouhin'	Bourbon	1868

Introduced Between 1870 and 1880

*'American Beauty'	Hybrid perpetual	1875
'La Reine Victoria'	Bourbon	1872
'Madame Alfred Carriere'	Noisette	1879
'Madame Pierre Oger'	Bourbon	1878

Introduced Between 1880 and 1920

*'American Pillar'	Rambler	1902
*'Belle Vichysoise'	Noisette	1897
*'Climbing Cecile Brunner'	Climbing polyantha	1894
'F.J. Grootendorst'	Hybrid rugosa	1918
'Hansa'	Hybrid rugosa	1905
'Louise Odier'	Bourbon	1881
*'Mermaid'	Hybrid bracteata	1918
'Monsieur Tillier'	Tea	1891
'Painter Renoir'	Shrub	1911
*'Paul's Scarlet Climber'	Large-flowered climber	1916
'St. John's Rose'	Shrub	1902
'Thalia'	Hybrid multiflora	1895

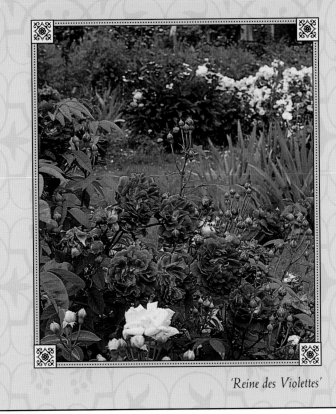

'Reine des Violettes'

'Gloire des Rosomanes'

THE MAIN ROSE VARIETIES DISCUSSED IN THIS SECTION WERE EITHER PAINTED OR GROWN BY THE IMPRESSIONISTS. FOR THE SAKE OF PRACTICALITY, HOWEVER, WE HAVE INCLUDED SOME MODERN ALTERNATIVES TO THE ORIGINAL IMPRESSIONIST ROSES—THESE NEWER ROSES ARE USEFUL SUBSTITUTES IN CASES WHERE THE ORIGINAL IS SHORT-LIVED, SUSCEPTIBLE TO DISEASE (NOTABLY BLACKSPOT AND MILDEW), OR NOW DIFFICULT TO FIND. IN CHOOSING ROSES FOR INCLUSION WE HAVE PRESENTED ROSES FROM AS MANY CLASSES AS POSSIBLE, SO THAT EVERY GARDENER'S NEEDS AND TASTES COULD BE ACCOMMODATED. IN NARROWING DOWN THE LONG LIST OF ROSES, WE FOCUSED ON THOSE WITH APPEALING COLOR, VIGOROUS GROWTH HABIT, AND POTENTIAL FOR DRAMATIC LANDSCAPE USE, THAT IS, THE ABILITY TO COMPLETELY COVER A ROSE ARCH OR MIX WELL WITH FLOWERING PERENNIALS.

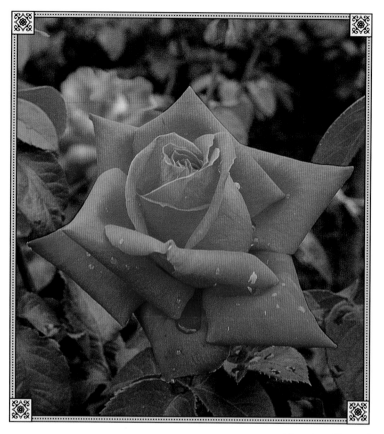

'American Beauty'

'AMERICAN BEAUTY'

Hybrid perpetual

Zones 6 to 9

Renoir and Caillebotte both loved this rose for its rosy pink color and exquisite form. Resembling a modern hybrid tea, 'American Beauty' flowers repeatedly and possesses a memorable fragrance. There are rose experts who believe that it has never been outclassed for flower substance despite the fact that it dates back to 1875. Indeed, when the rose was proposed as a national floral emblem for the United States, some rosarians lobbied for 'American Beauty', which was already the floral emblem for Washington, D.C. But it was decided that the national emblem should be a generic flower, rather than a particular variety.

'American Beauty' was developed by a Washington, D.C., gardener, James Brady, who worked at The White House during Ulysses S. Grant's administration. This spectacular rose's popularity soon spread to Europe, especially France. Brady introduced his new rose long before plant patents were available, and he never made a penny on 'American Beauty', although two Washington florists became wealthy from growing it in greenhouses and selling it year-round to Washington society.

Plants grow to 5 feet (1.5m) high. Although there is a climbing form that will grow to 15 feet (4.5m), listed as 'Climbing American Beauty', it is not a true sport but rather a cross that has 'American Beauty' as a parent, and it has no repeat bloom.

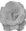

'AMERICAN PILLAR'

Rambler
Zones 6 to 8

Introduced in the United States in 1908 by Doctor W. Van Fleet, the propagation and distribution of 'American Pillar' was taken over by Conard & Jones, of West Grove, Pennsylvania. The company may have submitted samples of 'American Pillar' to the Bagatelle Rose Gardens in Paris, where Claude Monet went frequently to evaluate new roses. Monet called it his "Pennsylvania Rose" and promptly planted it to grow up his tallest arches, those that surrounded his boat dock. He also propagated it in his greenhouse and gave rooted cuttings to friends.

Although 'American Pillar' blooms only once each season—for a three-week period in late spring—it presents an astonishing avalanche of flowers at its peak. The individual flowers are small (about 1 inch [2.5cm] across), but they are held in generous clusters, like bunches of grapes, and they light up the landscape with their carmine-pink flowers. The centers have golden yellow stamens set in a white eye. Flowers are followed by bright red hips eagerly sought by songbirds. Glossy and dark green, the leaves are susceptible to mildew. The canes are strong and exceedingly thorny. For best flowering, remove all but five canes at the end of the season. An extremely vigorous climber, 'American Pillar' grows up to 20 feet (6m). Plants will tolerate some shade.

'DORTMUND'

Kordesii

Zones 5 to 9

Where mildew is a problem, a suitable modern alternative to 'American Pillar' is 'Dortmund', developed by Kordes, Germany, and released in 1955. The single flowers are larger than 'American Pillar' (up to 4 inches [10cm] wide), and crimson. They have a powdery yellow crown of stamens at the center of each flower, surrounded by a white eye. The flowers present a "pillar of fire" when in full bloom. Reaching to 12 feet (3.5m), 'Dortmund' does not grow quite as tall as 'American Pillar'. The leaves are a lustrous bright green and disease resistant. Its clean foliage makes it suitable as a background plant, even when out of bloom.

'American Pillar' was used by Monet in the same way as 'Belle Vichysoise' (page 86), and he grew the two together over his highest arches. But he preferred 'American Pillar' for its deeper coloration and ability to stand out in the landscape.

'American Pillar' is the predominant rose used in rose gardens around Paris—not only in Monet's garden, but also at Bagatelle, Roseraie de l'Hay, and the Hotel Baudy—yet it is hardly known in North America. If you want to see some splendid specimens of 'American Pillar', visit Longwood Gardens in Pennsylvania in early June and see it used as a circle of flowering arches surrounding an Italian wellhead.

'APOTHECARY'S ROSE'

Hybrid gallica

Zones 3 to 8

'Apothecary's Rose' has deep pink, velvety petals, and is botanically known as *Rosa gallica officinalis*. It produces large, semidouble flowers (up to 4 inches [10cm] across) on a vigorous, bushy plant. The flowers are highly fragrant, and the rose's cultivation goes back to at least the seventeenth century, when it was grown by herbalists for distilling a fragrant oil. The flowers retain their pronounced perfume even when dried. Plants grow to 4 feet (1.2m) high and bloom for several weeks in late spring. 'Apothecary's Rose' makes a good informal hedge, requiring little more than trimming of wayward stems in winter to keep it within bounds.

OPPOSITE: *'American Pillar' in Monet's garden*

'ROSA MUNDI'

Gallica

Zones 3 to 8

The original 'Apothecary's Rose' gave rise to a natural mutation which is commonly known as 'Rosa Mundi' and botanically as *Rosa gallica versicolor*. The flowers are beautifully striped in pink, red, and white. It is appealing planted alone as a specimen, and it also makes an attractive hedge. 'Rosa Mundi' is very similar in appearance to the Gallica 'Camaieux', as both are bicolors with a candycane pattern of white and red on the petals. 'Rosa Mundi', however, has semidouble flowers with an appealing crown of powdery yellow stamens at the center, while 'Camaieux' has fully double flowers that usually hide the central yellow crown.

Plants have a bushy habit and grow a dense knit of arching canes to stand up to 4 feet (1.2m) tall. A heavy flush of bloom occurs in late spring. The canes are only lightly thorny, and the leaves are an attractive dark green.

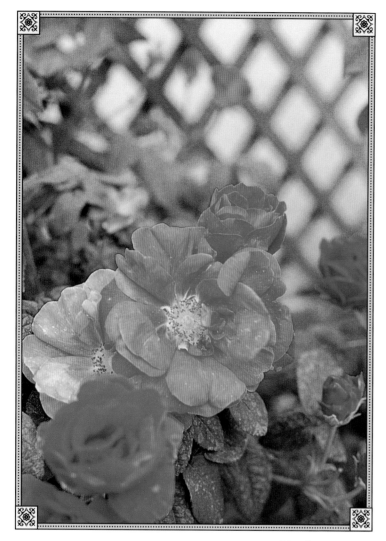

'Apothecary's Rose'

'Apothecary's Rose' was probably introduced into Europe by crusaders returning from the holy lands. It has been used endlessly in hybridizing, and it is these hybrids that were extremely popular in public and private gardens during the Impressionist era. Special favorites of the Impressionists include 'Belle de Crécy' (page 85), 'Cardinal de Richelieu' (page 89), and 'Charles de Mills' (page 92)—most of these roses featured prominently in the paintings of Fantin-Latour.

'BARON GIROD DE L'AIN'

Hybrid perpetual

Zones 4 to 9

'Baron Girod de l'Ain', a distinctive hybrid perpetual, was introduced by the French rosarian Reverchon in 1897. A sport of the old garden rose 'Eugéne Furst', 'Baron Girod de l'Ain' is widely available today and much admired for its unusual petal color. Its large, double flowers (up to 4½ inches [11cm] across) are a bright crimson with ruffled petal tips and a beautiful, fine, white line outlining the ruffled edge, as though a painter had

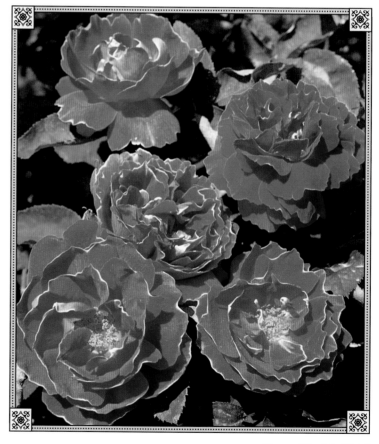

'Baron Girod de l'Ain'

dipped his brush in white and outlined the entire flower. This rose's impact in the garden is startling, and it is indeed a beautiful flower to paint. Plants grow to 4 feet (1.2m) tall and nearly as wide. You may want to propagate these plants by pegging down the longest canes, which will take root and create a thicket or a continuous hedge of bloom.

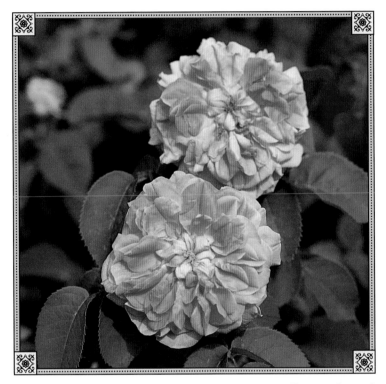

'Baronne Prévost'

'BARONNE PRÉVOST'

Hybrid perpetual

Zones 5 to 8

A class of rose called hybrid perpetuals—produced from a complex hybridizing program that involved China roses, Portlands, Bourbons, Noisettes, and later the tea rose—became popular in the 1830s. The term "perpetual" is an exaggeration, for they are either sporadically repeat-blooming or produce another flush of color in the autumn. Throughout the Impressionist era the hybrid perpetuals were planted extravagantly in rose gardens, and they featured prominently in competition classes. Floral arrangers loved them for their swirling petal pattern and good fragrance. The modern British rose hybridizer David Austin has improved upon their appearance and habit with flowers of similar form, but with stronger repeat-flowering performance.

'Baronne Prévost' is a distinctive hybrid perpetual known to the Impressionists. Possessing a strong constitution (plants from the mid-1800s still survive to this day), it was developed by the French nursery Desprez, and introduced in 1842. A deep rose pink, the flowers are large, double, and heavily fragrant. Plants are vigorous, grow to 5 feet (1.5m) tall, and develop an almost equal spread.

'BELLE DE CRÉCY'

Hybrid gallica

Zones 4 to 8

'Belle de Crécy' was introduced in 1829 by Roeser, Crécy-en Brie, France. Although variable in flower color (depending on the age of the blooms), this rose usually displays rich mauve-purple petals that fade to pale lavender. The heavily doubled flowers are flattened, up to 4 inches (10cm) across, and have an intoxicating fragrance. Indeed, the flowers are so large, multipetaled, and heavy that support for the plant is desirable. The petals of 'Belle de Crécy' swirl, and are usually quartered around a green button eye. Though the plant's habit is upright, the canes tend to weep,

creating a dense, bushy plant that may grow up to 4 feet (1.2m) tall and equally wide.

Another superb Gallica, which actually makes a fine companion for 'Belle de Crécy', is 'Anaïs Ségalas'. It was introduced by the French nurseryman Vibert in 1837, but unfortunately it can be difficult to find. The flowers are similar in form to 'Belle de Crécy', but much more uniform, and lovely soft pink. It, too, is so heavily fragrant that one flower can fill a room with its heady perfume.

Some David Austin look-alikes, which possess similar flower form and better repeat-flowering characteristics, include 'Gertrude Jekyll', 'Mary Rose' (p. 97), and 'Heritage' (p. 97)—all good substitutes for 'Anaïs Ségalas', while 'William Shakespeare' is a good modern substitute for 'Belle de Crécy'.

'BELLE VICHYSOISE'

Noisette

Zones 6 to 9

'Belle Vichysoise' was a favorite of Claude Monet—in fact, he seized on it the minute it was introduced in 1897. He realized that with its ability to grow up to 30 feet (9m)—and almost suffocate itself with masses of small, pompon-shaped, pink flowers—it was capable of making an astonishing visual impact in his garden. This climber was particularly effective in his water garden, where he erected tall arches to accommodate its luxurious growth. Monet also encouraged it to creep up into the tops of the tall trees surrounding his pond, where the rose contributed a cascade of blossoms.

Introduced by the French nurseryman Lévêque, who discovered it in the town of Vichy, it is classified as a Noisette. The development of this beautiful group of roses began in Charleston, South Carolina, where John Champneys, a rice plantation owner, produced a climbing hybrid rose by crossing 'Old Blush' (a China rose) with R. moschata. The result was named 'Champneys' Pink Cluster' for its abundant bunches of small, double, pink flowers, which bloomed in spring, then continued intermittently through autumn.

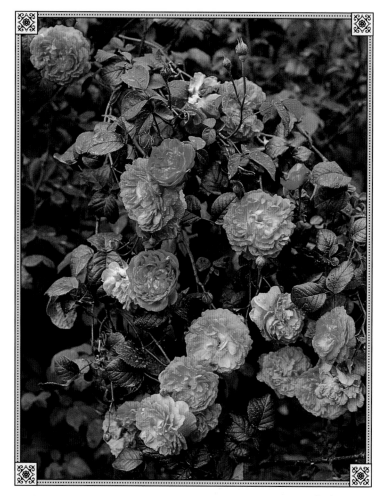

ABOVE: *'Belle de Crécy'*
OPPOSITE: *'Belle Vichysoise' in Monet's Garden*

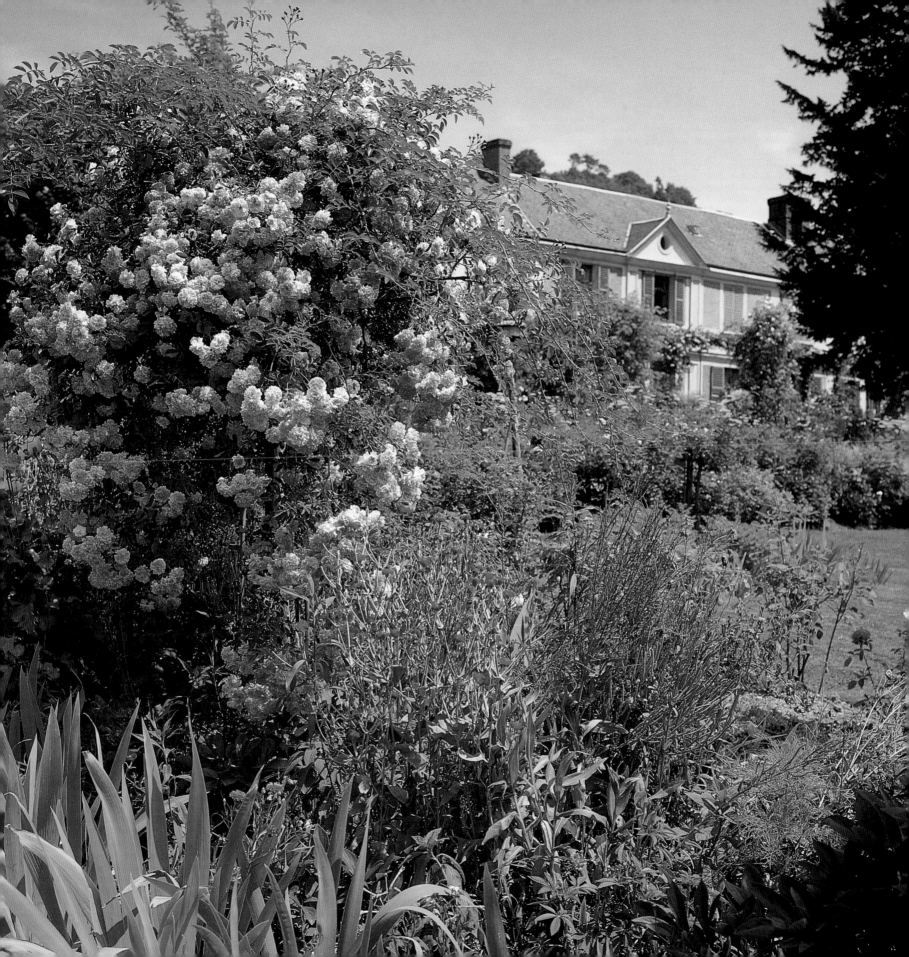

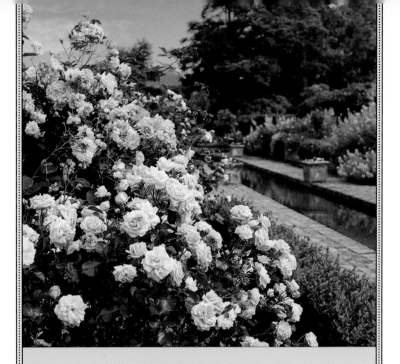

'ALBERTINE'

Large-flowered climber

Zones 5 to 9

A cross between *Rosa wichuraiana* and the hybrid tea 'Mrs. Arthur Robert Waddall', this bushy climber was first introduced in 1921 by the French rosarian Barbier. The double, salmon-pink blooms make a good companion for 'Constance Spry', which is a deeper pink—the two roses share a similar flower form, fragrance, and climbing habit. Though prone to mildew, the plant is not normally affected until well after its spring flowering.

The vigorous plants can grow to 12 feet tall (3.5m), and are perfect candidates for cottage gardens where a billowing effect is desirable. Young leaves are generally a coppery bronze, changing to a dark, lustrous green as they mature. Fragrant 'Albertine' is much used for romantic effect in British and French gardens, where it is often planted to form a generous protective canopy over a cozy bench. This lovely rose is used extensively in Monet's garden, trained along metal frames in the Clos Normand.

Champneys' neighbor, Phillip Noisette, sent seeds of the rose to his brother in France, who grew them and found among the seedlings a bushier, deeper pink form, which was introduced as 'Blush Noisette' in 1817. This in turn helped to produce beautiful colors and a new class of rose—the Noisettes. With a much more vibrant color range than any previous rose family, the Noisettes added a stunning variety of yellows and apricot tones to the regular reds, pinks, and whites.

Today, 'Belle Vichysoise' is a rarity, but some other vigorous climbers can be grown as suitable replacements. One of the best substitutes is 'Dorothy Perkins'—a rambler—which was introduced by the American rose breeders Jackson & Perkins in 1902. The avalanche of small, double, clear pink flowers are borne on vigorous canes that can extend 15 feet (4.5m) or more.

'Albertine' and 'Angelique' are two look-alike pale pink climbing roses used extensively in Monet's garden today. 'Albertine' especially is an excellent substitute for 'Belle Vichysoise'.

The double, salmon-pink blooms are highly fragrant and a good companion to 'Constance Spry' (a David Austin hybrid) which is a deeper pink but displays a similar flower form, fragrance, and climbing habit. 'Constance Spry' and 'Albertine' can both grow to 15 feet (4.5m) high. They are perfect candidates for cottage gardens where a billowing, flowery bower effect is desirable. Young leaves are generally a coppery bronze, changing to dark, lustrous green. You will often see 'Albertine' or 'Constance Spry' used to romantic effect in French and British gardens. Look for these two bushy pink roses to form a protective and fragrant canopy over a cozy bench.

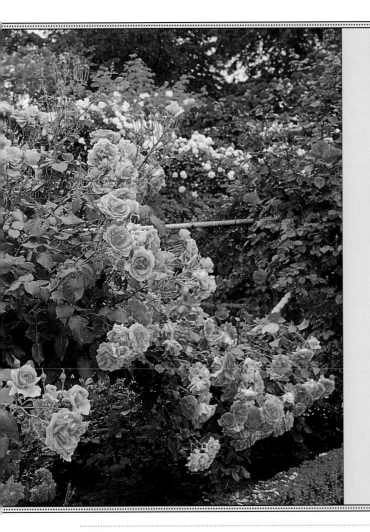

'CONSTANCE SPRY'

Shrub

Zones 6 to 9

Named for a famous British floral arranger who established the first Western flower arranging school, the rose 'Constance Spry' was British rosarian David Austin's first major breeding achievement. Introduced in 1961, it is a cross between the Gallica rose 'Belle Isis' and the floribunda 'Dainty Maid'.

Plants grow 6 to 15 feet (1.8 to 4.5m) tall, and are best used espaliered against a wall or trained along a fence. If grown as a shrub, the long canes arch out like a fountain and create a self-supporting shrub 6 feet (1.8m) high. Each cane will be studded with hundreds of highly fragrant, cup-shaped blooms composed of swirling petals that are alluringly romantic and old-fashioned. When fully mature the flowers can measure up to 5 inches (12cm) across, and are exquisite in arrangements. 'Constance Spry', though it has an initial heavy flush of bloom in spring, does not repeat. Later roses hybridized by David Austin, known as English roses, do have the favorable trait of repeat-flowering.

'CARDINAL DE RICHELIEU'

Gallica

Zones 4 to 9

If we could have only two old garden roses on our property, one would certainly be 'Cardinal de Richelieu'. We love its fabulous dusky purple color and the fruity fragrance, most pronounced when the flowers are dried. Our other choice would be 'La Reine Victoria', for its exquisite, shell pink, swirling, cup-shaped blooms and sweet, heavy fragrance.

'Cardinal de Richelieu' was introduced by the house of Laffay in France in 1840, though it may have originated in Holland as rose Van Sian, from a Dutch rosarian, Van Sian. The plants, which grow bushy and compact, up to 4 feet (1.2m) high, are good for hedging.

The vigorous shrublike Gallica roses were first cultivated in ancient Crete, where they undoubtedly formed the basis of Western rose breeding. Other outstanding members of the gallica family include 'Belle de Crécy' (page 85) and crimson 'Charles de Mills' (page 92).

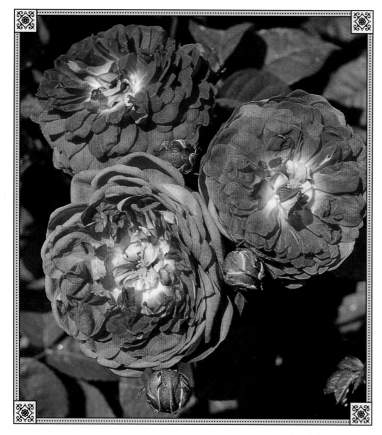

'Cardinal de Richelieu'

and a shrub form of this popular rose. The vigorous canes of 'Climbing Cécile Brunner', introduced in 1899, can reach 25 feet (10.5m) in height, with heaviest flowering in spring and autumn. The double, pale pink blooms are little more than an inch (2.5cm) across and lack fragrance, but the flowers are so densely packed on arching canes that the plant presents a veritable blizzard of blooms. Certainly there are few better climbers for cottage gardens—it is an inspired choice for covering a high arbor or training over a garden shed.

There is also a shrubby version of this cultivar called 'Cécile Brunner', sometimes known as the Sweetheart Rose or Mignon. The original, shrubby form was introduced by French

Some of the new David Austin roses make excellent repeat-blooming substitutes for these Gallicas. 'Othello' (page 92) and 'The Prince' (page 96) are particularly noteworthy.

'CÉCILE BRUNNER'

Polyantha and climbing polyantha
Zones 6 to 9

Here is proof that size is no way to determine the value of a rose. Introduced by the American rosarian Hosp, what these roses flowers lack in size they make up for in sheer romantic charm and lavish abundance. There is both a climbing form

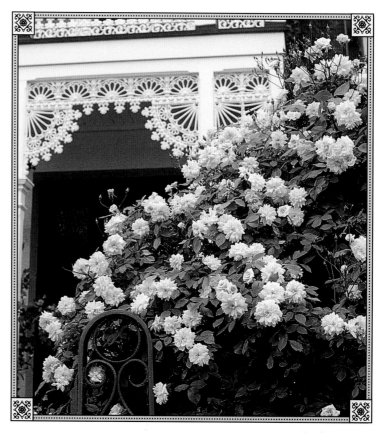

'Cécile Brunner'

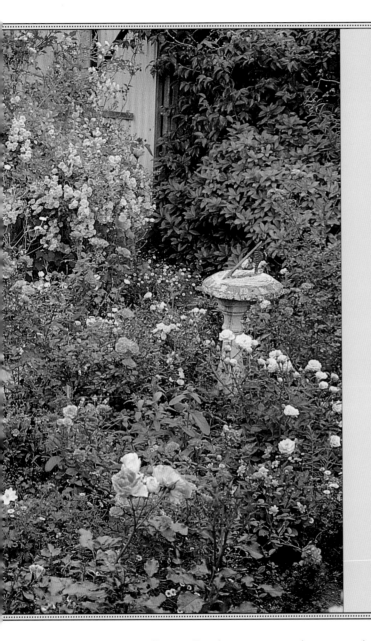

'THE FAIRY'

Polyantha

Zones 4 to 9

Also known as 'Fairy', this charming clear pink rose features button-size flowers held in tight clusters. Released by the British rosarian Bentall in 1932, it is actually a cross between a polyantha rose (all of which have some *R. multiflora* in them) and *R. wichuraiana*. There is also a more recent red sport (released in 1992), called 'Red Fairy'. Both varieties exhibit miraculous vigor; glossy, tight clusters of flowers; leathery, green leaves; and the capacity to bloom incessantly and excessively from late spring through summer and well into autumn.

Plants grow to 4 feet (120cm) tall, creating a mounded shape. Left to its own devices, 'The Fairy' will spread to create a dense groundcover, but may also be used as low informal hedging, grafted into a tree form, massed in containers (or even in hanging baskets), or featured as a low flowering shrub in a mixed perennial border. 'The Fairy' can even be used for covering slopes to control soil erosion—space plants 3 feet (1m) apart so the spreading canes can knit tightly together. Today, in Monet's Giverny garden 'The Fairy' is used extensively in beds of lavender and as standards in containers. Although the flowers individually are barely 1 inch (2.5cm) across, collectively they present a glittering cascade of color.

nurseryman Pernet-Ducher, in 1881, but it tends to be shy-flowering compared with the climbing form.

'Climbing Cécile Brunner' is ideal for training up walls, over arches, and along frames to create the lace curtain effect so much admired by Claude Monet. The rose is also lovely when trained up into trees and mixed with the blooms of small-flowered clematis such as 'Minuet'. You will find that 'Climbing Cécile Brunner' is a good candidate for grafting onto a straight rose trunk to create a standard. But today, in Monet's garden at Giverny, the gardeners prefer to use a small-flowered pale pink everblooming rose, 'The Fairy', instead of 'Climbing Cécile Brunner' as their choice for tree roses.

'CHARLES DE MILLS'

Gallica

Zones 4 to 8

Little is known about the origins of this exceedingly beautiful rose—or about the man for whom it is named. 'Charles de Mills' (the largest-flowered Gallica) is an old rose cultivar, and almost a trademark of French rose gardens. The flowers are highly fragrant and have plum-red petals that create a swirling pattern around a small green button eye. The flowers are often quartered, with the petals forming pie-shaped segments—a

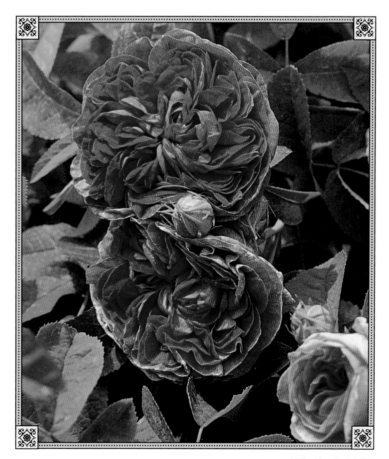

'Charles de Mills'

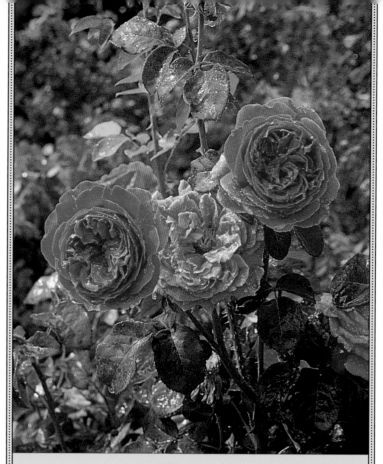

'OTHELLO'

Shrub

Zones 5 to 8

There are two modern David Austin, or English, roses that many rose growers consider indispensable for an old-fashioned rose garden. These are 'Othello', a dusky plum-red that deepens to a purple hue, and 'Graham Thomas', a glowing golden-yellow (page 98). Both were hybridized by David Austin and present a flower pattern similar to 'Charles de Mills'.

'Othello' was introduced in 1983, the result of crossing 'Lilian Austin' with 'The Squire'. The large, heavily fragrant, 4- to 5-inch (10 to 12cm) flowers are circular, cupped, and filled with swirling petals. More importantly, they feature recurrent bloom. Plants are bushy, dense, and thorny, and grow to 8 feet (20cm) tall with dark green leaves.

quality that is highly valued by floral arrangers and was admired by the Impressionists. Indeed, a special area of Monet's garden is devoted entirely to old garden roses that possess the lovely swirling petal formation of 'Charles de Mills'.

A perfect companion to 'Charles de Mills' is the Gallica 'Cardinal de Richelieu' (page 89). Though slightly smaller in flower size, it has the same swirling pattern to the petals but blooms in a royal purple color that almost borders on blue, plus a haunting fragrance.

'COMPLICATA'

Gallica

Zones 4 to 9

'Complicata' is a strange name for an exquisite rose, and refers to the crease that occurs along each delicate petal. Although 'Complicata' is classified as a Gallica, it looks nothing like most other Gallicas, which are famous for their tightly doubled flowers. This is a five-petaled pink flower that first unfolds into a

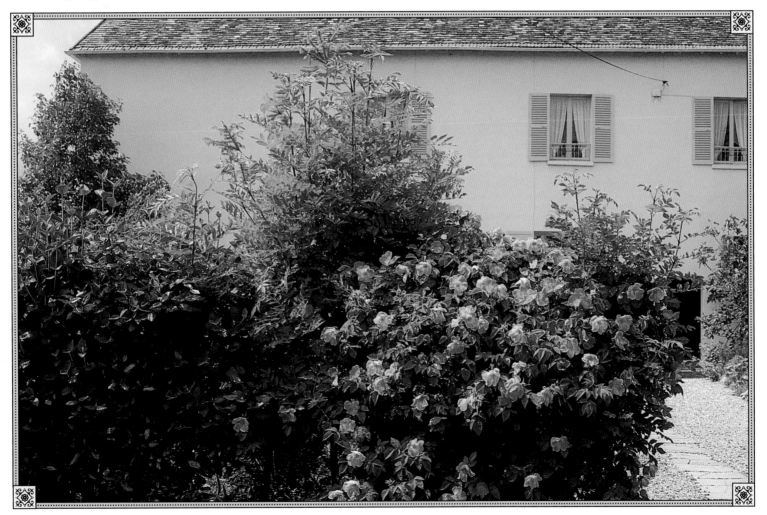

'Complicata' in front of Monet's Blue House

saucer shape. It was a favorite of van Gogh, who found it growing in shady parts of the garden of the asylum at Saint-Rémy. Monet, who was also an admirer of 'Complicata', planted it in front of the Blue House, a property at Giverny he owned at the other end of the village from his home, the Pink House.

The pink coloring of 'Complicata' has a soft purity and a brilliance found in few other roses; moreover, it doesn't have the highly bred look of many hybrid roses—it has a satisfying "wild rose" appearance that is absolutely refreshing. The shrubby plant has a tendency to produce tall, erect stems, and it can be trained to be a climber, up to 10 feet (3m) high. When sheared appro-

priately, it also makes an exquisite, dense, flowering hedge. The flowers are followed by attractive orange-red hips.

In recent years a number of rose varieties with a wild rose appearance similar to 'Complicata' have been produced. These include 'Wind Chimes' (a climbing hybrid musk that grows to 15 feet [4.5m] high), 'Betty Prior' (a vigorous, bushy floribunda introduced in 1935) and 'Nearly Wild' (a vigorous, bushy floribunda introduced in 1941, with better recurrent bloom). Consider grouping these roses in a small meadow planting—wildflowers such as poppies, ox-eye daisies, and cornflowers make lovely companions scattered among the roses.

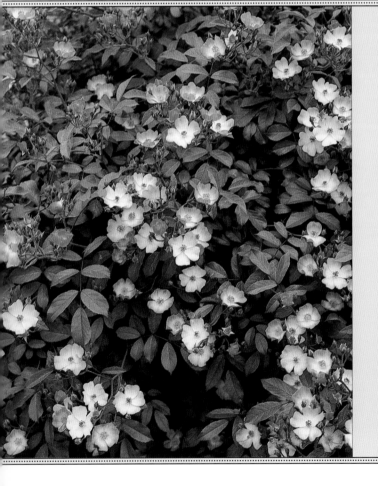

'BALLERINA'
Hybrid musk

Zones 4 to 9

Introduced in 1937 by Bentall, a prolific British rosarian, this bushy rose is actually a variety of hybrid musk from the Himalayan Mountains of Northern India. It has the look of a wild rose, with its small, single, cup-shaped pink flowers, white centers, and boss of yellow stamens. The dainty flowers are borne in generous clusters in a mad flush of bloom in late spring, and then continue into autumn with intermittent rebloom, especially during cool weather.

Plants grow to 4 feet (1.2m) high, spread equally wide, and make a beautiful hedge. 'Ballerina' is a good rose to plant beside a retaining wall so the canes can cascade down, or wherever a wild rose look is desired, such as in a cottage garden. Although some dieback is common north of Zone 6, plants are root hardy into Zone 4, allowing this rose to come back even after severe winters.

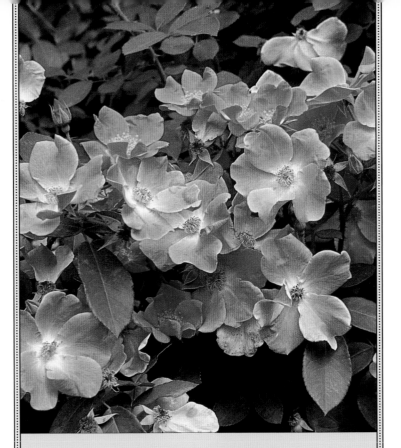

'BETTY PRIOR'

Floribunda

Zones 5 to 9

Most people think of floribundas as smaller-flowered versions of hybrid teas, with double blooms held erect on sparse, strong stems to form brilliant clusters. 'Betty Prior' is different in that it is plump in form, bushy, and single-flowered with an appealing wild rose appearance. Introduced by a British nurseryman in 1935 and named for the originator's wife, this rose has endeared itself to those gardeners who like a carefree, informal appearance. Though the flowers are not very fragrant, plants display masses of deep pink blooms that fade to a paler pink near their powdery yellow stamens.

Plants grow to 3 feet (1m) high, spreading to 4 feet (1.2m). Attractive both alone and as an informal hedge, 'Betty Prior' is a disease-resistant "survivor."

'DUCHESS OF PORTLAND'

Portland

Zones 5 to 9

This ancient garden rose stands out in a crowd. Reportedly introduced into England from Italy in about 1790 by the Duchess of Portland, it crossed over to France to form part of Empress Josephine's ambitious rose collection at Malmaison. It spawned a new race of roses called Portlands, or sometimes damask perpetuals, which are hybrids between China roses and old European roses such as 'Autumn Damask'.

'Duchess of Portland' is an incredible crimson with a conspicuous crown of powdery yellow stamens at the center of each saucer-shaped, semidouble flower. The flowers measure up to 3½ inches (8cm) across, and they have an intoxicating fruity fragrance. If spent blooms are deadheaded, flowering continues all season, especially where summers are cool.

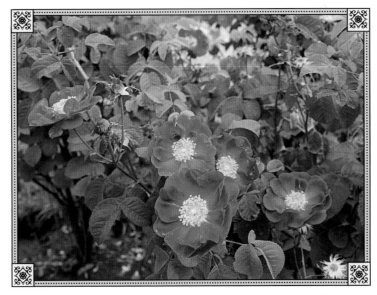

'Duchess of Portland'

95

'THE PRINCE'

Shrub

Zones 6 to 8

Introduced in 1990 by David Austin, 'The Prince' resembles a gigantic Portland rose. Its flowers—up to 5 inches (12cm) across—open into a cupped shape, presenting a swirling petal formation and a button eye. As the flowers open the highly fragrant petals are a rich crimson, but quickly mature to a rich, royal purple. Most catalogs describe the plant as low and bushy, averaging 2 feet (60cm) in height, but in North America, where summers are hot, the plants grow taller, often reaching 3 to 4 feet (1 to 1.2m).

Other Portland roses that make good companions to 'Duchess of Portland' include 'Rose du Roi' (a huge, fragrant deep pink), and 'Comte de Chambord' (a large, double-flowered, fragrant light pink). 'Jacques Cartier' is similar in color to 'Comte de Chambord', but it has a more open face, and generally is the less appealing of the two. All of these roses grow 4 feet (1.2m) tall, with an equal spread.

'FANTIN-LATOUR'

Centifolia

Zones 5 to 9

Little is known about this old garden rose, despite the fact that it is named for Henri Fantin-Latour, a famous painter of floral still life arrangements. Since Fantin-Latour's rose paintings were the rage in England, it is possible that the rose was intro-

'Fantin-Latour'

'MARY ROSE', 'HERITAGE', AND 'ABRAHAM DARBY'

Shrubs

David Austin, the British rosarian, broke with tradition about forty years ago, and instead of breeding popular hybrid teas he selected for flat, circular, cupped blooms; old-fashioned fragrance; and dense, swirling petals. Because they were developed in the maritime British climate, plants are not always as free-flowering in other locations, or as compact as described in catalogs.

In the world of Austin's roses, there are several that resemble 'Fantin-Latour', in particular blush pink 'Mary Rose' (shown below), which is almost an exact replica of 'Fantin-Latour', but with larger flowers and repeat-flowering. Another 'Fantin-Latour' look-alike is light pink 'Heritage'. For a little more originality of color, consider 'Abraham Darby', a large yellow with apricot tones. In cool climates all these plants mature at 4 feet (1.2m) tall, but where summers are hot, the canes will stretch to 8 feet (2.4m) or more. These roses possess vigor, moderate disease resistance, good repeat-flowering, and the lush appearance shared by 'Fantin-Latour'.

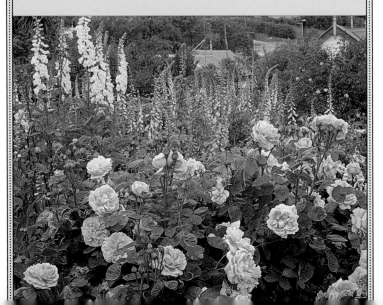

duced in the late 1800s by a British nurseryman. Although he was a salon painter who stayed true to the traditions of the Ecole des Beaux Arts by painting his subjects realistically, he was a close friend of all the great early Impressionist painters, including Renoir and Monet, and in some of his floral still-life arrangements he did venture into the Impressionist style (see page 37).

'Fantin-Latour' is shrubby in habit, maturing at 5 to 6 feet (1.5 to 1.8m) tall, with an equal spread. In spring it covers itself in delicate blush pink blooms that generally exhibit an outer ray of reflexed petals surrounding a flourish of swirling petals, like some peonies. The flowers are large and vivacious, often held together in clusters of three, on arching canes that have few thorns. Foliage is dark green.

'GLOIRE DE DIJON'

Climbing tea

Zones 6 to 9

When this beautiful orange-pink–flowered climbing tea rose was introduced by the French nurseryman Jacotot in 1853, Monet was thirteen years old. By the time he was twenty-two and looking at gardens as a painting subject, 'Gloire de Dijon' had been on the market nearly ten years—about what it takes for a new rose variety to catch on with the general public. How this cross between an unknown tea rose and 'Souvenir de Malmaison' (a white Bourbon) resulted in such a beautiful large-flowered orange-pink rose is something of a mystery. Though not reliably hardy above Zone 6, plants will grow to 15 feet (4.5m) high.

Orange is an important color in many of Monet's rose paintings, and he used it extensively in his garden at Giverny. Indeed, he was so fond of orange, apricot, and yellow roses that he created a special planting along his Grande Allée where all of these hot colors combined. We can see the gorgeous color harmony in his painting *Monet's Garden at Giverny* (1922). 'Gloire de Dijon' not only appears to be used as a tree-form rose in the foreground but also as a climber in the background. In Monet's garden today, the floribunda 'Westerland' has largely replaced 'Gloire de Dijon' as the favorite orange-flowered climber because of its strong repeat bloom. Also consider 'Graham Thomas' or 'Orange Honey' for hot color gardens.

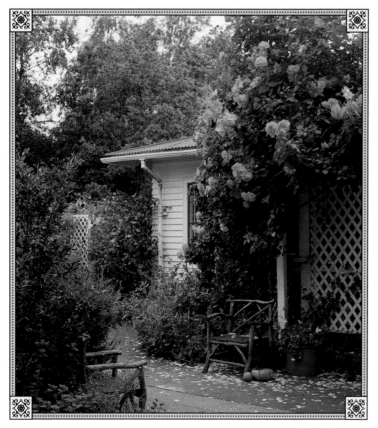

'Gloire de Dijon'

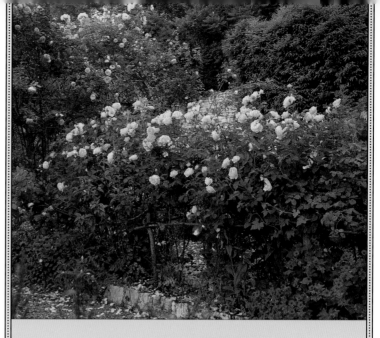

'GRAHAM THOMAS'

Shrub

Zones 6 to 9

The result of rose breeder David Austin's cross between 'Charles Austin', a seedling of 'Iceberg', and an unidentified shrub rose, 'Graham Thomas' was named for a famous British rosarian and garden writer. This moderately hardy shrub rose has an exquisite flower form, featuring cup-shaped, heavily fragrant, double flowers with petals arranged in a swirling pattern, reminiscent of old garden roses. Indeed, 'Graham Thomas' looks like a yellow version of 'Reine des Violettes'—the most popular of all old garden roses.

'Graham Thomas' performs best in a maritime climate, where cool summers can keep it flowering all season; but even where summers are hot it can produce a stunning flush of bloom in spring and early summer. Plants grow bushy to 6 feet (1.8m) high, although longer canes can shoot skyward where summers are hot. Use it as an accent in mixed shrub borders or as a hedge. Although plants are subject to most rose pests and diseases, preventive sprays can keep the plantings looking clean and healthy.

'ORANGE HONEY'

Miniature

Zones 5 to 9

This beautiful, free-flowering, everblooming rose is a bicolor with yellow and orange petals. Growing to 2 feet (60cm) tall, with double flowers just 1½ inches (3.5cm) across, it is a remarkable achievement of Sequoia Nurseries, a California nursery that specializes in breeding miniature roses. The flowers are delightfully fragrant—an unusual trait for a miniature. Plants are bushy, form a dense, spreading cushion of dark green leaves and thorny canes, and cover themselves with blooms from late spring until autumn frost.

'Orange Honey' is wonderful in rock gardens, especially if its spreading canes are encouraged to hang over a rock ledge or retaining wall. It is perfect for mixing with perennials in flower borders—this rose looks especially lovely combined with gaillardias, anthemis, and coreopsis to create a startling hot color harmony. Perhaps its most treasured uses, however, are as an edging to garden paths and in container plantings for sunny decks and patios.

'LA FRANCE'

Hybrid tea
Zones 6 to 8

Introduced in 1867 by the French nurseryman Guillot, this large-flowered, light pink rose, with its signature high-centered form, was the first to be classified as a hybrid tea. When compared to modern hybrid teas, however, its substance is short-lived. The nodding, fragrant flowers actually seem to be two-toned. The front side of the petal is a beautiful silvery pink, while the reverse is a bright pink, a dual personality that gives 'La France' great charm—especially in floral arrangements. The plants are loose and bushy, vigorous and free-flowering. In 1893 Peter Henderson, an American nurseryman, introduced a climbing sport called 'Climbing La France'.

The hybrid tea flower form we know today did not occur until 1900, when French nurseryman Joseph Pernet crossed the bright yellow double *Rosa foetida persiana*, commonly called 'Persian Yellow', with a purplish hybrid perpetual. The result was an apricot-yellow hybrid named 'Soleil d'Or', which featured a large, looser petal arrangement. When crossed with 'La France' it produced the repeat-flowering and classic high-peaked urn shape of the modern hybrid teas; it also opened up a Pandora's box of exciting new colors, especially in the yellow-

apricot-orange range. In deference to Joseph Pernet, these were at first called Pernetiana hybrids, but by the 1930s the distinction between the Pernetianas and hybrid teas was so slight that the group was merged into one—the great hybrid tea classification.

The early hybrid tea varieties did come with some drawbacks, including fickle hardiness, dislike of heavy pruning, and susceptibility to blackspot and mildew, so most hybrid teas sold today are all budded onto a special hardy

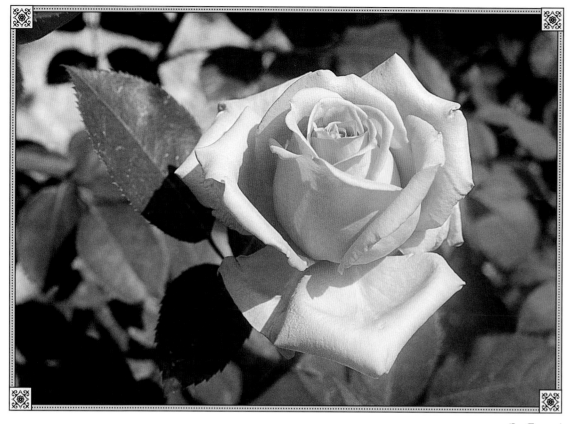

'La France'

rootstock. Modern hybridizers are also much more conscious of the need to introduce disease-resistant roses. Here are three outstanding representatives of the modern hybrid tea: 'Double Delight'—a red-and-white bicolor; 'Peace'—a yellow-edged pink; and 'Queen Elizabeth'—an incredibly large pink grandiflora rose.

In Monet's garden today the gardeners favor a large-flowered floribunda rose, 'Centenaire de Lourdes', over 'La France' because of its stronger repeat-flowering performance and good disease resistance. 'Centenaire de Lourdes' is similar in appearance to the American-bred 'Carefree Beauty' (see page 126).

LADY BANKS ROSE (*Rosa banksiae*)

Species
Zones 7 to 9

There are four variations of this distinctive tender rose, which was introduced to North America from China in 1796. There are two white varieties ('Normalis', a single-flowered white, and 'Alba Plena', a double-flowered white) and two yellow varieties ('Lutescens', a single yellow, and 'Lutea', a double yellow). The most popular is *Rosa banksiae lutea* the double yellow form, which is commonly called the Yellow Lady Banks Rose after the wife of a plant explorer. A component of Renoir's rose garden at Les

'HARISON'S YELLOW'
(ROSA × HARISONII)

Hybrid foetida

Zones 5 to 8

Sometimes called Harison's Rose (often misspelled Harrison's Rose), this old garden variety was introduced in 1830 from the garden of a New York City resident. It is a strong-growing, bushy plant with long canes like a climber. In early spring the thorny canes are studded with beautiful yellow 2-inch (5cm) double flowers that have a malodorous "yeasty" fragrance similar to one of its parents, *R. foetida*. The other parent is believed to be the Scotch briar rose, *R. spinosissima*. Plants grow to 8 feet (2.4m) tall and tolerate shade better than most other roses.

'Harison's Yellow' is best used in informal gardens—such as cottage gardens—for climbing a short trellis or cascading over a picket fence. The canes are also easily espaliered against a brick wall. Plants are susceptible to blackspot, mildew, and chewing insect pests, causing defoliation (which explains its rather low rating from the American Rose Society), but the defoliation does not normally happen until well after the magnificent flowering display, which occurs for three weeks in spring.

Collettes, near Nice, it flowers early in the spring, about the same time as azaleas and tulips, and it is capable of growing to 20 feet (6m) high, with clusters of 1-inch (2.5cm) -wide, slightly fragrant flowers cascading down its thornless branches like an avalanche. The small, serrated, dark green leaves are evergreen. Plants can be kept bushy and compact by rigorous pruning.

Yellow Lady Banks is a popular component of southern gardens, a favorite for covering arbors, scrambling along fences, and climbing into the lofty limbs of loblolly pines in company with wisteria. Plants are pest- and disease-free.

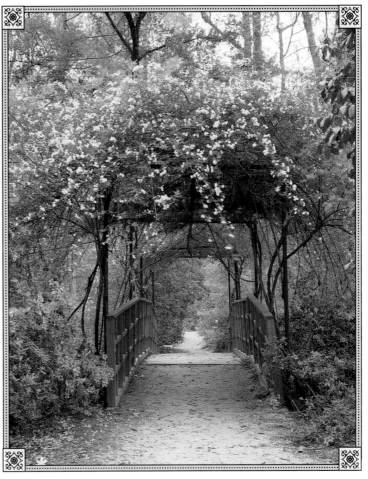

White Lady Banks Rose

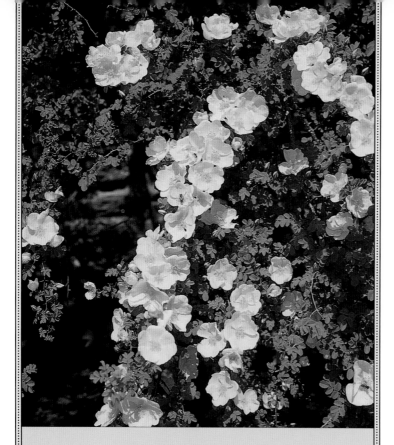

FATHER HUGO'S ROSE
(ROSA × HUGONIS)

Species

Zones 4 to 8

Known as Father Hugo's Rose for the missionary who introduced it from China, this bushy plant produces masses of lemon yellow, saucer-shaped flowers. The individual flowers measure almost 3 inches (7cm) across, and are borne along weeping canes on a mounded plant that can reach 8 feet (2.4m) in height.

Father Hugo's Rose is a popular component of cottage gardens and may be planted as a highlight at the back of mixed perennial borders. The flowers are followed by attractive orange-red hips in autumn, when the leaves turn shades of orange and bronze. It has a high rating from the American Rose Society (8.5), a good indication of its pest- and disease-resistance.

Two other early-flowering yellow roses—with larger flowers and better hardiness than Yellow Lady Banks—make beautiful substantial free-standing shrubs. They are 'Harison's Yellow' and Father Hugo's Rose (*Rosa hugonis*).

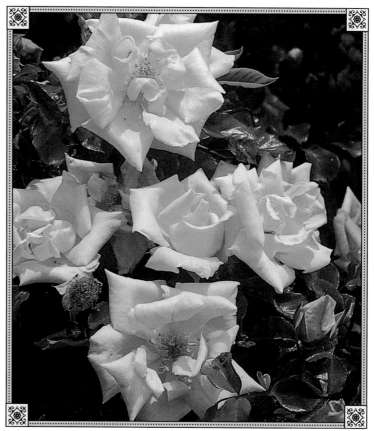

'Maréchal Niel'

'MARÉCHAL NIEL'

Noisette

Zones 6 to 9

'Maréchal Niel' was introduced in 1864 by the French nurseryman, Pradel. This climbing yellow rose was used to span one of Monet's rose arches along his Grande Allée. Considered to be a

seedling mutation of 'Chromatella', the golden yellow flowers are large and double. The canes are vigorous, and the leaves a rich dark green.

Since the introduction of 'Maréchal Niel' there have been many improved yellow roses, including 'Golden Showers', 'Graham Thomas' (page 98), 'Lady Hillingdon', and 'Céline Forestier.

'MERMAID'

Hybrid bracteata
Zones 7 to l0

'Mermaid' was Monet's favorite rose—a vigorous climber that he trained to cover the canopy of a porch that ran almost the length of his house. It can climb to 20 feet (6m) or more, and the thorny canes produce red juvenile growth that turns a lustrous

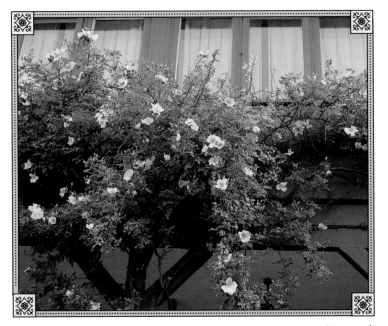

'Mermaid'

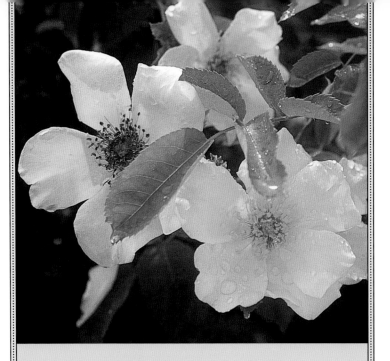

'GOLDEN WINGS'

Shrub rose
Zones 4 to 9

The flowers of 'Golden Wings' are very similar in appearance to those of 'Mermaid', but 'Golden Wings' in many ways represents an improvement, not only because it is hardier than 'Mermaid', but also because the five-petaled single blooms are a deeper yellow and lightly fragrant. Although 'Golden Wings' does not grow canes as long as those of 'Mermaid', it is repeat-flowering. The thorny, bushy, vigorous plants grow to 5 feet (1.5m) tall and up to 4 feet (1.2m) wide.

Originating in the United States from a cross between 'Soeur Thérèse' and a seedling of R. spinosissima 'Altaica', plants were released in 1956 and received a Gold Medal from the American Rose Society. The plants display an old-fashioned appearance, and have lustrous, light green leaves that are disease-resistant.

Monet, in particular, liked single-flowered roses, for their translucent petals.

dark green. The five-petaled flowers are extraordinary—a creamy white that deepens to golden yellow toward the center of each petal, with a crown of golden stamens that enhances the yellow "eye" effect. Introduced in 1918 by William Paul, who produced another Monet favorite ('Paul's Scarlet Climber'), 'Mermaid' has flowers that are sweetly fragrant and may measure as much as 4 inches (10cm) across.

Monet also planted 'Mermaid' in his water garden, and trained it to climb into tall trees. 'Mermaid' is a little too tender for northern gardens, where a good substitute is 'Golden Wings', which has a bushy, rather than climbing, habit.

'PAUL'S SCARLET CLIMBER'

Large-flowered climber

Zones 5 to 9

'Paul's Scarlet Climber' was introduced by the British rose hybridizer William Paul in 1905, when Monet was at the peak of his gardening success. It received an award at the Bagatelle Rose Gardens (where Monet probably first saw it), along with a Gold Medal from the British National Rose Society. Monet seized on it for his garden, where he trained it over rectangular frames, planting pairs at opposite ends of the metal frames so they would

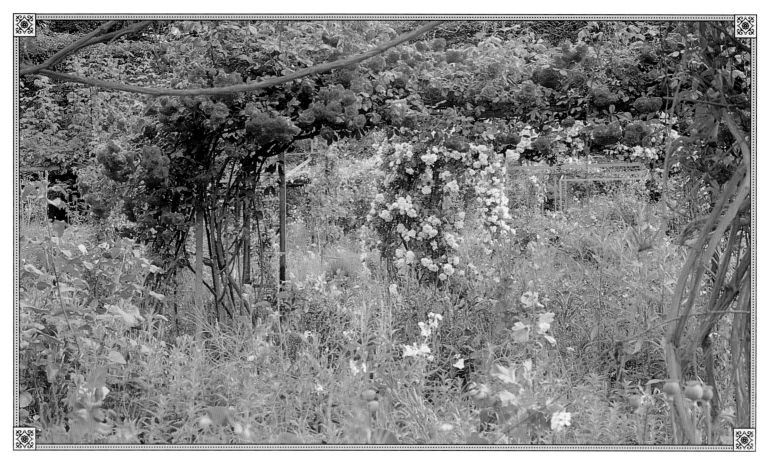

'Paul's Scarlet Climber' in Monet's garden

'BLAZE'

Large-flowered climber

Zones 5 to 9

Using 'Paul's Scarlet Climber' as a parent and crossing it with 'Gruss an Teplitz', an old garden rose of Hungarian origin, the North American rose growers Jackson & Perkins produced 'Blaze', introducing it in 1932. Also known as 'Paul's Scarlet Improved' when it was first introduced, 'Blaze' offers curtains of bright red, semi-double, cupped flowers up to 3 inches (7cm) across, with some intermittent bloom later in the season. The canes can grow to 12 feet (3.5m) and more in height, and the plants can be sheared to promote a bushy habit suitable for hedging.

Try pairing 'Blaze' with a pink climber such as 'Seven Sisters' (a hybrid multiflora of similar size that dates to 1816) and training the two roses over a rustic arbor to meet and mingle.

meet in the middle. It is still displayed in the same way at the garden at Giverny, where it produces a mass of scarlet red flowers, each 3 inches (7cm) across, cupped, double, and held in clusters.

Monet loved to look through his metal rose frames to a view of annuals and perennials in cool colors—especially blue and mauve—highlighted with plenty of glittering white flowers. The placement of a strong red in the foreground and cool colors beyond gave the garden an illusion of greater depth and produced a misty appearance.

Since Monet's day there have been many good new climbing red roses, including the large-flowered 'Dublin Bay', a McGredy hybrid introduced in 1976, and 'Don Juan', a Jackson & Perkins hybrid whose dark velvety red is a richer color than

'Paul's Scarlet Climber'. But the best-selling climber of all is 'Blaze', which has 'Paul's Scarlet Climber' in its parentage.

'PHYLLIS BIDE'

Climbing polyantha

Zones 6 to 9

'Phyllis Bide' was introduced in 1923 by the British rosarian S. Bide & Sons three years before Monet's death, so it is conceivable that Monet grew this fine climber in his garden. In any case, it is one of the favorite climbers used by the gardeners at Giverny today, trained mostly as a pillar rose or as a standard to create an umbrella of flowers.

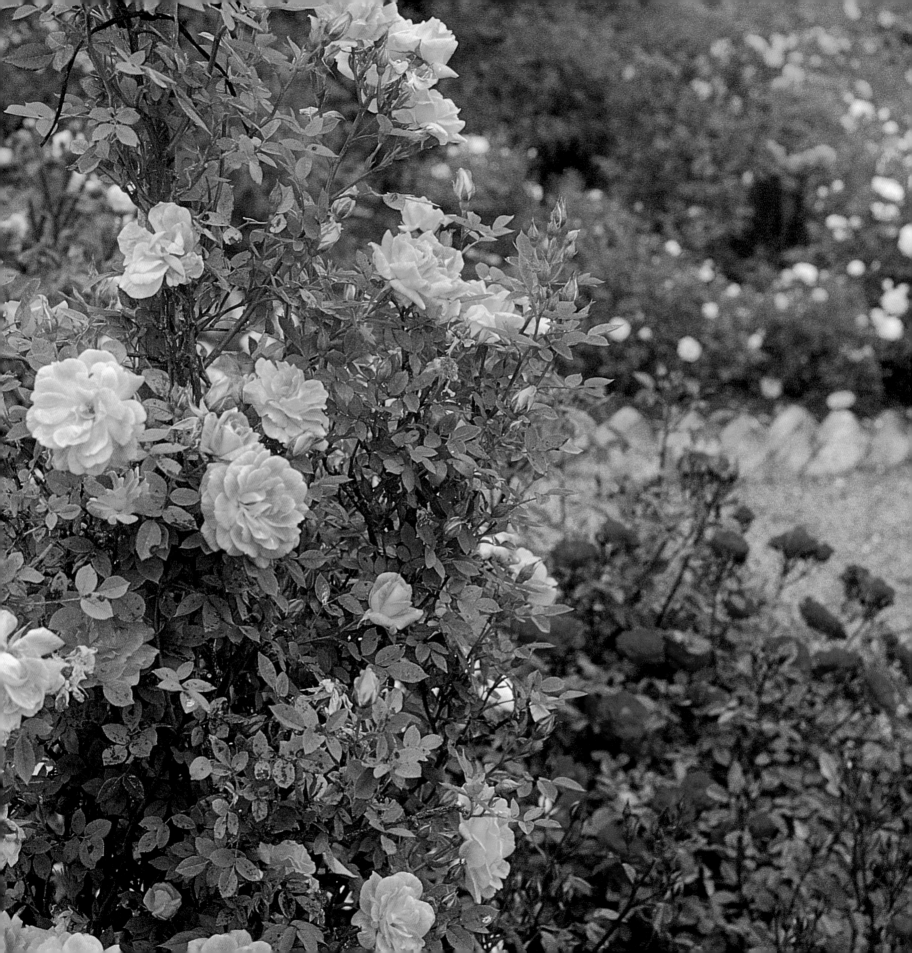

A hybrid between the polyantha 'Perle d'Or' and the climbing tea 'Gloire de Dijon', the color of 'Phyllis Bide' is elusive—a beautiful deep peach-pink in its early stages, fading to gold and pale yellow. The double blooms are just 2 inches (5cm) across, produced in generous clusters throughout the season.

'QUEEN ELIZABETH'

Grandiflora

Zones 5 to 9

This beautiful pink modern rose is classified as a grandiflora by the American Rose Society, but this is a controversial category in the rose world. Indeed, the British do not even recognize the class, which was invented by an American rose breeder, Lammerts, after winning an All-America Award for 'Queen Elizabeth' in 1954 and discovering that the judges could not agree on a classification. The plant exhibited traits of both a hybrid tea (large flowers) and a floribunda (flowers held in clusters). Also, the plant had a tendency to grow taller than typical hybrid teas and floribundas.

In spite of the difference of opinion that still exists between British and American rosarians concerning its correct classification, 'Queen Elizabeth' is a popular plant for garden display. It produces large, lightly fragrant, pink flowers in mostly twos and threes on long canes that may grow to 6 feet (1.8m) tall. There is also a climbing form that can reach 10 feet (3m) high. Individual flowers can be 4 inches (10cm) across, and bloom all season.

Opposite: 'Phyllis Bide'

'ICEBERG'

Floribunda

Zones 5 to 9

'Iceberg' pours forth a nonstop avalanche of fragrant, snow white, 3-inch (7cm), cup-shaped double flowers from spring through summer and well into the autumn months.

Introduced in 1958 by the house of Kordes in Germany, 'Iceberg' garnered gold medals in Germany and Great Britain. It is a cross between 'Robin Hood', a carmine pink hybrid musk often used for hedging, and 'Virgo', a white hybrid tea. Plants grow to 4 feet (1.2m) high and equally wide, but training selected stems can encourage it to produce longer canes that may climb to 8 feet (2.4m) or more. The dark green glossy leaves are a good background for the clear white petals. Although the plant is susceptible to blackspot in areas with humid winters, it has a high ARS rating of 8.9.

'Iceberg' is used extensively in Monet's garden today, and is planted in every conceivable way—as a tree rose, clipped to form a shrub, as a pillar, and even in its climbing form, 'Climbing Iceberg', to arch over frames. However, for climbing effect the preferred rose in Monet's garden is 'Purity', usually planted with red 'American Pillar'.

Although the floribunda class was unknown to the Impressionist painters, it contains many very fine roses—some of which are used today by the gardeners of the Monet's garden. 'Amber Queen' is an amber yellow with large, fully double flowers up to 3¹/₂ inches (8cm) across and glossy, dark green foliage. 'Picasso' has a truly extraordinary color—its semidouble flowers are a raspberry pink, with the edges of the petals outlined in white. But of all the floribundas, none can surpass the extraordinary flowering performance—and repeat-flowering ability—of 'Iceberg' (page 107).

'Queen Elizabeth'

'SEXY REXY'

Floribunda

Zones 6 to 9

The rosarian Sam McGredy used to be based in Ireland, but he moved his business to New Zealand. And it is in New Zealand that he developed some of the world's most beautiful roses, of which 'Sexy Rexy' is probably the most notable. Introduced in 1984, this pale pink rose produces enormous quantities of double flowers with slight fragrance, inheriting its heavy-blooming quality from its parents, 'Seaspray' and 'Träumerei' (also known as 'Dreaming'). Plants are bushy and grow to 4 feet (1.2m) high, with attractive foliage in a lustrous light green.

'Sexy Rexy' is winner of a Gold Medal from the New Zealand Rose Society, and it is said that the prestigious Royal Horticultural Society also wished to honor the rose. But before confirming the award they requested that McGredy change its name to something more refined. He declined, stating that 'Sexy Rexy' was the best-selling rose he had ever developed and he did not wish to tamper with success.

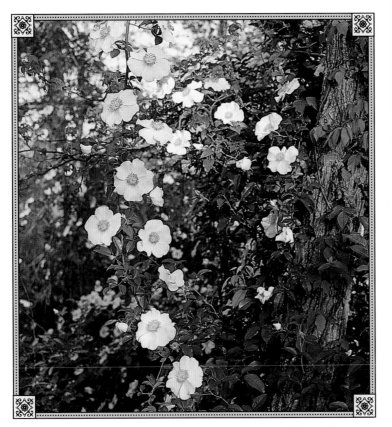

Rosa laevigata

ROSA LAEVIGATA

Species

Zones 7 to 9

Commonly known as the Cherokee Rose, this vigorous climber is native to southern China. It is naturalized throughout the American South, and has the honor of being the state flower of Georgia. The fragrant, pure white, single flowers measure up to 4 inches (10cm) across and are enhanced by a crown of powdery yellow stamens. Blooming in early spring, the flowers are borne on long, fast-growing canes. The whiplike canes are thorny and will hook onto tree limbs and climb 10 feet (3m) or

'SALLY HOLMES'

Shrub

Zones 5 to 9

The first time I saw this elegant rose was at the Virginia Robinson Garden in Los Angeles. Its long, arching canes were trailing across and over an ornate balustrade, and from a distance it looked like a rhododendron in bloom because its 3$^{1}/_{2}$-inch (8cm), ivory white, saucer-sized, five-petaled blooms were clustered together. Weeks later in Maine we saw it growing just as contentedly beside a rustic arbor in a connoisseur's rose garden.

Introduced out of Great Britain in 1976, this is a cross between the beautiful floribunda 'Ivory Fashion' and the perky hybrid musk 'Ballerina'. Plants grow to 6 feet high, and spread as wide. It's a good rose for cutting since the blooms are clustered five or six together, and snipping a stem produces an instant small bouquet.

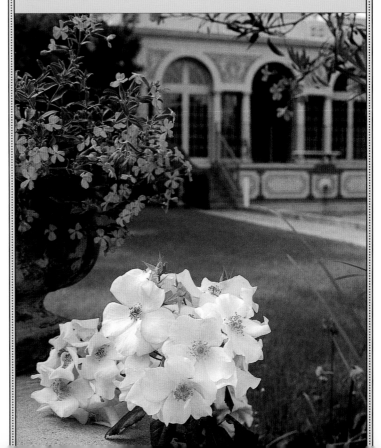

higher. Otherwise, plants can be pruned hard each spring to form a low, spreading bush. Plants are also beautiful trained along fences or positioned at the edge of ponds, so the canes arch out from the bank and dip into the water.

The Cherokee Rose is tender and most suitable for southern gardens. But there are many hardy roses that are similar in appearance and appropriate for growing in northern gardens, notably 'Nevada', a hybrid of *R. moyesii*, and 'Sally Holmes' (page 109), both shrubs.

🌼 'REINE DES VIOLETTES'

Hybrid perpetual

Zones 5 to 9

Translated from the French, the name of this rose means 'Queen of the Violets'. Introduced by the French rosarian Milet-Malet in 1860 from a seedling of 'Pius IX'—a similar violet-colored rose—'Reine des Violettes' produces elegantly arching thornless canes and gray-green leaves on plants that reach 6 to 8 feet high (1.8 to 2.4m). The flowers are variable in color, ranging from pink and magenta to lilac and lavender-blue, depending on location, but the predominant color is a smoky lavender-purple. In soils enriched with chelated iron the blue tones can be enhanced.

The pepper-scented, fully double blooms measure up to $3^1/2$ inches (8cm) across, with petals arranged in a beautiful swirling pattern. Though the plant generally has sparse foliage, it is repeat-flowering where summers are cool, and is considered to be the most widely planted of all old garden roses.

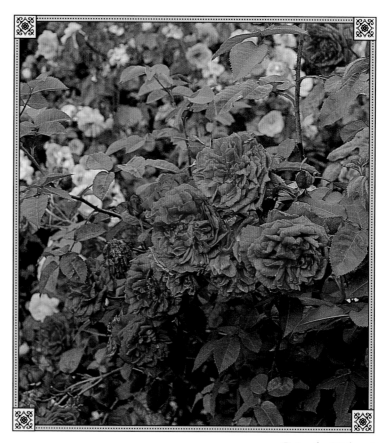

'Reine des Violettes'

'Reine des Violettes' forms a prominent part of the old rose collection in Monet's garden. For floral arrangements it is supreme.

🌼 THE ROMANTICAS

Hybrid tea (in most cases)

Zones 4 to 9

Born in Provence, at the House of Meilland, this unique family of mostly hybrid tea roses has been specially developed for qualities admired by the Impressionist painters, such as an

old-fashioned appearance, outstanding vigor, continuous bloom, and heavy fragrance. It is the type of breeding program that helped make David Austin a household name in the rose world—in other words, Romanticas are old-fashioned bushy plants with regal, voluptuous flowers. Recognizing the appeal of the David Austin varieties, but realizing that they had some shortcomings—such as susceptibility to heat stress and border-line hardiness—Meilland sought to improve them. They made thousands of crosses, selecting for disease tolerance, hardiness, large blooms, controlled growth habit (most grow to 4 or 5 feet [1.2 or 1.5m] high), profuse blooming qualities, and heavy fragrance. The Romanticas look sensational in the garden, and they make exquisite cut flowers as well. In fact, the more they are cut, the healthier they grow. They are ideal for landscape settings—especially for mixing with perennials in borders and cottage gardens.

Many of the Romanticas have 130 petals per bloom and a swirling pattern to their petals, making them almost unrecognizable as hybrid tea roses. Moreover, some of the blooms measure fully 6 inches (15cm) across. Unlike many old garden

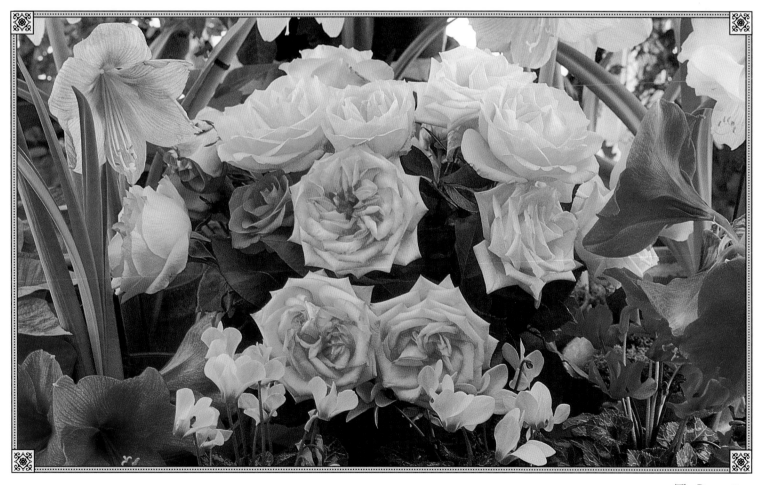

The Romanticas

roses—with their delicate flowers and overall frailty—flowers of the Romanticas hold their heads for long periods. Deadheading faded blooms and watering regularly will keep them blooming from late spring until heavy autumn frost.

Another surprising fact about the Romanticas is that they don't smell like typical hybrid teas (a scent that is similar to that of dried tea leaves). Recognizing the importance of pleasing scent among home gardeners, Meilland's breeders worked with a French perfumery to identify the world's most desirable fragrances. They then identified genes that could replicate these scents in rose breeding, producing fragrances to match six essential oils. The cultivar 'Toulouse-Lautrec' is a yellow rose with a lemony fragrance, while shell pink 'Guy de Maupassant' and red 'Traviata' smell of apples. The cultivar 'Auguste Renoir' is not unlike the old pale pink garden rose 'Painter Renoir', but with a fruity fragrance, repeat-flowering, and larger size (up to 6 inches [15cm] across). Indeed, it recalls the old Provencal cabbage roses that were greatly admired by Renoir and van Gogh, but 'Auguste Renoir' is far hardier.

ROSA RUGOSA

Species

Zones 2 to 8

Known as rugosa rose, and introduced into North America from Asia in 1845, these everblooming plants have rugged constitutions, tolerating poor soil and even salt spray. The rugosas are such good coastal plants that they will root in almost pure sand just above the tide line. There are several forms, with lustrous, dark green leaves and magenta or white single flowers on thorny, arching canes. The highly fragrant flowers can measure up to 3 1/2 inches (8cm) across, and produce large red hips, the skins of which are edible.

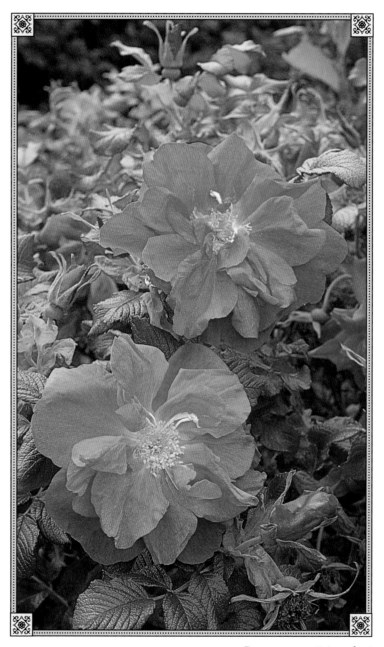

Rosa rugosa *Magnifica*

In addition to the wild species there are more than fifty hybrids in cultivation. Some of the best include 'Hansa' and 'Magnifica', both of which have extra-large, semidouble, purple-red flowers up to 4 inches (10cm) across; and 'Frau Dagmar Hastrup', which bears masses of light pink, 2-inch (5cm) single flowers and a conspicuous crown of bright yellow stamens.

Although susceptible to Japanese beetles and to mild infestations of blackspot, the plants are otherwise pest- and disease-free, and resent spraying of any kind. Rugosa roses make very good security hedges, especially for coastal locations, and they are also excellent groundcovers for holding soil in place and preventing erosion.

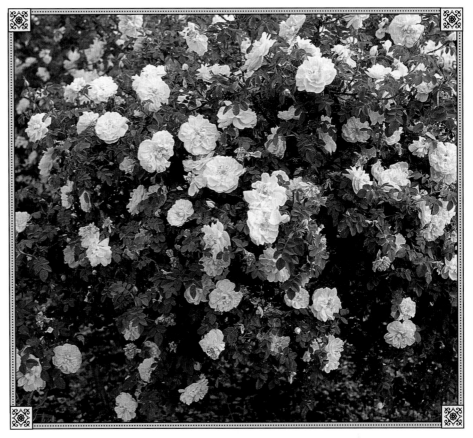

'Stanwell Perpetual'

'STANWELL PERPETUAL'

Hybrid spinosissima

Zones 5 to 8

The species rose *R. spinosissima* (also known as *R. pimpinellifolia*)—commonly called the Scotch briar—was popular in French gardens during the Impressionist era. 'Stanwell Perpetual', thought to be a cross between *R. spinosissima* and a damask rose, was introduced in 1838 by the British nurseryman, J. Lee. The 3-inch (7cm) flowers are a blush pink that fades to white, and are double, cupped, and with the swirling petal pattern so much admired by the Impressionists. They are repeat-flowering, and form a dense, thorny, bushy shrub—up to 5 feet (1.5m) high—with small, gray-green leaves.

'VEILCHENBLAU'

Hybrid multiflora

Zones 6 to 9

Also known as Blue Rambler, Blue Rosalie, and Violet Blue, 'Veilchenblau' is an outstanding, tall-growing, cluster-flowered rose. It was developed by a German rose breeder and selected for the intensity of its blue coloration—possibly the closest to a true blue of any rose ever developed. Introduced in 1909, when

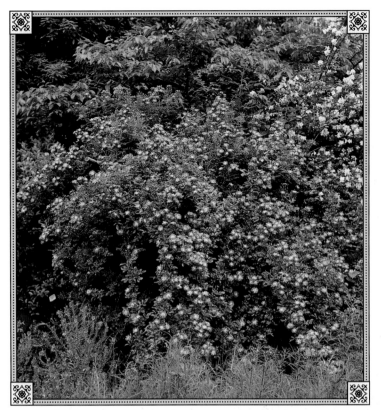

'Veilchenblau'

Monet's garden was at the height of its fame, it is one of the most widely used roses throughout the garden. It is trained as a pillar, as a standard rose, and pruned heavily to form a bushy shrub.

The flowers of 'Veilchenblau' are semidouble, lightly fragrant, violet-blue with a white center, and each measures just 1¼ inches (3cm) across. But the flowers are held in generous clusters and drape down the plant like bunches of grapes. The plants grow to 15 feet (4.5m) high, have few thorns, and are covered in glossy, light green leaves.

'Veilchenblau' is sometimes bothered by mildew, so be sure to provide good air circulation. If mildew is a real problem in your area, substitute a disease-resistant lavender rose such as 'Lavender Dream'.

Special mention should be made of another good lavender-blue rose—'Reine des Violettes' (page 110)—which is a component of Monet's garden.

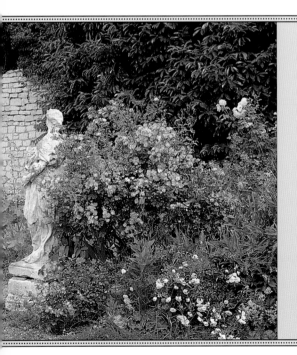

'LAVENDER DREAM'

Shrub

Zones 5 to 9

'Lavender Dream' was not available to the Impressionists, but it is used extensively today in Impressionist gardens. In Monet's garden, for example, it is used as a shrub and as a standard to create a spreading dome of beautiful cup-shaped clusters of 1-inch (2.5cm) flowers in a delicate shade of lavender-pink. At the nearby Hotel Baudy it thrives in a woodland garden, billowing down shaded slopes over stone terraces.

The rose is repeat-blooming and disease-resistant and, though it has no fragrance, flowers are produced in great abundance against a background of matte green leaves.

'ZÉPHIRINE DROUHIN'

Bourbon
Zones 6 to 9

Introduced in 1868 by the house of Bizot in France, 'Zéphirine Drouhin' is probably the most heavily fragrant climbing rose you can grow. The vigorous plants will reach to 15 feet (4.5m) high, and are covered in 3-inch (7cm), cup-shaped, double blooms. The deep carmine-pink flowers are borne in great profusion on thornless canes. Young spring foliage often starts off a deep bronze color, but changes to bright green. Although susceptible to blackspot, the foliage of 'Zéphirine Drouhin' is otherwise disease-resistant.

There are two heavy flushes of bloom—in late spring and again in autumn—and plants will flower intermittently all season in regions where summers are cool.

Consider partnering 'Zéphirine Drouhin' with a clematis such as blue-flowered 'Will Goodwin' or the bicol-ored red and white 'Dr. Ruppell', so that the rose and clematis entwine their stems and flower together.

Use this old garden rose for covering a trellis or training over an arbor, or shear it sharply to create a dense, informal hedge. It is used extensively in Monet's garden to decorate large expanses of stone walls. Plants survive north of Zone 6 when sheltered by a wall.

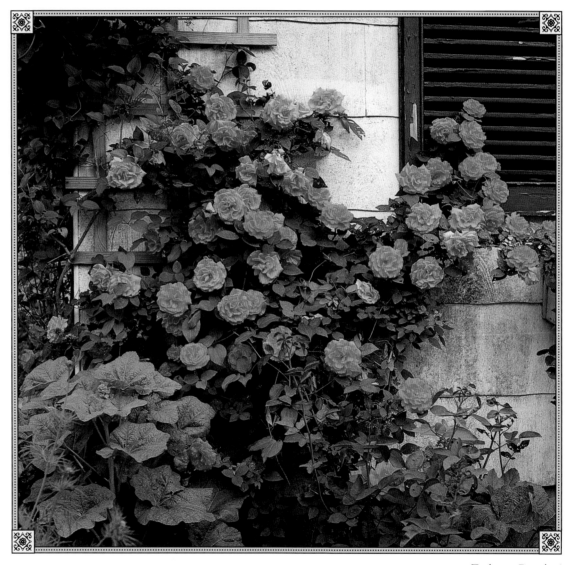

Zéphirine Drouhin'

Chapter 5
CARING FOR ROSES

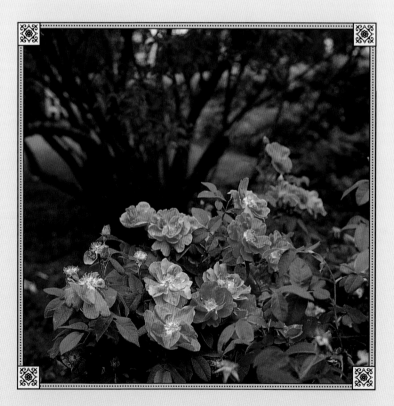

Though many old garden roses, such as *Rosa multiflora* and *R. laevigata* can live for a century without care, hybrid roses generally require some periodic maintenance. Most roses benefit from regular pruning for shape, fertilizing for maximum bloom, and winter protection to prevent damage and winterkill. The following pages will help you care for your roses properly by showing you how to choose healthy plants, improve the soil, and fend off pests and diseases. If you live in a climate with severe winters, you'll find a special selection of roses suited for low temperatires. And for the adventurous, there's advice on hybridizing your own roses.

ABOVE: *St. John's Rose, cultivated since 1902, was introduced to European gardens from Abyssinia.* OPPOSITE: *An informal cottage garden is the perfect setting for free-flowering miniature roses.*

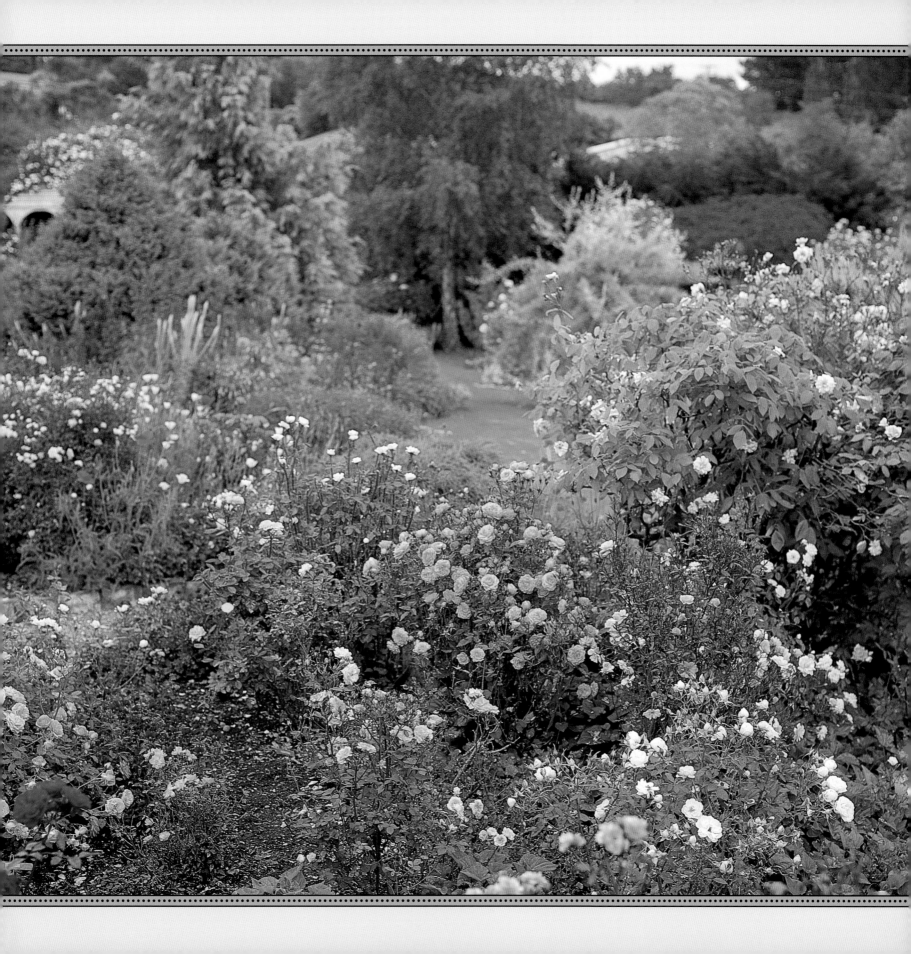

Choosing Roses

When selecting roses for your garden, it is a good idea to make a wish list of the roses you'd like to grow and then check with a nearby public rose garden or the local county extension agent to determine whether those roses will do well in your area. In refining your wish list, be aware that many of the old garden roses are highly suscepti-ble to mildew and blackspot, and there may be some per-fectly acceptable modern sub-stitutes that are preferable to the original varieties. Although the most common source for roses is the local garden center, you may be disappointed with the choices when you compare them with the selection offered by mail-order suppliers. But you may be able to find a spe-cialty rose nursery in your area.

Roses sold at garden cen-ters are usually potted, and are typically well-rooted in soil. Be sure to give the canes a gentle but firm tug to find out if they are really well-rooted or whether the plant was actually bareroot stock recently placed in the pot for appearance's sake. To judge a good rose plant, look at the trunk portion just above the roots and select one with a thick main stem. Roses are graded according to caliper (stem thick-

ness)—a #1 or #1½ grade will have a stem almost as thick as a person's thumb and several erect branching stems about the thickness of a pencil. A containerized rose of premium grade should be your first choice.

Mail-order sources nearly always supply bareroot stock. These are plants that have been dug from the field, had the soil washed from their roots, and had their canes cut to within 6 inches (15cm) of the root. The roots are generally nested in moist sphagnum moss or moist shredded newspaper and encased in a clear plastic sleeve. Planting should be done as soon as possible after the shipment is received. But do soak the roots in a bucket of tepid water for at least an hour before planting to give the roots a good drink.

TWO SOURCES OF ADVICE ON ROSE SELECTION

There are two dependable organizations that help gardeners determine the best roses for North American conditions. One is All-America Rose Selections, an impartial testing organization established by the American rose industry for the purpose of testing roses nationwide and presenting awards for the best choices. These are announced each year and the award winners are identified by a printed tag when offered for sale.

OPPOSITE: *Buying healthy plants of top grade is the first step in cultivating beautiful roses.*
BELOW: *A garden full of old roses graces the grounds of the Hotel Baudy.*

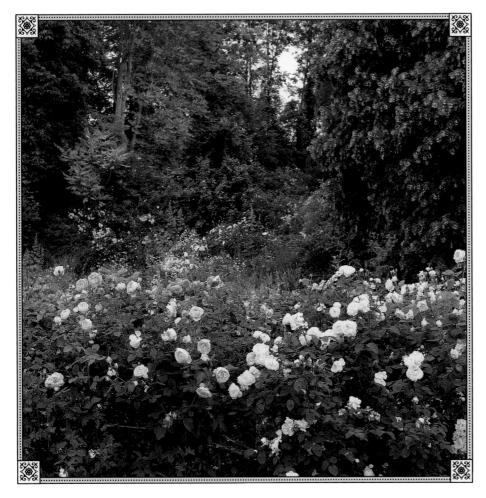

The American Rose Society (ARS) administers a rating system from 1 to 10 as a guide to garden-worthy roses. The ratings are based on members' reports from across the country, with particular attention paid to disease resistance—especially against such troublesome afflictions as blackspot and mildew. The ratings are published in a book available from ARS headquarters (see Sources). No rose has ever been rated a 10, but any rose awarded a 9 or above is considered top quality, with anything over 8 excellent. The ARS also has a network of consulting rosarians all over North America who can provide you with advice on roses. Contact the ARS in Shreveport, Louisiana, at 318-938-5402 or at www.ars.org.

Site Selection

Though some roses will tolerate a lightly shaded location, most demand both full sun and a fertile soil that drains well. A site that receives sunlight for at least six hours is necessary to produce good results for most roses. But if you have a shady site, don't despair—there are several ways to improve it. First, outline the bed where you wish to plant your roses and time how long the sun remains on it. If it is sunny for less than six hours, you may be able to improve the light duration by pruning away some overhead tree limbs. The removal of a single large limb is often enough

to make a site sufficiently sunny. Light intensity can also be increased by mulching around the base of the roots with white landscape chips or by painting adjacent surfaces—such as walls and fences—white.

To determine how well a site drains, simply dig a hole 1 to 2 feet (30 to 60cm) deep and pour in a bucket of water. If the water drains away within an hour, the site has good drainage. If the hole remains mostly full after several hours then drainage is poor. This test is best done in winter or early spring when the ground is already saturated with water, rather than in summer when groundwater can be low. The best solution for a site with poor drainage is to dig a drainage ditch and line it with drainage pipes, creating a system whereby excess water can flow away from the site. A less expensive and less laborious solution is to create a raised bed, using landscape ties, bricks, or stones to hold in enough topsoil to create a well-draining area.

Soil Conditioning

Many species roses—such as the rugosas—tolerate poor, even impoverished, soil. But the more highly hybridized a rose is, the more it demands a deep, fertile soil in which to grow. The ideal is a soil that can provide good anchorage for the root system, such as a clay soil enriched with compost to make it crumbly. Overly clay soils must be improved since they tend to puddle water and resist root penetration. To improve a clay soil, add gypsum (powdery granules sold in garden centers) and plenty of well-decomposed organic material such as peat moss and garden compost.

Sandy soils tend to offer poor anchorage, and they drain nutrients away too quickly. To improve a sandy soil, haul in some screened topsoil from a garden center and add well-decomposed organic material. Bales of peat can be purchased from garden centers, and garden compost can be made from heaping garden and kitchen waste in a bin, though the latter takes time to decompose.

If you have never grown roses in your soil before and you are not sure whether it is suitable, consider conducting a soil test. Local garden centers will provide the names of soil test laboratories, which are usually located at state universities. The soil test will involve filling a pouch with tablespoons of soil

taken from different locations in your yard. After you send the sample in for analysis, you will receive a computer printout that not only advises you of any pH imbalance but also explains how to correct it. If there are nutrient deficiencies, the report will advise how to replenish them using commercial fertilizer. If a soil is considered to be too alkaline for roses, the recommendation may call for an addition of sulfur (available from garden centers). If the soil is too acidic, then the report may prescribe an application of lime. For soils lacking in organic matter, you will be advised to add humus.

Planting Roses

The best time to plant roses is in spring, but if you live in an area with a mild winter, you can also plant in autumn. When creating a new bed, first be sure the site is level and then remove any covering of turf by taking a flat-bladed spade and pushing it under the first 2 inches (5cm) of soil in a horizontal movement. This will expose the bare soil, which will need to be dug to a depth of at least 18 inches (45cm). Remove any debris in the soil, such as stones and weed roots, and if any additives are needed—such as peat moss, fertilizer or lime—mix these into the soil at this time. Break up any lumpy clods with the spade and then use a rake to make a crumbly, level surface. If you must tread over the site, first place a board over the soil to cushion your footprints.

The methods for planting potted and bareroot roses are different. For potted roses, dig a hole to accommodate the root ball and make sure there is good soil contact between the root ball and surrounding soil by firming around the top with your feet. If the soil is

ABOVE: *When preparing a new rose bed, make sure the soil surface is level after mixing in some peat moss and a granular slow-release fertilizer.* OPPOSITE: *Sand (lower left), clay (right), and rich loam (rear) are the three main types of garden soil.*

impoverished or stony, dig the planting hole the size of a bushel basket and dump in some topsoil before setting the root ball in place.

When planting bareroot roses, dig a hole the size of a bushel basket. This will accommodate the depth and the spread of the roots, which should radiate out like the arms of an octopus. If any roots are tangled into a spiral, gently untangle and spread them evenly apart. Trim away any broken roots above the break. Handle the top with care, since there may be some delicate young sprouts of immature sideshoots and flowering stems that can be easily damaged.

Create a cone of soil inside the hole so that the roots fit snugly around it, then fill in among the roots to the top of the hole. Many rose plants—especially hybrid teas, floribundas, and grandifloras—are grafts (which have a swelling—the bud union—where the bud was inserted, indicating that the base is a different root stock than the plant itself). For hybrid teas and grandifloras in mild-winter areas the union can be kept clear of the soil surface, but in severe-winter areas the bud union for these roses should be buried 2 to 4 inches (5 to 10cm) deep for the best winter protection. Any shoots (suckers) that grow up from below the soil or below the bud union should be removed by pruning because they will not be true to the variety.

For both bareroot and potted plants, leave a slight depression as a water catchment to help retain soil moisture and maintain a cool soil temperature. This can be topped with an organic mulch as a weed barrier.

Feeding

There are several ways to feed roses—with granular or liquid fertilizer or with regular applications of garden compost. Granular feeds may be either fast-release or slow-release, while liquid feeds are usually applied as a soil drench, though some have formulations that work well when sprayed onto the foliage. Liquid feeds generally need to be diluted, and the dilution rates vary according to brand. Seafood and seaweed extracts make particularly good fertilizers. Roses are generally heavy feeders, and benefit from two applications of a

Compost bins at Cedaridge Farm help produce the rich organic matter that keeps roses happy and healthy.

slow-release fertilizer at least twice a year—in spring before active new growth begins and again at the end of summer. Liquid feeds and fast-acting granular feeds have different rates of application according to brand. Some need to be applied every two weeks; others once a month during spring and summer.

To maintain rose plantings using only compost, be sure that the compost is well decomposed and apply it in a thickness of 3 to 4 inches (7 to 10cm) at least twice a year, in spring before active growth and again at the end of summer. If you have time for a third application, do it in midsummer.

Pest Control

In spite of the thorns, deer are drawn to roses, especially in winter when other food may be scarce. To control deer you can cover rose plants with netting during winter months, and at other times apply a deer-repellent spray that makes the plant distasteful to them.

Rodents are especially troublesome to roses during winter when they may burrow into mulch covering the soil and girdle the trunk or eat away the roots. Some roses—such as the Meidilands—have such tough roots that they can tolerate rodent abuse, but many hybrid teas and floribundas are vulnerable. Control is very difficult, although mixing moth balls or rodent-repellent flakes into the soil can be effective.

Different regions of the country experience different kinds of insect pests. A visit to your local extension service or a reputable garden center will provide information about prevalent rose pests in your area. When using sprays, choose those that

Roses are a favorite of Japanese beetles, who will flock to the blossoms.

are considered safe for the environment, such as insecticidal soaps and powders made from plant parts, such as pyrethrum. Following are the most common insect pests:

Aphids are colonies of soft-bodied insects that cluster along the most tender parts of a rose plant—usually below a bud. Generally they are gray in color, but they can also be red, orange, green, brown, or black. You can control aphids by blasting them with a jet of water and by using an organic spray such as insecticidal soap.

Borers are rarely seen, since they are the larval stage of a moth or beetle that burrows into wood. Instead, evidence of a borer's presence will be seen in the sudden wilting of the bush (if the

borer has entered the main trunk) or the sudden wilting of a cane (if it has entered a side branch). You may see a pile of sawdust around the hole where the borer entered.

Control once the insect has entered the cane is difficult. If the entire plant is wilted, you can cut below the entry hole and hope the plant has enough energy to sprout new shoots below it. If only one cane is affected, prune away the cane and paint over the cut with shellac. A bacterial control called BT (*Bacillus thuringiensis*) can be applied at the beginning of the season and at two-week intervals to control borers.

Caterpillars are soft-bodied larvae of moths or butterflies. But it is the moth larvae that do the most damage, as they can be extremely voracious, skeletonizing rose plants by eating their leaves. Caterpillars are rarely evident since many are night feeders, hiding beneath foliage during the day. BT, the bacterial disease control, can be dusted or sprayed on plants at two-week intervals as a control.

Japanese beetles spend their winters as white grubs, curled up in the soil, especially under turf grass. They emerge in summer as hard-shelled beetles with a metallic green iridescent sheen. Roses are their favorite food, and they eat both leaves and flowers. Dozens can be seen clustered around a rose flower in a feeding frenzy.

Fortunately Japanese beetles are slow moving and easily hand-picked using a glove to gain a good grip. Otherwise, consider using milky spore, a bacterial control. This powder, which is applied to the lawn, kills the grubs before they can emerge as adults. It is also advisable to use Japanese beetle traps that draw the beetles into a disposable bag.

Nematodes are microscopic eel-like worms that live among the roots of roses, sucking their juices. Evidence of their presence is a general decline in health, browning of leaves, wilting of canes, and leaf drop. Pull up infected plants and destroy them. Soil drenches that can be used to clear soil of nematodes are available from garden centers. In nematode-prone areas, garden centers will also sell a steam-treated topsoil that can be used in raised planters to maintain a nematode-free planting area.

Scale insects are gray or brown scablike creatures that adhere to canes, causing wilting and leaf drop. Remove them by scraping them off or cutting away infected canes. However, when infestations are severe it is best to destroy infected plants and then use a scale control spray on subsequent plantings.

Spider mites look like tiny spiders, and are usually red in color, though they may also be green or black. They weave fine webs among the canes and cause rosebushes to defoliate, especially during dry weather when the insects are most active. To control, use a spray or powder specifically formulated for mites. If you don't spray, natural enemies will often control spider mites.

Thrips are small, slender insects that hide among the buds and opening flowers, causing them to be distorted and turn brown. Thrips are slithery and able to hide quickly when disturbed. Control them with a spray or powder formulated for thrips.

It is often possible to find a general-purpose insecticide that will control the majority of insect pests without having to buy an arsenal of sprays or powders.

Diseases

Although there are a number of roses with good disease resistance ('Carefree Beauty' and the Meidilands, for example), roses can be afflicted by a number of diseases, the worst of which are blackspot and mildew. Following is a list of the most troublesome diseases and how to prevent them:

Blackspot wreaks havoc with a cluster of rose leaves.

Blackspot is a fungal disease prevalent in wet weather, and causes defoliation as well as a general decline in health. It is identified by yellowing leaves covered by black spots. There are disease-resistant varieties such as 'Carefree Beauty', 'Floral Carpet', and 'The Fairy', but controlling blackspot for many other roses can be achieved only by spraying with a fungicide.

Cankers and **galls** are swollen sections of cane—ugly growths caused by bacteria or fungus that enter the plant through a cut, causing a general decline in health. When infestation is severe, the entire plant should be destroyed. Otherwise, prune away the infected area with a hand pruner, sterilizing the blade between cuts by dipping into a detergent solution.

Dieback is a general decline of rose plants that can be caused by many factors. For example, rodents may eat away at the plant's roots, leaving it to die. And during a severe winter, cold winds may cause dehydration and kill a plant. In areas with harsh winters it is a good policy to guard against dieback from wind by pruning exposed plants to within 6 inches (15cm) of the ground. Enclose the plant with burlap or heap shredded leaves high against the canes, holding the leaves in place with a circle of chicken wire. Climbers should have their canes thinned to the five strongest, and then should be held firmly in place against this trellis with twist ties so they do not flap about. In gardens where a lot of plants need protection, dig a spade into the soil and lever each plant into a prone position. Cover well with shredded leaves and let them alone for the duration of the winter, levering them back into an upright position after frost-danger in spring.

THE MOST DISEASE-RESISTANT ROSES

THE MOST DISEASE-RESISTANT ROSE OF ALL TIME IS PROBABLY 'THE FAIRY' (PAGE 91).
HERE ARE SEVERAL OTHERS THAT ARE TRULY OUTSTANDING.

'Carefree Beauty' (shrub; zones 4 to 8) was introduced in 1977 by Dr. Griffin Buck of Iowa Sate University, and is a maintenance-free cross between 'Prairie Princess' and an unnamed seedling. Highly resistant to blackspot and mildew, the bushy plants of 'Carefree Beauty' are covered all season with large, semidouble, lightly fragrant pink flowers up to 4½ inches (11cm) across. Plants grow to 5 feet (1.5m) high, and form a dense knit of canes that makes it suitable for hedging and massing in beds and borders.

'Carefree Beauty' is similar in appearance to the equally disease-resistant 'Simplicity', which was introduced by

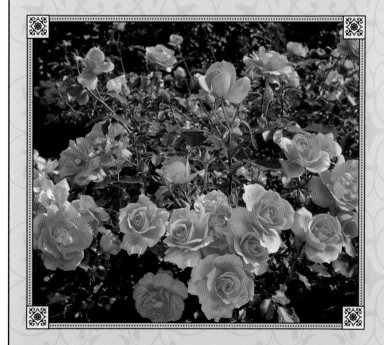

ABOVE: 'Country Dancer' OPPOSITE: 'Carefree Beauty' (foreground) grows together with 'Fantin-Latour'.

Jackson & Perkins, in 1979. A cross between 'Iceberg' and an unnamed seedling, 'Simplicity' is classified as a floribunda, holding its 4-inch (10cm) flowers in clusters. It is a slightly lighter pink than 'Carefree Beauty', with a yellow zone at the center of each petal.

'Country Dancer' (shrub; zones 5 to 9) is considered by many to be Dr. Buck's best introduction. Growing to 3 feet (90cm) high, the bushy plants produce fragrant, deep pink, semidouble flowers all summer long on disease-free plants that grow dark green, glossy foliage.

'Flower Carpet' (shrub; zones 5 to 9) was developed in Australia for bedding display and groundcover effect—thousands of these tough, easy-care plants are used as highway dividers throughout the southern hemisphere. Originally a red rose, 'Flower Carpet' is now the name for a series of low, spreading roses with bright, cup-shaped, 3-inch (7cm), semidouble flowers and dark green, lustrous foliage. It is highly resistant to both blackspot and mildew—the curse of most rose plantings—though plants may succumb at the end of the season. First flowering in late spring, plants bloom intermittently throughout summer and heavily again at the onset of cool autumn nights.

Plants grow to 4 feet (1.2m) high, but can be kept lower by shearing any upward-sprouting canes. Where summers are hot, 'Flower Carpet' may show a tendency to throw some long upright canes and flower sparingly the first season, but

will perform exquisitely once established. In addition to carmine, there are deep pink, light pink, yellow, and white. The 'Flower Carpet' series performs beautifully as a landscape accent, in flower beds, mass plantings, and large patio containers. As a tree-form rose it is especially attractive.

'Starina' (miniature; zones 5 to 9), introduced in 1965 by French rose breeder Meilland, is the highest-rated miniature rose by the American Rose Society, with a score of 9.4. Winner of more awards worldwide than any other miniature, 'Starina' is my favorite mini because it produces lavish

displays of flowers all season in a scarlet color that positively shines in the sunlight.

Plants grow to 18 inches (45cm) high, forming a low, bushy, compact cushion of dark green leaves and bearing so many flowers that they at times almost hide the foliage! The flowers are double, up to 2 inches (5cm) across. Use 'Starina' in all kinds of containers (especially window boxes), as an edging to flower beds, massed for low bedding, or as an everblooming indoor potted plant. It is highly disease-resistant.

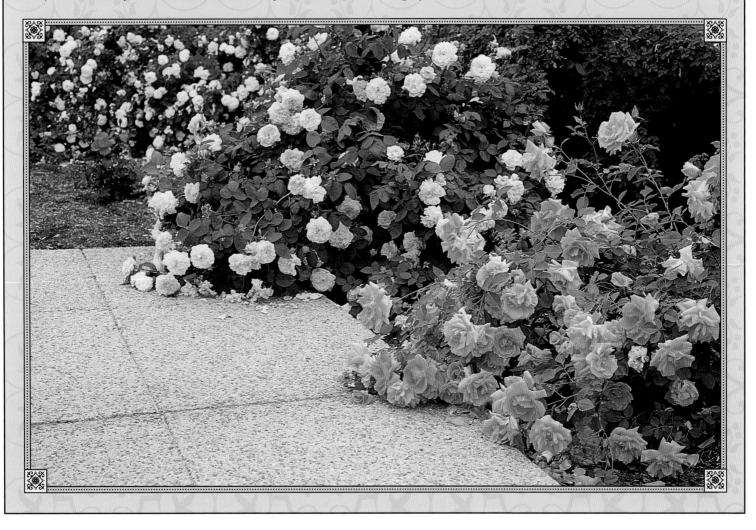

Mildew is a powdery fungal growth that coats the surface of leaves, and is prevalent during wet weather. There are resistant rose cultivars such as 'Carefree Beauty', 'Mister Lincoln', and the Meidilands, but for most roses the best control is a fungicidal powder or spray applied every two weeks.

Rust is identified by small orange pustules covering the undersides of leaves, which eventually cause defoliation. It is prevalent in areas where winters are mild, such as coastal California and the Pacific Northwest. Fungicidal sprays can control it.

You can probably find a general-purpose fungicide that takes care of all the fungal disease problems.

Watering

Roses hate to have water puddling around their feet, relishing instead a cool, moisture-retentive soil that allows excess moisture to drain away. A soil with a high humus content usually has good moisture retention and drainage. Well-decomposed leaf mold and garden compost are especial-

ABOVE: *Before planting bareroot roses, steep the roots in a bucket of water for at least an hour. After you've got the a in the ground, water with 2 gallons of water.* OPPOSITE: *After watering, mulch around the base of plants to deter weeds.*

Weeding

To prevent weeds from competing for moisture and nutrients it is advisable to place a layer of organic material—such as wood chips, shredded leaves, and grass clippings—as a mulch around the base of rose plants. These mulches will need topping up at intervals as they decompose and become part of the soil. Longer-lasting weed barriers include woven fiber mats—usually made of coconut matting—which can be placed around rosebushes. These are more desirable than plastic mulches, which can look unsightly unless covered.

ly good mixed into poorly draining soils. To prevent rapid evaporation of soil moisture, mulch around the rose's roots with organic material such as wood chips or shredded leaves.

Watering should be done whenever the soil surface feels dry. Although a watering can is suitable for watering a small number of roses, a watering wand attached to a garden hose is more efficient. It allows you to water plants right at the roots without wetting leaves, which can induce fungal diseases. To water a large area you can use a sprinkler, but more efficient is a system of drip irrigation in which flexible hoses with emitters or porous sides drip moisture into the root zone. Timers can even be used to turn the watering system on at pre-set intervals. Some drip lines can be covered with a light layer of mulch to keep them hidden.

Pruning

Pruning helps keep roses vigorous and blooming freely. How you prune depends on what effect you wish to produce. Some roses—such as shrubs and miniatures—rarely need pruning because they look most attractive when bushy and dense. If you want a rose to be bushy and billowing but it starts to look uneven or overgrown, the simplest way to rejuvenate it is to cut it back to within 6 inches (15cm) of the soil, forcing new juvenile growth from the base. If you want to

ABOVE: *The folding scimitar saw is a handy tool for reaching into rose bushes and pruning unwanted canes.*

wood, and the healthy canes should be left untouched or pruned back to make the entire shrub look shapely and even in appearance.

Always prune on a slant, $1/4$ inch (0.6cm) above an outward-facing bud so water is shed away from the bud. If you prune straight, the cut can harbor rot, and if you prune above an inward-facing bud it tends to force sidebranches inward, creating a dense, messy tangle that can induce rot through lack of proper air circulation.

control the height of a rose and concentrate the blooms for a good flowering display, take hedge shears and simply snip off a third of its growth, shortening all the canes to the same height. Tests conducted at rose gardens have shown that this type of shearing actually stimulates the greatest number of blooms.

Unfortunately, winter weather—and other environmental conditions—sometimes conspire to play havoc with the growth of a rose, killing some of the canes all the way to the soil line, killing others partially, and leaving still others completely unscathed. In the event of winter dieback, some judicious selective pruning is called for. The dead canes should be cut out entirely, the partially dead canes should be snipped back to live

With climbing roses, you generally want to encourage long canes loaded with flowers, and so each year, in autumn, you must selectively prune away the damaged or weak canes, leaving just four or five strong canes to receive all of the plant's energy. In the spring, examine these main canes again, and if any have brown tips from winterkill, then snip away the dead part so the plant's energy is directed into producing a new juvenile cane rather than trying to heal itself. To discourage winterkill of climbers, consider wrapping them in burlap, black plastic, or horticultural fleece (a lightweight fabric that covers plants like a spider's web). Winter protection is especially important for exposed climbers, such as those trained over arbors or up pillars.

Winterizing Roses

In areas with severe winters—especially where the ground freezes—it pays to take preventive measures to avoid damage from cold and freezing winds. For hybrid teas, floribundas, and grandifloras, it is advisable to shear plants to reduce their height by at least one third, and bunch the canes together in a column by binding them with twine. Once bunched it is easy to wrap each plant with burlap or horticultural fleece. Alternatively, enclose each plant with a circle of chicken wire and fill the middle with shredded leaves. Remove the fleece or leaves in spring when the ground has thawed and a warming trend has started.

Few roses will survive Zone 4 and north without extra precautions. The safest way to pull roses through severe winters is to uproot them with a spade and lie them on their sides, covering the entire plant with shredded leaves. This forces the plants into a deep dormancy that helps protect them from harsh freezing winds and deeply frozen soil. In spring, when hard freezes are past, the plants are uprighted and replanted.

For climbing roses, pull the canes together and secure tightly so they do not flap about. Additionally, climbers on exposed walls should be wrapped in burlap or horticultural fleece.

LEFT: *A wire cylinder filled with leaves protects a tender rose in winter. Heavy mulching also offers winter protection.* TOP: *Dormant roses show mounded mulch that protects roots.* ABOVE: *Canes of climbing roses should be tied securely to supports.*

HARDIEST ROSES

HARDINESS IS AFFECTED BY MANY FACTORS, NOT LEAST OF WHICH IS COLD WINTER TEMPERATURES. BUT EVEN THE HARDIEST OF ROSES CAN SUFFER WINTERKILL UNLESS SEVERAL OTHER ISSUES ARE ADDRESSED, INCLUDING EXPOSURE TO DESICCATING WINDS, A SHALLOW SOIL THAT PREVENTS A DEEP ROOT SYSTEM, AND—IN THE CASE OF CLIMBERS—CANES BEING WHIPPED ABOUT IN THE WIND. FOLLOWING ARE SOME OF THE BEST ROSES FOR REGIONS WITH HARSH WINTERS.

Sub-Zero Roses, (hybrid tea; zones 4 to 9) developed by Dr. Walter D. Brownell, includes a whole series of remarkable hybrid tea roses—all noted for unusual cold hardiness. Dr. Brownell's breeding program was conducted in Rhode Island, and his roses were subjected to the harsh winters of New England as part of his rigorous evaluation process. 'Helen Hayes'—named for the actress—is a beautiful yellow that deepens to orange. Plants grow to 5 feet (1.5m) high, with only slightly thorny canes and a lustrous, dark green foliage. Individual blooms are recurrent, and each can measure up to 5 inches (12cm) across. It is an excellent choice for massing with other Sub-Zero roses as well as for the cutting garden.

Other varieties in the Sub-Zero family include 'Lily Pons' (white), 'Queen of the Lakes' (red), and 'Curly Pink'. Although other rose breeders test for hardiness as part of their evaluation process, most rose breeders are located in areas with mild winters—such as California and the South of France—and so their hardiness is generally not as reliable as roses bred in northern climates.

Meidiland roses (shrub; zones 4 to 8) were developed by the famous French rose breeding family, Meilland, and are hardy, easy-maintenance shrub roses. They are not only resistant to blackspot and mildew, but they are repeat-blooming, making a bold flush of bloom in early summer and continuing sporadically through autumn with another bold flush. An added plus for the Meidiland rose family is that they are not grafted roses—they are grown on their own root systems. Therefore, there is no tendency for the root stock to throw up undesirable suckering canes from an understock. If the top is harmed by winterkill or deer, the root system will generate identical new top growth. There are five favored varieties that share similar characteristics in growth habit and landscape use, but each is different in flower form and color. These rugged roses are superb for creating an informal boundary hedge, and for covering a hard-to-plant slope to control soil erosion. My favorites include:

'Bonica'—This shell pink, double-flowered shrub variety makes up in quantity of bloom what the individual flowers lack in size. Plants are bushy, with a mass of arching canes covered in small, dark, semiglossy leaves that help to display the myriad 2-inch (5cm) blooms.

'Red Meidiland'—A single-flowered crimson shrub with a white eye and crown of golden stamens, this should not be confused with 'Scarlet Meidiland', which is orange-red in color and holds its double button–shaped flowers in generous clusters. 'Pink Meidiland' (single-flowered) and 'White Meidiland' (double-flowered) are more low-growing and spreading than the others.

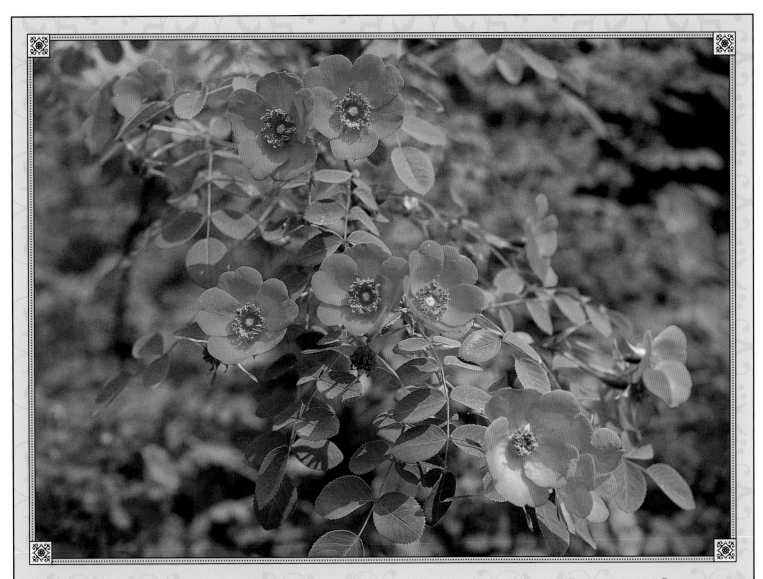

Rosa moyesii

Rosa moyesii (species rose; zones 4 to 8) is a distinctive single-flowered rose from western China with intense red blooms in a five-petaled cup shape. Although the shrubby plants are not noted for fragrance and bloom only once for several weeks in spring, the flowers are followed by decorative, orange, vase-shaped rose hips that ripen in autumn. Plants grow to 8 feet (2.4m) tall.

The most desirable variety is 'Geranium'. Introduced in 1938, it is a vigorous plant with tall arching, thorny, canes that are studded in spring with orange-red flowers.

The cold-hardy Canadian Explorer strain includes 'William Baffin'—a semidouble deep pink hardy to Zone 4—and 'Henry Hudson'—a fragrant, single or double bloom in white, pink, or yellow that is hardy to Zone 2.

Propagation

Roses can be propagated from seed, by cuttings, by layering, by budding, or by grafting, usually on Fortuniana stock. Seed-starting produces variable results among roses—especially with hybrids. Growing roses from seed usually results in inferior progeny unless the plant is a species rose. Also, it takes much longer to grow a rose to the blooming stage from seed than from cuttings.

GROWING ROSES FROM SEED

To grow a rose from seed, simply take a ripe hip, peel away the skin, and shuck out the seeds. Plant the seeds in a shallow tray filled with a sandy or peat-based potting soil. Cover with just enough soil to anchor the seeds. Maintain a temperature of 70°F and keep the soil moist by enclosing the seed tray in clear plastic. When the seedlings are about 1 inch (2.5cm) tall, separate them and plant them into individual pots to grow larger. Once the seedlings have grown about 4 inches (10cm) tall they can be transferred to the garden into their permanent positions. They will generally take at least two years to bloom.

GROWING ROSES FROM CUTTINGS

Cuttings produce plants that are exact replicas of the parent plant. To start a cutting, select a healthy young rose cane and cut it into 5-inch (12cm) segments, making sure that each segment has a leaf bud or cluster of healthy leaves. Scrape away 1/4 inch (0.6cm) of bark at the base of the cutting with a knife and dip the base into rooting hormone—a powdery substance

available from garden centers. Stick the cutting upright into a moist peat or sand-based potting soil, to a third of its length.

Dozens of cuttings can be spaced in a propagating tray. Place the tray in a lightly shaded location and maintain a moist soil. Rooting should take place in six to ten weeks. The rooted cuttings can then be pulled from the propagating tray and moved to individual pots to allow them to increase in size or placed in nursery beds, spaced at least 18 inches (45cm) apart to develop into flowering plants. Once the plants flower they can be moved into permanent locations in the garden.

A successfully rooted rose cutting is ready to be transplanted.

HYBRIDIZING ROSES

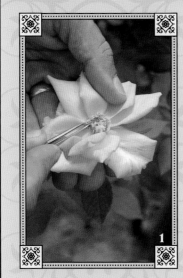
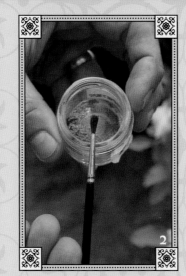

Roses are relatively easy to hybridize. To try hybridizing roses at home, first select your female parent. Take a mature bud and force the petals open to reveal the powdery, yellow, pollen-bearing anthers. Using tweezers, remove the outer ring of anthers (the male part of the flower) so their pollen does not pollinate the central cluster of stigmas (the female part of the flower). This procedure is called "the emasculation" (1).

Then, collect the pollen-laden anthers from another rose variety (the male parent) in a jar (2). Using a camel's hair brush, transfer pollen from the jar to the stigmas of the female parent. This procedure is called "the cross" (3).

Tag the crosses with the names of the parents and dates of the cross (4). As the seed pods (the hips) ripen, collect the seeds and plant them in potting soil. When the seeds germinate, grow them to transplant size (about 4 inches [10cm] high) and transfer to the garden for evaluation. Then, when the seedlings bloom, evaluate them to see if any are worth saving. If they are, give each hybrid a name or number, and increase the quantity of plants by taking cuttings.

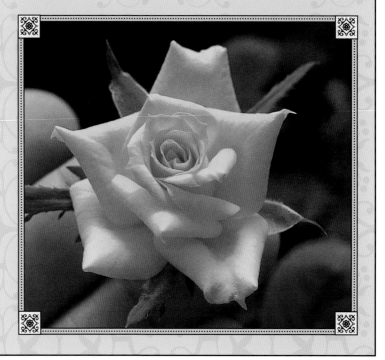

❧ LAYERING ❧

Layering produces plants identical to the parent. Bend a cane to the ground and, where it touches the ground, use a sharp knife to score the underside of the bark below a bud. Pin the cane to the ground with a wire loop so that the scored part of the cane remains in constant contact with the soil. Alternatively, pin the scored part to soil in a pot. Roots will form where the cane touches the soil. After a cluster of leaves has sprouted above the cut, detach the cane from the parent using hand pruners and plant the rose to grow independently.

ABOVE: *To raise roses from seed, sow seeds in trays filled with peat-perlite mix and cover with plastic lids to maintain humidity.* OPPOSITE: *Climbing 'Cecile Brunner' creates a beautiful floral arch punctuated by foxgloves and purple vervain.*

❧ BUDDING ❧

Budding is a grafting technique practiced mostly by professional growers. It requires a budstock (top segment) from the plant you wish to increase and a hardy rootstock (usually *Rosa multiflora*) from a plant onto which you want to bud the desired variety. A T-cut is made in the understock, and the "bud-eye" taken from the desired variety is fitted into the T. Once the budding takes, the top of the understock is cut off, stimulating the eye to break and grow. When mature the plant is dug and stored to be transplanted.

❧ GRAFTING ❧

Grafting is a method of propagation in which a budstock—a 3-inch (7cm) section of cane with a bud held erect—is grafted onto another rootstock, generally a Fortuniana. The base of the budstock is cut into a V shape. Then the rootstock is split to accommodate the V of the budstock. The two are held in place with a rubber band. Over time (usually ten weeks), the budstock and rootstock become one, fusing together to create a bud union. Once the union is successful and scar tissue has healed over the cuts, the branch can be severed below the graft and rooted to create a plant that will go on to flower. Like cutting, layering, budding, and grafting produce plants identical to the parent.

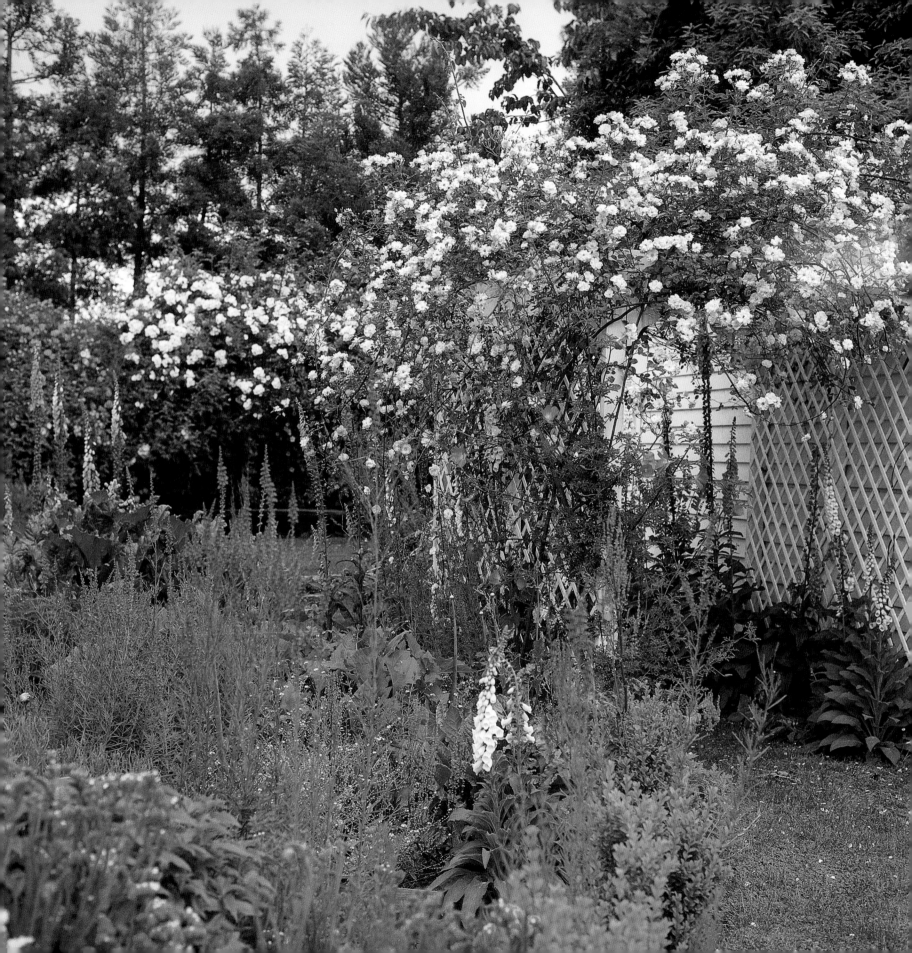

ABOUT THE AUTHOR

Derek Fell is a prolific writer and photographer who specializes in recording the romantic qualities of gardens. He lives in Bucks County, Pennsylvania, at historic Cedaridge Farm, where he cultivates extensive award-winning flower and vegetable gardens. His work is featured in *Architectural Digest, Hemispheres, Woman's Day, Gardens Illustrated,* and *Fine Gardening* magazines.

Fell has lectured on photography and the gardens of the great Impressionist painters at numerous art museums, including the Smithsonian Institution, the Barnes Foundation, the Philadelphia Museum of Art, the Denver Art Museum, the Walters Art Gallery in Baltimore, the Dixon Art Gallery in Nashville, and the Renoir Foundation. Fell's photography is sold in signed editions, and his photographic art poster, *Monet's Bridge* (Portal), is displayed and sold at the Monet Museum at Giverny, France. Another photograph, *Monet's Roses,* has been added to the series of Contemporary American Photographers note card sets.

Born and educated in England, Derek Fell worked for seven years with Europe's largest seed house before emigrating to the United States. After six years with Burpee Seeds, he became executive director of All-America Selections (the national seed trials) and the National Garden Bureau (an information office sponsored by the American seed industry). The author of more than fifty gardening books and calendars, he has traveled throughout North America, Europe, Africa, South America, New Zealand, and Japan to document gardens. His books on the Impressionist painters include *Secrets of Monet's Garden* (Friedman/Fairfax), *Impressionist Bouquets* (Friedman/Fairfax), *Renoir's Garden* (Simon & Schuster), and *The Impressionist Garden* (Crown).

Fell's property, Cedaridge Farm, has twenty-four theme gardens that take inspiration from the great Impressionist painters. From April 25 through November 1 the gardens are open by appointment. For further information about visiting Cedaridge Farm, write Cedaridge Farm, Box 1, Gardenville, PA 18926.

Roses at Cedaridge Farm *(1998) by Julia Elliot*

PLACES TO VISIT

MUSEUMS AND GARDENS OF THE FRENCH IMPRESSIONISTS

Cezanne's Garden & Studio
Avenue Paul Cezanne
13090 Aix-en-Provence
Tel: 42 21 06 53

Monet Museum and Garden
Rue Cluade Monet
27620 Giverny
Tel: 32 51 28 21

Musee Americain Giverny
2, Rue Claude Monet
27620 Giverny
Tel: 32 51 94 65
Exhibition of American Impressionist Art
and Gardens

Parc de Caillebotte
6, Rue de Coney
91330 Yerres
House and gardens where Caillebotte
grew up

Renoir Museum and Garden
Chemin des Collettes
06800 Cagnes-sur-Mer
Tel: 93 20 61 07

Van Gogh's Walk, Arles
Place du Forum gift shops sell maps
showing location of many van Gogh
motifs.

Van Gogh's Walk, Auvers-sur-Oise
Tourist office, Manoire des Colombieres
provides maps showing the location of
many van Gogh motifs.

Van Gogh's Walk, Saint-Remy
Tourist office, Place Jaures, provides
maps showing location of many van
Gogh motifs surrounding the asylum.

PUBLIC ROSE GARDENS

Bagatelle Park
Route de Sevres-a-Neuilly
Bois de Bologne
Paris
Historic house and gardens owned by
the City of Paris since 1905. The rose
garden is part display garden and part
test garden, which Monet visited to
evaluate new rose hybrids.

Malmaison Rose Garden
Rueil-Malmaison
Home of Emperor and Empress
Bonaparte. Located 8 miles west of

Paris. Site of historic rose garden found-
ed by Napoleon's wife, Josephine. Part of
her vast collection has been restored.

Public Rose Garden, Roseraie de l'Hay
8 Rue Albert-Watel
L'Hay-les-Roses
3,000 varieties of roses displayed in large
formal garden just 3 miles south of Paris.

Hotel Baudy
Rue Claude Monet
27620 Giverny
Beautiful rose garden in a woodland
setting close to Monet's Garden.

SOURCES FOR ROSES

UNITED STATES

Antique Rose Emporium
Route 5
Brenham, TX 77833
Specializing in old garden roses.

Conard Pyle Company
228 Schoolhouse Road
West Grove, PA 19390
Source of 'Romanticas'—new hybrid tea
roses with old rose appearance.

Rosieraie at Bayfields
PO Box R
Waldoboro, ME 04572
Specializing in old garden roses.

Roses of Yesterday & Today
802 Brown's Valley Road
Watsonville, CA 95076
Specializing in old garden roses.

Wayside Gardens
Box 1
Hodges, SC 29695
Specializing in David Austin English
roses.

CANADA

Aubin Nurseries
Carman
Manitoba ROG 090

Carl Palleck & Son
Virgil
Ontario L0S 1T0

Hortico Inc.
Waterdown
Ontario L0R 2H0

Morden Nurseries
Manitoba R0G IJ0

Pickering Nurseries
Pickering
Ontario LIV IA6
Specializing in old garden roses.

Walter Le Mire
Oldcastle
Ontario N0R IL0

UNITED KINGDOM

David Austin Roses
Albrighton
Wolverhampton WV7 3HB
Specializing in David Austin's English roses.

Peter Beales Roses
Attleborough
Norfolk NR17 IAY
Specializing in old garden roses.

Cants Roses
Colchester
Essex CO4 5EB

James Cocker & Sons
Whitemyres
Aberdean AB9 2XH

Gandy's Roses
Lutterworth
Leicestershire LE17 6HZ

R. Harkness & Co
Hitchin
Hertfordshire SG4 0JT

Trevor White
Norwich
Norfolk NRI0 4AB
Specializing in old garden roses.

AUSTRALIA

Rainbow Roses
Ferntree Gulley
Victoria 3156

Reliable Roses
Silvan
Victoria 3795

Ross Roses
Willunga
South Australia 5172
Specializing in old garden roses.

Swane's Nursery
Dural
New South Wales 2158

Treloar Roses
Portland
Victoria 3305

Walter Duncan Roses
Watervale
South Australia
Specializing in old garden roses.

NEW ZEALAND

Egmont Roses
New Plymouth

Tasman Bay Roses
Motueka
Specializing in old garden roses.

GARDEN CREDITS

In addition to the gardens mentioned in the text, the author wishes to acknowledge the following:

Barbara Taylor, Akaroa, New Zealand
The Barnyard, Carmel, California, US
Bremdale Garden, Gisborne, New
 Zealand
Buchardt Gardens, Victoria, Vancouver,
 BC, Canada
Cypress Gardens, Charleston, South
 Carolina, US
The Country Garden, Auckland, New
 Zealand
Suzanna Grace, Rathmoy Garden,
 Hunterville, New Zealand
Longwood Gardens, Kennett Square,
 Pennsylvania, US
Magnolia Plantation, Charleston, South
 Carolina, US
Middleton Place, Charleston, South
 Carolina, US
The Secret Garden, Waimate, New
 Zealand
Linda Wilson, Parkside Garden,
 Oamaru, New Zealand
Van Dusen Botanical Garden,
 Vancouver, BC, Canada

INDEX

INDEX